C000142061

Wordsworth's
GARDENS

Wordsworth's
GARDENS

Carol Buchanan
Photographs by Richard Buchanan

Texas Tech University Press

Library of Congress Cataloging-in-Publication Data
Buchanan, Carole.
 Wordsworth's gardens / by Carole Buchanan ; photographs by
Richard Buchanan.
 p. cm.
 Includes bibliographical references and index.
 ISBN 0-89672-445-X (alk. paper)
 1. Wordsworth, William, 1770–1850—Knowledge—Botany
2. Landscape gardening—England—History—19th century.
3. Gardens—England—Design—History—19th century. 4. Wordsworth,
William, 1770–1850—Homes and haunts. 5. Wordsworth, William,
1770–1850—Aesthetics. 6. Poets, English—19th century—Biography.
7. Gardeners—England—Biography. 8. Gardens in literature.
I. Buchanan, Richard. II. Title.
 PR5892.B65 B83 2001
 821'.7—dc21

 00-011136

 01 02 03 04 05 06 07 08 09 / 9 8 7 6 5 4 3 2 1

© Copyright 2001 Texas Tech University Press

All rights reserved. No portion of this book may be reproduced in any form or
by any means, including electronic storage and retrieval systems, except by
explicit, prior written permission of the publisher except for brief passages
excerpted for review and critical purposes.

This book was set in Garamond, Snell, and Lapidary 333. The paper used
in this book meets the minimum requirements of ANSI/NISO Z39.48-1992
(R1997). ∞

Design by Tamara Kruciak

Printed in China

Texas Tech University Press
Box 41037
Lubbock, Texas 79409-1037 USA

800-832-4042

ttup@ttu.edu

http://www.ttup.ttu.edu

For George Kirkby

O happy Gardens! whose seclusion deep
Hath been so friendly to industrious hours;
And to soft slumbers, that did gently steep
Our spirits, carry with them dreams of flowers,
And wild notes warbled among leafy bowers . . .

William Wordsworth
"A Farewell"

Contents

Foreword

"This is my master's library, where he keeps his books, but his study is out of doors." So said a servant to a visitor to Rydal Mount as she pointed to Wordsworth's bookcase.

Since Marian and I moved to Rydal Mount from South Africa, we have made many wonderful and interesting friends. Two friends, however, stand out because of their genuine encouragement and thoughtful advice, two people who have extended the sincere hand of friendship to us in what were very new and different circumstances. Now Carol and Dick have given me the honor of writing the foreword of their new book, a work that has caused

them to travel many thousands of miles, work many long hours devoting much time and energy to producing a very different and exciting new book; a work of art that I feel sure Wordsworth would have enjoyed and that would have graced his very bookcase.

As most of my friends will tell you, my knowledge of gardens and gardening was (to say the least) very limited indeed. Shenstone could well have teased me about the difference between ranunculas and an anemone. I thought they were creatures of the sea. However, thanks to the help of my very patient gardener, Tony Braithwaite, and the kindness and understanding of the Wordsworth family, my knowledge has improved a little.

Then along came this marvelous book, which has now put the meaning of the humble servant's words, "his study is out of doors," into context. I can now try to understand more of the background of this great man's gardening achievements, especially as far as the beautiful garden of Rydal Mount is concerned.

To study nature as Wordsworth did is to be aware and sensitive of your whole surroundings. As this book tells us, the poet was a man with the perception to feel the "oneness" of nature, who felt the spiritual power of a creative force that has produced such inspiring beauty. Even a tiny daisy can live in harmony with a giant sycamore, for there is room for both. Carol and Dick, by taking a closer look at the mind of the poet, have helped me and will help the many others who read the book to stand back, stop,

take stock, and realize, as did Wordsworth, that the planet Earth is indeed a beautiful place.

It must be very difficult trying to understand the mind of such a man after so many years. To understand why the stones were laid in a certain way, why the path wandered in a certain direction, why certain plants were used or a building was positioned where it was. Yet with great patience and meditative thought, Carol has managed, I feel, to enter his mind and so understand his purpose of design. She sees in Wordsworth's planning of a simple fish-pond for Lady Beaumont his intention to show that not only in life, but also in death, there is a purpose. On a lighter note, she explains why thyme would have been a good remedy for a hangover: "An infusion of the leaves removes the headach ocasioned [sic] by the debauch of the preceding evening." A good enough reason for us to plant the herb in our gardens! There are many more subtle conclusions like this. It is almost as if Carol has been so caught up with her investigations that she has dug herself deep into the character she has spent so many years researching.

Another example of understanding the poet's purpose of design, and one that I shared with Carol and Dick, is the discovery of why the poet placed his summerhouse in Rydal Mount where he did. It only became obvious to me when we cleared the surrounding area of overgrown rhododendron, laurel, and Japanese

knotweed. Once that was done, the views were opened up, and it was clear there could have been no better siting for this small stone shed. In Wordsworth's day, it would have commanded views of the beloved garden he had landscaped and of his cherished Lakeland countryside. Wordsworth, as a romantic, was aware that his creation blended harmoniously with the nature that surrounded his garden.

Carol brings out another insight into this man's mind, something simple and straightforward yet so wonderfully creative. We are told how the poet, when designing water features, places rocks in different positions to change the tune of the water. This from a man who Carol tells us was "unable to appreciate instrumental music." He enjoyed the music made by nature, the water, birds singing, bees humming, breezes through the trees. As I write this, I wonder what poetry he would have written about the sounds of the African bush.

How many of us really understand or appreciate the poetry of a garden? Again, Carol shows how Wordsworth brought the two together. This is something that on the face of it should not be difficult, yet somehow we take so much for granted and miss the obvious. Of course it is one thing to see poetry in the beauty of our gardens, but another to write poetry about it. A poem that comes to mind, and one of my favorites, is "Lines Written in Early Spring":

I heard a thousand blended notes,
While in a grove I sate reclined,
In that sweet mood when pleasant thoughts
Bring sad thoughts to the mind.

Through primrose tufts, in that green bower,
The periwinkle trained its wreaths;
and 'tis my faith that every flower
Enjoys the air it breathes.

The birds around me hopped and played,
Their thoughts I cannot measure
But the least motion which they made,
It seemed a thrill of pleasure.

The budding twigs spread out their fan,
to catch the breezy air
and I must think, do all I can,
that there was pleasure there.

Carol and Dick, by taking a closer look at another important aspect of the Poet's life—a part that was obviously close to his heart and mind—will help us to stop and appreciate just what treasures our gardens hold, to be more aware of our environment.

Certainly they have encouraged and motivated me again to continue searching this garden for more of the Poet's treasures that may be hidden beneath its soil. Through the pages of this book, they have linked together the poetry, the design and spirituality of a man, an icon in his own lifetime. With the help of print and film, they have shared with us some of his deepest thoughts, a study of nature expressed by his creative genius, not only by poetry but also through the nurtured landscape of his gardens.

Surely any man who is prepared to shovel manure is aware of his position in life. Wordsworth is aware that nature cannot be improved upon. Orange, red, blue, and green all go together in our gardens, and in the countryside that surrounds us, maybe it is only man's arrogance that thinks it needs improving.

How often in this world of ours, as we dash headlong into it, and as we stare daily at flashing screens, do we stop to look and study—as he did—the natural beauty that surrounds us? "My heart leaps up when I behold a rainbow in the sky. . . ." Even those of us who are fortunate to live among this nature can sometimes take it too much for granted and "look through a glass darkly," but Dick's photographs will help us all—residents and nonresidents alike—see its beauty more clearly, and even experience the gardens as if we were there.

If this book can help to bring together a better understanding, a fuller appreciation of the beauty that surrounds each one of us, then not only will William Wordsworth have continued to show us what to look for, but Carol and Dick will have made their contribution to our contentment, ensuring our hours of labor in our own gardens are more meaningful and that their long hours of devotion to this study were worthwhile.

God saw all that he had made, and it was very good.

<div align="right">

Peter Elkington
Rydal Mount and Gardens

</div>

Preface

This book is the product of thirty years' appreciation for the poetry of William Wordsworth and a love of gardening that coalesced when Dick and I visited Dove Cottage in 1987 and saw the garden. At that point I knew I had to write about it, and Dick, being the supportive spouse he is, offered to take the photographs.

Our work first resulted in an article, "Wordsworth the Gardener," published in *Pacific Horticulture* in 1990, but other book projects intervened, so it was not until 1999 that I completed the fourth chapter. By then, Peter Elkington had been the curator for some years, and had made great strides in restoring the

terraces—in particular, discovering the terrace now called Dora's Terrace. Had I written the fourth chapter prior to 1999, it would have been premature.

During the decade of the 1990s, we continued to visit the gardens at Rydal Mount and Dove Cottage, and to photograph them in their various seasons and moods.

This book is the result of years of research, as any cross-discipline work must be. It has been great fun to expand my own knowledge of gardening and of Wordsworth's poetry, in the gardens and in the great libraries of Dove Cottage, the University of Washington, and the Natural History Museum in London. Although literature seems to have overlooked the connection between them, this book is for the lover of Wordsworth's gardens and his poetry, and not intended as a work of scholarship.

We both hope that the readers of this book will enjoy exploring his gardens and poetry as much as we have.

Acknowledgments

No book is ever a one-person project, and this one is certainly no exception. Dick and I are grateful to the following people for the assistance and encouragement given to us over the years: Russell and Cynthia Gore-Andrews, owners of Racedown Lodge (which William and Dorothy Wordsworth borrowed from June 1795 to July 1797), not only for their kind permission to photograph and use materials pertaining to Racedown, but also for their active assistance, interest, and encouragement; Gordon (Don) Brookes, curator of Rydal Mount (retired), for his gracious assistance with permissions and encouragement; Peter and

Marian Elkington, present curators of Rydal Mount, for their many kindnesses and practical assistance, and free rein of the grounds to photograph the gardens at all times of the year; Professor Mark L. Reed, University of North Carolina, Chapel Hill, for his encouragement and suggestions on an early draft of this book; Carol Latham-Warde (Mrs. Richard Sharples) for generously sharing her extensive knowledge of the Lake District and helping to make us acquainted with its many beauties; Ann Lambert, who succeeded George Kirkby as chief guide and gardener at Dove Cottage, for her generosity in keeping us up to date about changes in the garden; Jeff Cowton, registrar of the Dove Cottage Library, for his kindness in making the facilities of the library available; Robert Woof, chairman, and the trustees of the Wordsworth Trust, for their practical assistance and encouragement with this project, both in making the facilities of the library available and in opening the garden to us whenever we visited the Lake District; A. F. Deakin, director of the British Coal Board, for his kind permission to visit and photograph the remnants of the Winter Garden on the grounds of his home; Richard K. Wood, for taking a day to guide us around the part of Leicestershire where Coleorton is located, and for generously sharing all of the information at his disposal about Coleorton, the Beaumonts, and the Winter Garden; Judy Olson and Clint Kilbourne, who took the time to interview George Kirkby in 1990 and acquire an expanded list of plants from him; and Judith Keeling and Jacqueline McLean, of Texas Tech University Press, for their experienced and expert editing. Judith has also been of great help in guiding us through the process of bringing *Wordsworth's Gardens* from proposal to the book you are reading now.

For more than thirty years George Kirkby worked at Dove Cottage to restore the garden to its Wordsworthian state. Without George's helpfulness, good humor, and encyclopedic knowledge of Lake District flora, this book could not have been written. One of our fondest memories of George was to walk about the garden as he recited Wordsworth's poetry in his Cumbrian accent. To hear George was to hear the poetry as Wordsworth would have pronounced it. George read and enjoyed the chapter on Dove Cottage, but to our everlasting regret, he did not live to see the book in print.

A Note on Vocabulary

Some words or usages in this book are peculiar to the Lake District. Derived from the Old Norse, they are remnants of the Nordic invasions of the British Isles in the tenth century, and reflect the Nordic roots of the local population. Their definitions are given in this table.

fell	a hill, as in Loughrigg Fell, Lingmoor Fell
force	a waterfall, as in Aera Force.
how	a high point. This term is used to designate hills, such as Silver How, and houses (Fox How, the former residence of Dr. Thomas Arnold, Matthew Arnold's father).
tarn	a pond or small lake, as in Loughrigg Tarn
mere	a lake, as in Grasmere, Thirlmere, Windermere.
raise	a mountain pass, as in Dunmail Raise
water	a lake, as in Rydal Water

Wordsworth's

GARDENS

Prelude to Wordsworth

LANDSCAPE DESIGN AND THE CONCEPT OF
NATURE IN THE EIGHTEENTH CENTURY

Artists are children of their time. They come to their work equipped with the traditions of that time as well as innate talents and developed skills. And greatness, in the art of gardening or in poetry, lies in how their unique vision transforms what they are given. William Wordsworth's gardens, like his poetry, come from the traditions of his time, the eighteenth century. As his poetry transcended those traditions and created a new aesthetic, which became known as romanticism, so his ideas on garden design also heralded a new aesthetic.

Design and Discovery

In the eighteenth century, the arts of landscape—poetry, gardening, and landscape painting—were related. Poets influenced landscape gardening and were influenced by discussions of aesthetic principles carried out in garden design styles. The development of these arts may be said to have been dominated by the neoclassical during the first part of the century, and by its opposite, the picturesque, at the end. The change from the neoclassical to the picturesque was brought about by the inspired discoveries of the new empirical sciences, discoveries that broke down assumptions people had held since Roman times about the natural world and their relationship to it.

The Neoclassical Era

William Kent, a society portrait and ceiling painter, traveled to Rome in 1716. There he made a very important friend, Richard Boyle, the third earl of Burlington. The two young men shared an enthusiasm for the Italian paintings of the classical landscape by Claude Lorrain (1600–1682), Salvator Rosa (1615–1673), Gaspard Duget (1615–1675), and Nicolas Poussin (1594–1665). Rosa's paintings often feature bandits and gypsies in settings of extreme natural ruggedness, sometimes with overtones of cruelty amid extreme poverty. The titles of Claude's paintings are objective descriptions of the contents, usually classical or biblical subjects in a landscape, such as "Seaport with the Embarkation of Saint Ursula," or "Landscape with Narcissus and Echo." They contain idealized landscape elements—clumps of trees, ruins, rivers, and mountains—organized into balanced compositions with nymphs and swains in the foreground and ruined temples in the background. The coloring tends to somber tones in the brown range, with over all a golden or silvery light, and edges are not sharply defined, but in (as we would now say) soft focus, or as if viewed through a very fine mist. To Burlington and his friends, these paintings, based on actual Italian landscapes, represented the ideal external world.

When he returned to London in 1719, Burlington brought with him an enthusiasm for recreating the classical landscape, and he brought his new friend, Kent, whom he introduced to the rest of the Burlington circle: Lord Viscount Cobham; the landscaper, Charles Bridgeman; and the country's leading poet, Alexander Pope.

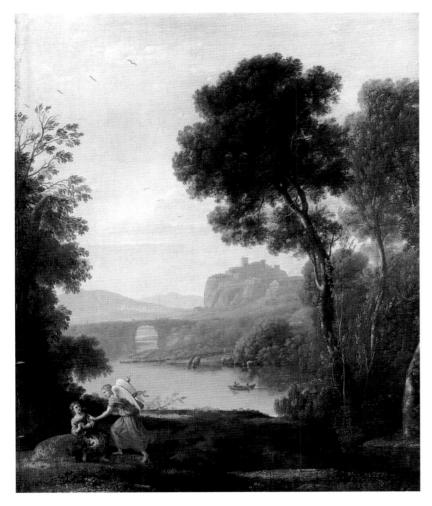

Landscape with Hagar and the Angel, by Claude Lorrain (1600–1682), courtesy The National Gallery, London, England. Paintings such as this one, with its soft edges, biblical figures, castle in the background, and the glow of sunrise (or sunset) in the far distance, represented the ideal natural landscape to the fashionable neoclassic artistic circles in early eighteenth-century England.

Art Imitates Nature

Alexander Pope was an avid gardener. Despite numerous handicaps, the result of a type of childhood tuberculosis, he was a literary lion whose society, friendship, and opinions were much sought after by the rich and famous. His works, often deadly in their satires of the pretentious and minimally talented, were widely read. Their ideas became part of the accepted opinions of educated people and stimulated the general distaste for the formal gardens of the previous era. In an influential essay in the *Guardian* (No. 173, Sept. 29, 1713), for example, Pope satirized topiary, a popular feature of formal gardens, as being too artificial and unnatural. He lists some statues carved from yew and other greenery, supposedly offered to him for sale; among them are

Adam and Eve in yew; Adam a little shattered by the fall of the tree of knowledge in the great storm; Eve and the serpent very flourishing.

A quickset hog, shot up into a porcupine, by its being forgot a week in rainy weather.

The tower of Babel, not yet finished.[1]

In the essay, Pope also lays down the famous maxim, "All art consists in the imitation and study of nature." But by *nature,* remember, he meant the neoclassical definition—an ideal that should be.

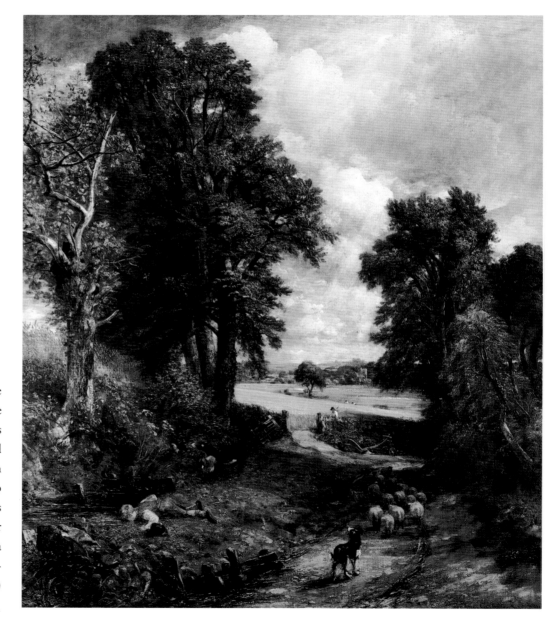

The Cornfield, by John Constable (1776–1837). The paintings of Constable, who forged his own way in art, are marked by clearly defined sunlight and shadow, as well as flecks of white (what he called *dew*), to give additional sparkle. The sky is partly cloudy, instead of being uniform like Claude's painting. While Constable's composition also leads the eye toward the center middle distance, in this painting a cornfield occupies that space instead of a ruin or castle. And instead of nymphs, swains, or biblical figures, a thirsty shepherd, his dog, and the sheep occupy the foreground. (*Corn* in English usage is wheat to Americans.) Courtesy The National Gallery, London, England.

For Pope, the ideal for both poetry and gardening was to be found in classical models. As he wrote in "A Discourse on Pastoral Poetry":

> If we would copy Nature, it may be useful to take this Idea along with us, that Pastoral is an image of what they call the golden age. So that we are not to describe our shepherds as shepherds at this day really are, but as they may be conceived then to have been: when the best of men followed the employment. . . . it would not be amiss to give these shepherds some skill in astronomy, as far as it may be useful to that sort of life. And an air of piety to the Gods should shine through the Poem. . . . [2]

Of Pope's garden at Twickenham, only a portion of the grotto still exists, but the plan survives, and as one garden history scholar points out, "the layout recalls Homer's description of the gardens of Alcinous, which Pope translated in 1713" and included in the *Guardian* essay as an example of a model garden.[3] In his own garden, as in his poetry, to imitate the classics was to imitate nature.

The delight of his life, Pope's garden featured classical structures; one pathway ended at a small temple. The house lay across the road from the garden, and he had constructed an underground passage between the two. He called this tunnel the grotto, and he lined it with geological specimens brought to him by friends from their travels. He liked to go there to meditate and court the Muses just as the classical poets had been accustomed to do in grottoes.

Pope's ideas influenced his friends and spread beyond the immediate circle. Cobham owned Stowe, which was for Pope the epitome of great contemporary gardens. Originally, Cobham employed Charles Bridgeman as landscape designer. In 1730, he brought in Kent as well, who had been working at Chiswick (Burlington's estate). After Bridgeman's death, Kent remained in charge of Stowe until his death in 1748.

Horace Walpole, in his essay "On Modern Gardening," attributes the eighteenth-century style in gardening to Milton and to Pope.[4] Milton, writes Walpole, inspired people with his description of the Garden of Eden in *Paradise Lost*. His "description of Eden is a warmer and more just picture of the present style than Claude Lorrain could have painted." Kent and Bridgeman, says Walpole, borrowed many of Pope's ideas for their landscape designs. In crediting Bridgeman with banishing topiary and parterre gardens, Walpole writes, "Whether from good sense, or that the nation had been struck and reformed by the admirable paper in the *Guardian,* No. 173, he banished verdant sculpture [topiary], and did not even revert to the square precision of the foregoing age."

Between them, Bridgeman and Kent went a long way toward changing the landscape of England. Walpole says Bridgeman invented the sunk fence, which kept cattle and sheep out of the

This photograph of the lake at Blenheim Palace shows the gently curving shoreline and mature clumps of trees. This landscape, planned and carried out by "Capability" Brown, has been maintained as an example of his work. (Photograph by Richard Buchanan reproduced with the cooperation of Blenheim Palace.)

garden. Because it could not be seen from the house, it opened up views of the countryside. Its common name, ha-ha, came from the laughter aroused when one's unsuspecting companions fell into it.

Significant as Bridgeman's contributions were, however, it is Kent who earns Walpole's highest praise, for he "leaped the [sunk] fence and saw that all nature was a garden." In a misguided attempt to recreate the natural landscape, Kent went so far as to plant dead trees in Kensington Gardens, but "was soon laughed out of this excess." Three of Kent's principles were "perspective, and light, and shade." Pope had advocated the use of perspective in gardening as in landscape painting, by placing trees and shrubs with lighter colored foliage further away from a vantage point to give the impression of greater distance. In the *Epistle to Lord Burlington,* he notices the pictorial effects of Nature as it "varies shades from shades" and "paints as you plant." Rather than influencing him, it is more likely the paintings expressed Pope's neoclassical ideal of landscape. He was already an established poet in the neoclassical mode by the time Burlington and Kent went to Italy. Because of his poor health, Pope did not travel to Italy, so he did not see the reality of Claude's or Poussin's painted landscapes as Burlington and Kent had seen them in the Italian countryside.

Kent's supreme contribution to garden design was his management of water, in which "the gentle stream was taught to serpentine seemingly at its leisure" rather than being confined to geometric shapes. The serpentine line is a gradual series of curves—an *S.* Used extensively in garden design throughout the century, it was also prominent in discussions of aesthetics, so prominent that the artist William Hogarth in his *Analysis of Beauty* (1753) named it the line of beauty. Bridgeman had joined a series of ponds in Hyde Park into (appropriately) The Serpentine, and on country estates, he and Kent changed the natural courses of streams so that they curved softly.

They called this practice teaching a stream to serpentine. It is an example of the neoclassical principle of art imitating nature. If the serpentine line is a beautiful line, then it is the line streams would flow in if they could achieve the ideal. Therefore, the stream should be rerouted to serpentine. For the neoclassicists, art, in imitating the ideal, improved upon nature.

This practice continued after Kent's death. Walpole writes, "Kent was succeeded by a very able master." That successor was Lancelot "Capability" Brown, who called himself an improver, and for whom the serpentine line became something of a trademark. Brown began as an under-gardener in the kitchen garden at Stowe, then worked his way up to be Kent's assistant. He earned the nickname Capability from his habit of referring to the potential of a property as its capabilities. It is estimated that he may have "improved" about 200 estates before his death in 1784, among them Blenheim Palace, Stowe (after Kent's death), Leeds Castle, and Hampton Court Palace.

The characteristics of Brown's designs can be seen in the photograph of the landscape at Blenheim Palace (see p. 8): belts of trees surrounding the park, and smooth, sweeping lawns with circular clumps of trees dotted about. Everything in the design is subordinate to the S. The borderlines of his belts of trees undulate about the perimeter of the grounds; roads meander through the belts; lakeshores have a curving shape. Brown does not seem to have been influenced by landscape painting, for as Walpole points out, lawns did not make good pictures. "A principal beauty in our gardens is the lawn and smoothness of turf: in a picture it becomes a dead and uniform spot, incapable of chiaroscuro, and to be broken insipidly by children, dogs, and other unmeaning figures."

Though his work was fashionable, Brown's career was always controversial; long after his death, his work was vilified by advocates of the picturesque. In his day, however, when people intensely disliked the previous generation's complicated geometric style, his work was considered natural.

The Era of Inspired Discovery

The biggest challenge to the neoclassical point of view in gardening as well as in aesthetics was already building during the height of Brown's and Pope's popularity. Scientific discoveries in the seventeenth century had challenged the biblical basis of knowledge about the earth and were the forerunner to empirical analysis, in which people reasoned to a conclusion based on direct observations of what actually existed. Empiricism yielded exciting new discoveries that taught people about the world around them. Scientists studied plants and animals without regard for the ideal to which they aspired. The Swedish naturalist Linnaeus (Carl von Linné) developed the Linnaean system of botanical classification, which assigned plants to their families, genera, and species, and gave them the binomial system of nomenclature. Scientific expeditions brought back new and wonderful species of plants from exotic places, such as the rhododendron from Asia, and the kalmia from America.

The spirit of scientific inquiry caught on also in aesthetics, as two midcentury thinkers applied empirical methods to their analyses of beauty. The first was Hogarth, and the second was Edmund Burke, whose *Inquiry into the Origins of our Ideas on the Sublime and the Beautiful* was published in 1757. Both writers extol the beauty of the serpentine line, but for them it is not an

example of neoclassical improvement of nature in bringing out the ideal natural world. It is beautiful because it has certain objective qualities that arouse in the mind of the observer the sensation of beauty.

As early as 1720, Hogarth had been openly at odds with the entire Burlington circle, whom he satirized in widely circulated engravings for promoting a foreign (chiefly Italian) influence at the expense of English art and artists. Hogarth objected to the neoclassical notion that art improved nature. His approach was empirical, not idealistic. Rather than seeking to improve human nature in conformance with an ideal, or to portray ideal human nature, he pictured life as it appeared to him with all its particularities, as he put it. The habit of close observation led him to create satirical series of paintings and engravings such as *The Rake's Progress, Marriage-à-la-Mode,* and the *Progress of Cruelty.* In his more traditional works, for example *The Graham Children,* it made him sensitive to delicate colors and lively expressions in the children's faces. It also placed him in direct opposition to the neoclassicists, for the life Hogarth portrayed was anything but ideal. The Graham children may be handsome and happy, but they are real children, who seem to be contemplating some piece of mischief. This empirical approach he also applied to aesthetics. In the *Analysis of Beauty,* he reduced beauty to a matter of lines and reasoned that as there are no straight lines in nature, a straight line could not be beautiful. Therefore, it followed that the most beautiful line was indeed the serpentine line. Thus he

arrived, albeit by circuitous route, at the same conclusion as the neoclassicists.

Burke also abandoned the neoclassical notion of the ideal. In his view, we consider an object (or person) beautiful because our senses perceive qualities we associate with the sensation of beauty. For example, we see the smooth petals of a red rose and smell its sweet fragrance, and conclude that it is beautiful because we associate the qualities of smoothness, color, and fragrance with beauty. Besides these, Burke listed smallness and gradual variation among the qualities of beauty. The *S,* for example, is beautiful because it has the quality of gradual variation. Citing line of beauty, Burke declares that he "cannot find any angular object beautiful."

In Burke's analysis, the opposite of the beautiful is not the ugly, but the sublime. If beauty is made up of smallness, smoothness, sweetness, and color (among other attributes), the sublime is huge, powerful, grand, obscure, difficult, magnificent.

Burke allied the sublime with the pity and terror aroused by tragedy. "Terror is a passion which always produces delight when it does not press too closely; and pity is a passion accompanied with pleasure because it arises from love and affection." Objects that give us this feeling are sublime, as long as the pity and terror remain at a distance. To be skiing in the mountains and witness an avalanche from a safe distance—to hear its thunder and see the enormous mass of snow crushing 80-foot fir trees—gives us a chilling sense of the power and might of the avalanche. That is

the sublime. To see Turner's *The Fall of an Avalanche in the Grisons* (see p. 13), a painting of an avalanche crushing a mountain cabin, arouses somewhat the same feeling because we are not caught in that cabin, nor are we acquainted with anyone who might have lived there. That is also the sublime. But to be caught in an avalanche produces only terror and, with luck, the wit and will to survive. There is nothing sublime about that. Another quality of the sublime, for Burke, is anything that approaches infinity, such as the limitless ocean. To stand on the shore and see the horizon disappear into the sky, with an accompanying sense of being dwarfed by the universe, is to experience the sublime. (In these days of a shrinking planet, one probably has to look at the night sky and consider other worlds or other universes to get the same feeling.)

Burke's categories were widely accepted, but not everyone was content with either a two-part classification of aesthetic qualities, or the serpentine line.

The Fall of an Avalanche in the Grisons by Joseph Mallord William Turner (1775–1851), exhibited in 1810. Reproduced by kind permission of the Tate Gallery, Millbank, London. Turner captures the awesome power of an avalanche hurling a giant boulder down onto a lonely mountain cabin, as if to prove that the forces of nature dwarf anything human beings can produce.

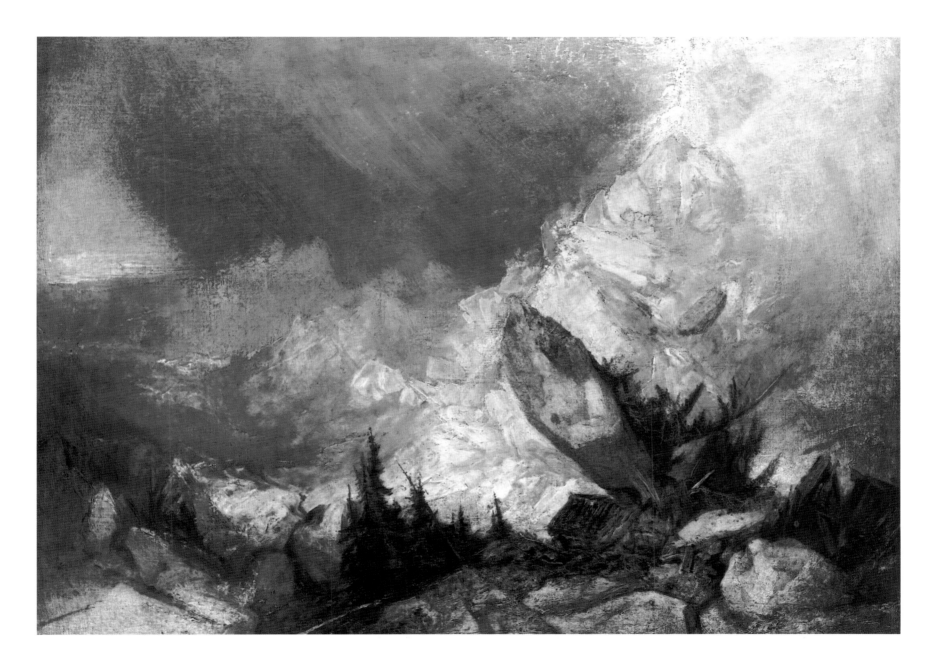

The Leasowes

While Brown was improving nature, and Hogarth battling the neoclassical ideal, about 1743 a minor poet named William Shenstone began a landscape garden at his small estate, the Leasowes. It became famous and attracted great numbers of visitors, among them William Wordsworth, who visited it in 1810 with his great friend Sir George Beaumont. It contains elements of the neoclassical and elements of Burke's theories, as well as ideas of Shenstone's own. In his quiet way, Shenstone may have caused a revolution in aesthetics as well as in gardening, for not only did he suggest a possible third classification to Burke's sublime and beautiful, but he was also the first to use the term picturesque gardening.

Shenstone began by being greatly influenced by Pope's writings and example. Like Pope, he recommended adopting the principle of perspective from landscape painting. To make a straight-lined avenue seem longer, he advised the use of "different types of trees with different colors of foliage, darker in front and growing more pale toward the end."[5] Like Pope's garden, the Leasowes contained neoclassical items (Virgil's grove and Virgil's tomb), as well as remembrances to various friends in the form of inscriptions on urns and benches.

Shenstone had a sense of humor about both his neoclassical imitations and his poetry. He wrote to his friend John Jago in June 1749 that the inscription at the root-house in Virgil's grotto was "for the admonition of my good friends the vulgar; of whom I have multitudes every Sunday evening, and who very fortunately believe in fairies, and are no judges of poetry."[6] (We can accept Shenstone's evaluation of the verses without reproducing them here.)

Two major departures from the neoclassical fashion in gardening existed in the garden and in Shenstone's writing on gardening. One was the "memorializing" of English historical sites. Whereas the neoclassicists, busily venerating the classics, had cared little for England's history, Shenstone believed that England's own antiquities should be preserved and emphasized in a garden, if the owner were so fortunate as to have a historical site on his property. Nor would he alter nature, by which he meant the material world, to suit the demands of a design, or to improve it, as he wrote in his own theoretical work *Unconnected Thoughts on Gardening*:

Art is often requisite to collect and epitomize the beauties of nature; but should never be suffered to set her mark upon them in regard to those articles that are of nature's province; the shaping of ground, the planting of trees, and the disposition of lakes and rivulets.

Shenstone would not dam a stream to make a lake for a bridge to cross, as Brown did at Blenheim; nor would he teach streams to serpentine. He would, however, allow that a landscape "should contain variety enough to form a picture upon canvas. . . . the landskip-painter is the gardener's best designer." In that statement we have the seeds of the picturesque movement; later on, its foremost exponent, Sir Uvedale Price, considered the presence of elements that lent themselves to a good landscape painting to be the primary criterion of good landscape design.

Neither the neoclassicists nor the improvers had made much use of flowering plants; indeed, they had driven parterre gardens, in which flowers were extensively used, out of style. But Shenstone used flowers and flowering plants extensively, and teased his friend Jago for not knowing the "difference between a ranunculus and an anemone."

It seems that as time went on, Shenstone became less influenced by Pope and the other neoclassicists. He read Burke's *Inquiry,* which may have encouraged him to think independently about garden design. And, like many gardeners, he may have been stimulated to think by the practical experience of gardening. (The plants teach us, if we let them.) As a result, he attempted a theoretical work of his own called *Unconnected Thoughts on Gardening.* It begins with a statement that suggests both a new type of gardening and a new aesthetic category.

Gardening may be divided into three species—kitchen-gardening—parterre-gardening—and landskip [landscape], or picturesque-gardening: which latter consists in pleasing the imagination by scenes of grandeur, beauty, or variety.

As the *Oxford English Dictionary* tells us, this is the first appearance in print of the terms landscape gardening and picturesque gardening.[7] Shenstone explains why he equates landscape painting and picturesque gardening: "I have used the word landskip-gardiners; because in pursuance of our present taste in gardening, every good painter of landskip appears to me the most proper designer." While he clearly felt the need for a third aesthetic category, he never quite arrives at precisely what that should be. At first, he intends that to be variety, which was for Burke merely a quality of beauty. Later in the essay, he writes of the "melancholy or pensive; to which last I know not but we may assign a middle place between the former two [the sublime and the beautiful], as being in some sort composed of both."

Shenstone never found a satisfactory solution to his dilemma. The picturesque does not become his alternative to the sublime or the beautiful as it was to some people later in the century, but in equating landscape painting and picturesque gardening, he helped shape aesthetic thought.

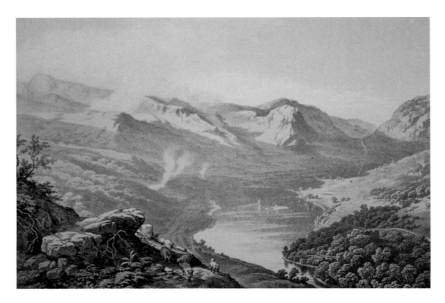

Grasmere from Loughrigg Fell, J. B. Pyne. Engraving published in 1859. Compare this with the photograph opposite.

The Picturesque

Seeds of the picturesque had been present in neoclassic gardening with the Burlington circle's admiration of Claude and Rosa, and in Pope's recommendation to consider perspective in selecting trees for their color and in placing them. Whereas the neoclassicists emphasized the classic, however, with structures and statuary placed strategically for best effect among the plants and at the ends of grassy walkways (called avenues), devotees of the picturesque emphasized the pictures the garden made, with foreground, middleground, and background. Both groups referred to the same paintings; they merely fastened on different aspects.

Although Shenstone had used the term "picturesque gardening," it was a country parson, the Rev. William Gilpin, whose *Essay on Picturesque Beauty* made the picturesque a category of aesthetics and introduced a new way of looking at nature. He also started a major fad.

The picturesque took nature, in the sense of the material world, as its starting point. At its best, it was a formidable aesthetic point of view that encouraged people to analyze and admire natural scenery. Like many another good thing, it was sometimes a bit much. Carrying their Claude glasses (named after the painter), people went in search of picturesque views (or

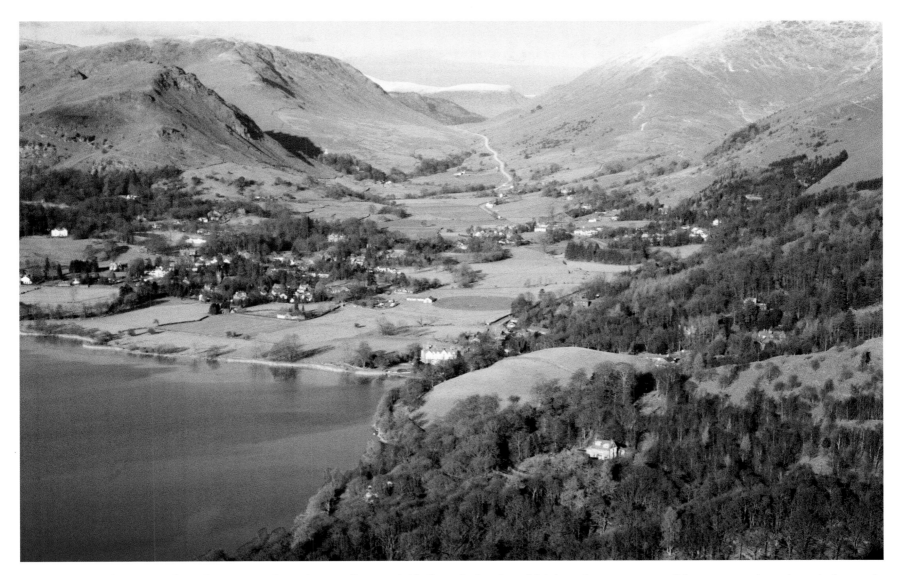

Photograph of Grasmere from the summit of Loughrigg Fell, 1997. Aside from the logging which has taken away most of the trees, note how the artist has made the hills in the engraving opposite more rugged than they are. The distinctive shape of Helm Crag, just outside the village of Grasmere, has been rounded in the painting. In the photograph it is more pointed.

prospects) and gave us the unforgettable picture of a fad at its silliest. The glass was a convex, oval mirror shaded so as to impart to the scenery the painter's brownish tints. They aimed it over their shoulders and looked into it for the right sort of picturesque view, in effect looking at nature backwards, in a dark glass. They analyzed a prospect for its picturesque qualities—for the correct placement of trees, the height and steepness of its mountains, and the form of its lakes. Even without a Claude glass, they criticized natural views for their lack of some picturesque quality. Perhaps a tree might be misplaced, or a stream not be rugged enough. Picturesque artists felt no compunction in altering a landscape to suit their ideas of what should be, rather than painting what was. The Lake District became a favorite haunt of picturesque painters, and its mountains often have an Alpine grandeur they lack in real life. When Sir George Beaumont painted a view from Greta Hall for Robert Southey, the poet laureate of England, Southey wrote to thank him in these terms:

It is a beautiful example of the manner in which, according to your principle, real subjects should be treated. You have dealt with this landscape as a poet does with an historical tale: modifying it to his purpose and supplying whatever it wanted to make it suitable for his art.[8]

Privately, Southey thought that if Beaumont had known him better, he would have realized it would have pleased Southey more to have painted the scene as it really was.

The picturesque became an important aesthetic point of view of the later eighteenth and early nineteenth centuries because of its powerful advocates, particularly Beaumont and his friend Sir Uvedale Price. Wealthy, influential, generous, and friendly, Sir George helped artists and poets whose work he believed in, among them, John Constable and Wordsworth. His friendship with Constable suffered from time to time from Constable's refusal to follow the picturesque. Constable was often derided by adherents of the picturesque for the flecks of white he added to paintings to give them light and sparkle—"dew" as he called it—rather than using the brown tones of Claude. Because of the influence on the Royal Academy by admirers of the picturesque, Constable waited years to be admitted, while J. M. W. Turner was admitted early in his career, when his admiration of Claude was at its height and his imitations of the Italian painter were closest. (Compare Constable's *The Cornfield* with Claude's *Landscape with Hagar and the Angel*.)

Sir Uvedale Price practiced picturesque gardening on his own property, Foxley. Price believed that the principles of landscape painting applied to landscaping, too, and advocated that landscape gardening follow the principles of art. In 1794, in *An Essay on the Picturesque*, he wrote:

The great leading principles of one art—a general composition—grouping the separate parts—harmony of tints—unity of character, are equally applicable to the other.[9]

Price contrasts Burke's concept of beauty with picturesque beauty. Burke's idea of beauty is smoothness, and "gradual variation, in which the lines do not vary in a sudden and broken manner, and where there is no sudden protuberance." On the other hand, the qualities of "roughness, and of sudden variation, joined to that of irregularity, are the most efficient causes of the picturesque."

With that publication, Price entered into a lengthy dispute with Humphry Repton, the leading professional landscape gardener of the day. Repton was the self-appointed successor to "Capability" Brown. His earlier designs were distinctly Brownian, though later in his career (after about 1810) he moved away from imitating Brown to the extent, for example, of placing parterre gardens near the house instead of bringing the lawn right up to the foundation as Brown had done at Blenheim.

In the *Essay,* Price is really arguing against Burke's idea of beauty as realized in Brown's and Repton's landscape designs. He attacks their improvements as insipid, disgusting, and unnatural:

Nothing can be more directly at war with all these principles [of the Picturesque], founded as they are in truth and in nature, than the present system of laying out grounds. A painter, or whoever views objects with a painter's eye, looks with indifference, if not with disgust, at the clumps, the belts, the made water and the eternal smoothness and sameness of a finished place.

Price, who appreciated the formality of earlier garden styles, criticizes the improvers for "changing the formal, but simple and majestic avenue, for the thin circular verge called a belt; and the unpretending ugliness of the straight, for the affected sameness of the serpentine canal." And of groups of trees dotted about a lawn, Price says, "the great distinguishing feature of modern improvement is the clump—a name, which if the first letter were taken away, would most accurately describe its form and effect."

Rather than Brown and Repton having improved nature, Price considered that they had not followed it at all. He discusses at length the "superiority of the natural river, with its irregularities, variety and intricacy over the smooth serpentine." For Price, gardens had to have variety and intricacy, two qualities found abundantly in nature. These, in turn, excited curiosity, the desire to see more, which was for Price a supreme virtue in any art.

He criticizes improved gardens in these terms: "As intricacy in the disposition, and variety in the forms, the tints, and the lights and shadows of objects, are the great characteristics of picturesque scenery; so monotony and baldness, are the great defects of improved places." If picturesque beauty is that which "pleases from some quality capable of being illustrated in painting," such

landscape elements as gravel and lawns are not pleasing: "When the walk before the door is of gravel, and that gravel is succeeded by the mowed grass of the pleasure ground, and that again by the grass of the lawn, nothing could be more insipid." Lawns and gravel walks could not, in his opinion (as in Walpole's), be reproduced to make an effective painting.

Repton was stung by Price's attack, for he and Price were friendly acquaintances. He retaliated (in 1795) with a *Letter to Uvedale Price, Esq.* which he circulated so widely in private that it became public knowledge, and he was forced to publish it before Price had read it. He wrote that other considerations applied to gardens than the merely pictorial. Among them were the "propriety and convenience" of a smooth gravel area in front of the house, a place to alight from one's carriage, or turn it around. In our terms, it would be as if Price had objected to a paved driveway because pavement is unaesthetic. Repton would not, he says, "sacrifice the health, cheerfulness, and comfort of a country residence to the wild but pleasing scenery of a painter's imagination." While it may seem obvious to us that a place for vehicles had to be allowed for, Repton may have been obliquely referring to the extremes taken by Richard Payne Knight, a mutual friend of his and Price's, who littered the front area of his mansion with boulders to simulate picturesque crags, forcing his guests to climb over or around them to enter the house. The core of Repton's objection to designing gardens as pictures, however, was that such a design method was too static. A picture may be viewed from just one angle—the painter's. A garden, on the other hand, is viewed from many points of view—from the house as one walks from room to room and looks at it from different windows, or from within it, as one walks or drives. Just because a scene may not be a good subject for a painting does not make it a poor garden design.

> I trust the good sense and good taste of this country will never be led to despise the comfort of a gravel walk, the delicious fragrance of a shrubbery, and soul-expanding delight of a wide extended prospect, or a view down a steep hill, because they are all subjects incapable of being painted.

For his part, Price's feelings were hurt when Repton published his letter before Price had read it. It required the intervention of mutual friends to soothe both men, but the debate eventually waned. Repton and Price remained friends, and learned from each other. Repton's later gardens have more roughness, variety, and intricacy. And Price's later discussions of the subject allow for more "convenience" near the house in such items as a smooth gravel walk leading to the front door.

Underlying the dispute is the opposition of an essentially neoclassical point of view to the fundamentally analytical approach of the picturesque. Whereas the neoclassical landscape garden seeks to bring nature in line with the ideal by improving it, the picturesque starts from the principles of landscape painting in

analyzing natural landscapes and creating landscape gardens. Both philosophies of garden design found their inspiration in paintings by seventeenth-century Italian painters, but they drew opposing conclusions from these works because their ways of approaching aesthetics were fundamentally opposed.

Neither improving on nature nor analyzing it appealed to William Wordsworth. While the Price–Repton debate raged, he and his friend Samuel Taylor Coleridge quietly brought out *The Lyrical Ballads* in 1798. In its radical choice of subject matter, ordinary and poor people living in natural surroundings, this manifesto of the romantic movement diametrically opposed both the neoclassic in its portrayal of real people (as Cromwell said, "warts and all"), instead of the idealized shepherds Pope had recommended for pastoral poetry. Wordsworth took the natural world as he found it, without wanting to improve it. Nor was he much impressed with the picturesque. It was "never much my habit," he writes in his autobiographical poem, *The Prelude*. He sought in his poetry to portray nature in terms of his own experience of the sublime and the beautiful, and he remained steadfastly opposed to analysis as a source of artistic creation or artistic experience. In the garden, he worked with nature's "realities" rather than trying to make the gardens resemble landscape paintings, and there, too, as in poetry, Wordsworth rose above the traditions he inherited.

His gardens share in the aesthetic that drove his poetry, as we shall see in chapter 1, "The Ode and the Dung." Chapter 2, "The Love of Flowers: Dove Cottage," shows how this aesthetic informed the first garden during the years when he composed the bulk of his greatest poetry. Chapter 3, "The Garden as Poem: Coleorton," describes the making of the Winter Garden at Coleorton in the midst of a picturesque landscaping effort. In chapter 4, "Rock of Ages: The Rydal Mount Garden," we see how gardening became the chief mode of Wordsworth's interaction with nature. And Chapter 5, "Wordsworth's Garden Legacy," concludes with an estimate of Wordsworth's contribution to landscape design in our time.

One

THE ODE AND THE DUNG

There was a time when meadow, grove, and stream,
The earth, and every common sight,
To me did seem
Apparelled in celestial light,
The glory and the freshness of a dream.

(4:1–5)[†]

[†]Unless specified otherwise, all lines of Wordsworth's poetry are from the five-volume series edited by Ernest de Selincourt, Oxford University Press, 1952. References are to volume and line.

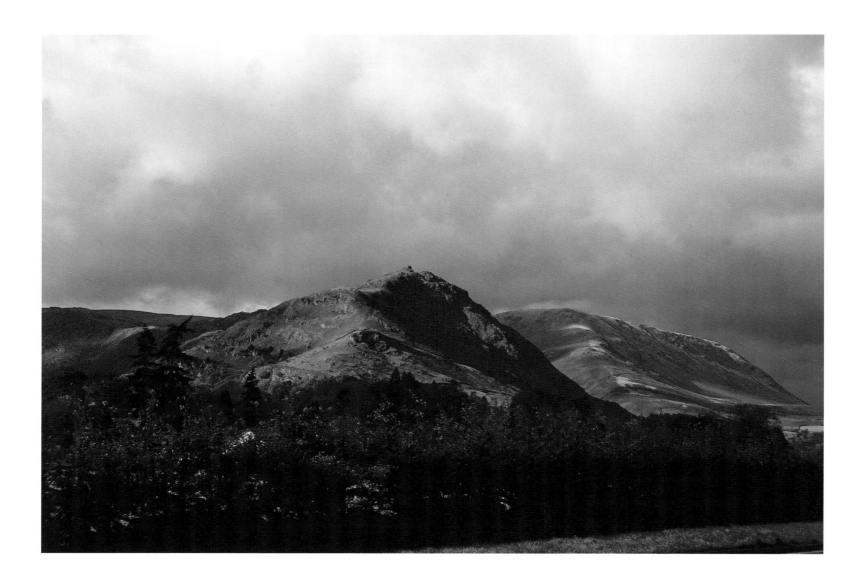

So begins William Wordsworth's "Ode: Intimations of Immortality from Recollections of Early Childhood." Although the title can be intimidating, the Ode is resplendent with joy in the beauty of the landscape.

Both as poet and as gardener, Wordsworth was deeply inspired by the bliss nature's beauty aroused in him. This emotion, however, was not merely pleasure in pretty flowers and the mountainous landscape of the English Lake District where he lived. Wordsworth's delight was an emotional response to beauty so intense that it could lift him into a mystical experience of union with the natural world. The Lake District photographs in the portfolio at the end of this book offer a sample of the sort of visual stimulation that Wordsworth found so provocative.

Mystic though he was, he was also a practical gardener for whom composing poetry and gardening were intertwined. His sister, Dorothy, describes the beginning of the Ode in her journal (Mar. 27, 1802):

A divine morning—at Breakfast Wm wrote part of an ode—Mr Olliff sent the Dung & Wm went to work in the garden.

The mental picture this incident inspires, of the poet shoveling manure while perhaps mulling over the ideas in the Ode, is irresistible, but it is typical of Wordsworth. In gardens and in poetry, Wordsworth celebrated his love of the natural landscape he

Helm Crag, one of the fells nearest Grasmere. The English Lake District is renowned for its beauty, and attracts many painters and photographers because of scenes such as this one (and in the Portfolio, beginning on page 183.)

lived in. Both were founded on his own feeling of joy, and in both, he sought to recreate that feeling for other people.

The Ode describes how, during certain all-too-brief moments, the beauty of the landscape—or a single flower—could move him to such elation that he would comprehend nature's unity. So supreme are these momentary flashes of understanding that they are "a master-light of all our seeing." When they occur, the poet experiences an emotional recognition that utterly convinces him of their truth. These moments guide his life, and are the source of joy.[1]

Nature itself returns this feeling. In phrases reminiscent of Isaiah, birds sing a "joyous song"; the moon "with delight" looks around; the "earth is gay," and the poet responds, "With joy I hear!" Sharing this emotion connects him and nature.

Underlying Wordsworth's rapture, however, is his realization that the mountains he loved for their awesome beauty have taken their toll of human lives in climbing falls and in winter's blizzards. His knowledge of human suffering adds an extra dimension to his feeling so that even a humble flower "can give/ Thoughts that do often lie too deep for tears" by reminding him of the terror implicit in the beauty of the landscape.

The poem, "To Joanna," tells how beauty connects the poet with the object he observes. In this poem, the narrator's delight, arising from his perception of beauty, joins the various separate things of nature (trees, rocks, flowers, and mountains) into a whole and engages the observer in the scene:

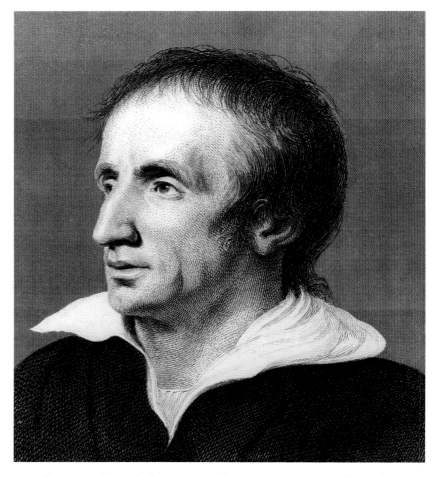

William Wordsworth, by B. R. Haydon, engraving © Wordsworth Trust. This informal engraving is known in the Wordsworth family as "The Brigand." Courtesy of Dove Cottage, The Wordsworth Trust.

. . . such delight I found
To note in shrub and tree, in stone and flower,
That intermixture of delicious hues,
Along so vast a surface, all at once,
In one impression, by connecting force
Of their own beauty, imaged in the heart.

(2:45–50)

The beauty of the landscape forms a single overpowering impression that becomes a connecting force to lead him to perceive the oneness of nature. In the fragment of an essay unpublished in his lifetime, Wordsworth described this perception as one of "intense unity, with which the Soul is occupied or possessed" when the beauty of nature overwhelmed him. He would be transfixed by the realization that however diverse nature might appear, it was unified: One life, one spirit, animated all natural objects, human and nonhuman.

In "Lines Composed a Few Miles Above Tintern Abbey," Wordsworth describes one of these mystical states as

that serene and blessed mood,
In which the affections gently lead us on,—
Until, the breath of this corporeal frame
And even the motion of our human blood
Almost suspended, we are laid asleep
In body, and become a living soul:

While with an eye made quiet by the power
Of harmony, and the deep power of joy,
We see into the life of things.

(2:41–49)

This process begins quite simply with the *affections,* Wordsworth's term for the kindly feelings of pleasure in a flower, or in the majesty of a mountain. The affections deepen and intensify as he concentrates on the harmony among natural objects, until their separateness blurs and he sees the whole. In this mystical state, joy and harmony are powers that enable him to "see into the life of things."

And the life of things has a spiritual basis. It is, as he explains later in the poem,

. . . a sense sublime
Of something far more deeply interfused,
Whose dwelling is the light of setting suns,

And the round ocean and the living air,
And the blue sky, and in the mind of man:
A motion and a spirit, that impels
All thinking things, all objects of all thought,
And rolls through all things.

(2:95–102)

Looking down the slope from the Farther Terrace at Rydal Mount, we see how sunshine and shadow, a distant green lawn, autumn-gold bracken fern, and silver tree trunks awaken the senses and emotions to natural beauty.

This portion of the Dove Cottage garden arouses curiosity as to what lies around the curve of the lawn, and delights the viewer with the shades of summer greens, sunshine on leaves, and the sparkle of flowers.

Only life itself has motion and spirit. Only living things can move and feel joy. Joy connects Wordsworth with the life that flows through all things, through light, sky, and his own mind. Life unites the mind that thinks with blue sky or setting sun it thinks about. This unity is deeply spiritual, and the experience of spiritual unity is what he calls intense unity.

As Wordsworth aimed at communicating this feeling through poetry, he also did so in his gardens. His aim could not have been further from the purpose of either school of contemporary fashionable garden and landscape design, from either improving or the picturesque, for neither school thought the natural landscape met their standards of beauty.

Ironically, the Wordsworth family became friends with a leader in the picturesque movement, Sir George Beaumont, who admired both Wordsworth's poetry and his character. The two men disagreed in a friendly way about landscape design. In a letter to Sir George (Oct. 17, 1805), Wordsworth wrote that the purpose of a garden is "to assist Nature in moving the affections." These are the same affections he had named in "Tintern Abbey," the emotions that gently lead us on to become a "living soul." Though feelings are important in all of the arts, he continued,

> How much more ought the feelings to prevail when we are in the midst of the realities of things; of the beauty and harmony, of the joy and happiness of living creatures; of men and children, of birds and beasts, of hills and streams, and trees and flowers; with the changes of night and day, evening and morning, summer and winter.

The materials of gardening are the "realities of things." Obviously, a gardener (poet or not) who shovels manure is aware of realities, but Wordsworth includes in this term things not usually intended by garden designers then or now—"beauty and harmony, and joy and happiness." And "changes." These include night and day, evening and morning, summer and winter. In all of these, he perceives a single unifying quality, the energy that comes from the one life-giving spirit that connects "thinking things" with "objects of all thought." Human beings, who think, are spiritually connected with that which we think about.

For Wordsworth, the art of garden design does not improve on nature or rectify its errors of taste. It clarifies nature. As he writes in the *Guide to the Lakes:*

> The rule is simple; with respect to grounds—work, where you can, in the spirit of Nature, with an invisible hand of art.

In recommending that art be invisible, he is not proposing that art be absent, or that a piece of ground be allowed to grow as it will. Art should be present, but with subtlety. The garden's beauty reveals the beauty of nature; the art of the garden is the path to joy in nature, the way in to the infinite.

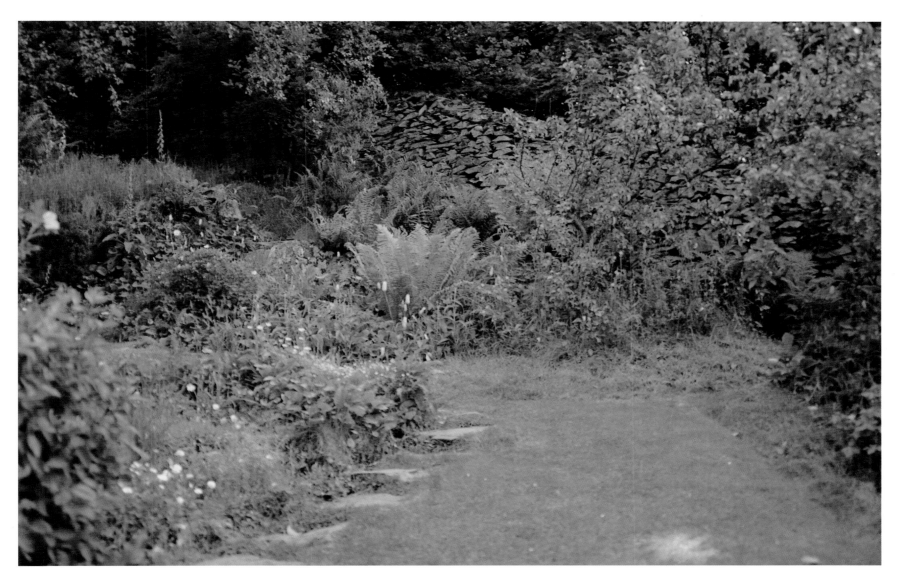

These stone steps at Dove Cottage curve around the perennial bed on the left and invite the visitor onward to explore amid cool shady greens (see p. 45).

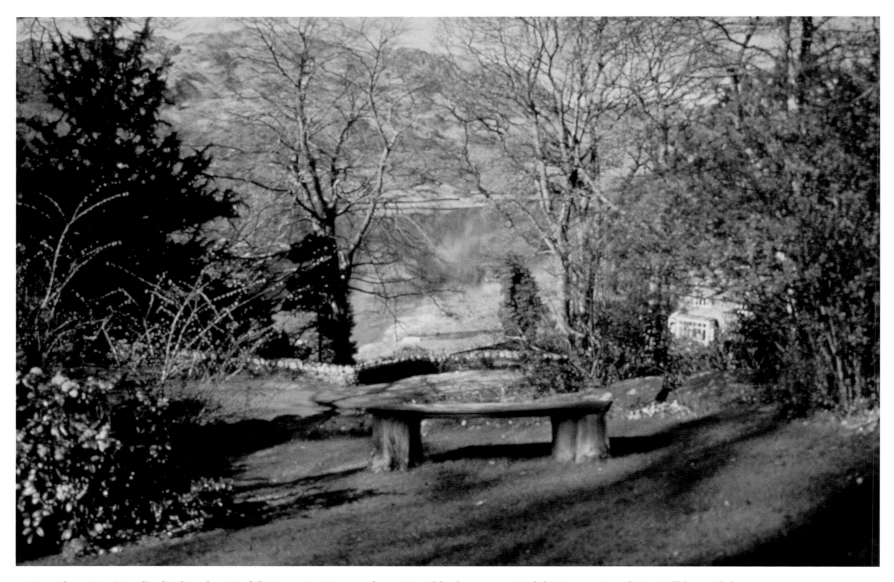

In early spring (April), this bench at Rydal Mount invites people to sit and look out over Rydal Water at Loughrigg Fell beyond, but . . .

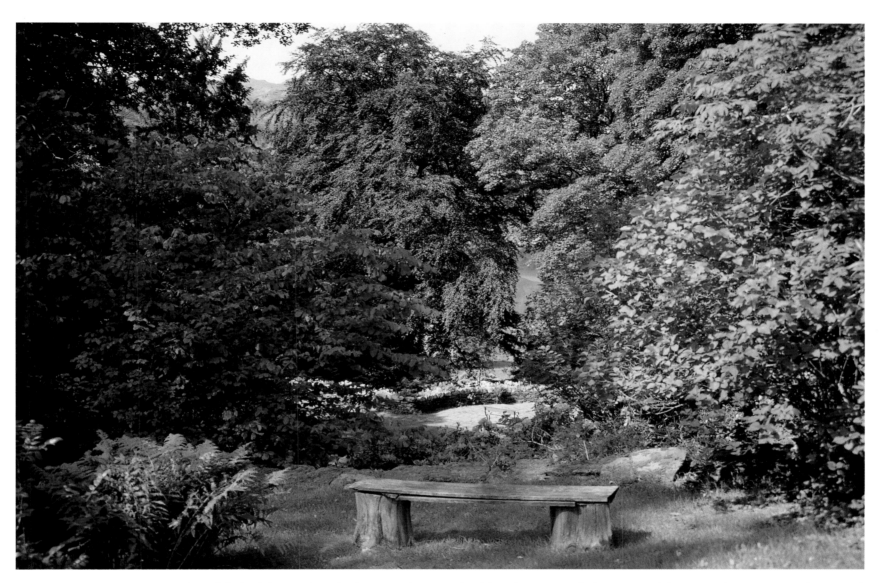

. . . in late summer the trees have fully leafed out. Though obscuring the view, they bless the scene with their own soft beauty and the contrast of green and deep red, and the sparkle of white flowers. The appreciation of this sort of contrast between seasons could awaken in Wordsworth the ecstatic response that inspired so much of his greatest poetry.

This spiritual goal makes a Wordsworth garden a glad feast for the senses in all seasons. It is a place of changes and contrasts, of surprises and colors. It is a sociable place, inviting to people as well as to birds, squirrels, and other small wildlife.

Although Wordsworth was unable to appreciate instrumental music, his gardens evoke the music of nature. Birds twitter and warble; bees hum among the blossoms of fruit trees and flowers; breezes sing alto among the oak leaves, and tenor through the firs. He coaxed different tones from flowing water by rearranging stones in streams and constructing pools (see pp. 37–39).

It is often the fate of gardens to disappear with time. Of the gardens Wordsworth made or advised on, three survive, at least partially. The Dove Cottage garden has been restored, but the garden at Rydal Mount has been overlaid by that of the next tenants, and the third garden, the Winter Garden Wordsworth designed and built for Lady Beaumont, survives in fragments only. These three are all recognizable as Wordsworth's gardens, however, for he founded his gardens on stone, doing much of the work himself. Even after nearly two hundred years, the stonework remains as his signature. He built stone terraces for walking and joined their walls onto rock outcroppings so that they almost seem to be part of the natural rock, especially after tiny alpine ferns rooted in the crevices, and shrubberies grew up around them (see pp. 40–46).

Hills and lakes become part of the garden, particularly in winter when the deciduous trees have lost their leaves. A visitor can enjoy the changing views in walks along the terraces, or sitting in a small hut that offers both shelter from the weather and a quiet place to think.

Neither the improving style nor the picturesque incorporated flowers into their designs, but Wordsworth roamed the hills on plant-hunting expeditions with whomever among his family members would accompany him. They brought back native perennials and planted them intermingled, as nature might have placed them, with ferns and grasses and stones. At every turn, these flowers are a happy discovery of bright treasures (see pp. 47–49).

In garden design, Wordsworth abandoned geometry in favor of a more natural organization of space. There are no beds or borders as such, no rectangles or contrived serpentine lines. Instead, space is comfortable, and the seemingly random organization of areas connected by paths entices a person to explore. One has a feeling of delightful anticipation, a sense that happy surprises lie around the next bend. Fences do not define areas or delineate the extent of the property. The garden, with its plantings of beech and sycamore, gradually gives way to the forest of oak and fir.

Lawns appear among the trees as glades in the forests instead of having trees clumped on them, in the manner of the improvers. A person can take pleasure in the dance of sunlight on leaves, the play of shadows laid across the lawn. Dorothy recorded in her Grasmere Journal (June 8, 1802) their dislike of the improvers' style:

They have made no natural glades, it is merely a lawn with a few miserable young trees standing as if they were half-starved. There are no sheep no cattle upon these lawns. It is neither one thing or another—neither *natural* nor wholly cultivated & artificial which it was before. . . .)

A Wordsworth garden is a practical garden. The poet and his family grew most of their food along with the herbs that warded off fleas, remedied their headaches, and settled their internal complaints. Edible plants mix with ornamentals; honeysuckle twines among the branches of fruit trees, and bistort (eaten like spinach) grows with foxglove.

In another, very special sense, Wordsworth's gardens were working gardens. Whatever the subject, all his life, he wrote his poetry in the garden, pacing out rhythms and chanting verses aloud as he strode along the paths, sometimes asking a nearby friend or relative for comment.

In the early years, that person was most likely to have been his sister Dorothy, his partner in both gardening and poetry. To-gether they worked in the garden, rambled over the hills, revised the poems. She noted her observations of nature and the events of their lives and the garden in her journal, which provided him with one of his many sources of inspiration.

In return, he paid tribute to her with some of the loveliest lines in English poetry, in which the chief metaphors are flowers from the garden. In his autobiographical poem, *The Prelude*, he credited her with rescuing him from depression:

But thou didst plant its crevices with flowers.
<div align="right">(XIV, l. 253)[2]</div>

To her, Wordsworth owed his sense of delight in nature, and perhaps his mental health. Without her, he might not have achieved his sense of joy.

Orphaned by the age of thirteen, Wordsworth and his three brothers were educated at the (sometimes grudging) expense of their relatives, while their only sister, Dorothy, was passed from one relation to another and largely ignored. After leaving Cam-bridge, he traveled on the Continent, fell in love with a young French woman named Annette Vallon, and had a child by her. Parted from her by the war between France and England, feeling guilty at his treatment of her, and chagrined at his lack of pros-pects, he settled in 1795 with Dorothy at Racedown Lodge in Dorset (see p. 42).

The stay at Racedown gave Wordsworth direction for his life. There he tried writing various types of literature and journalism, but nothing caught on—unfortunately for their bank balance, but fortunately for English literature, for instead of another hack journalist, England gained a great poet. During this time, he was exposed to Dorothy's simple pleasure in the natural beauty of

the landscape and birds, trees, and flowers. Her uncomplicated enjoyment of nature caught his imagination, and so began one of the great literary and gardening partnerships, a partnership that ended only with Dorothy's physical and mental breakdown during the 1830s.

At Racedown they worked in their kitchen garden and enjoyed the features of the existing pleasure ground. Here, gardening was a necessity; they depended on the garden for most of their food. Dorothy wrote to a friend in the winter of 1796:

The country is delightful; we have charming walks, a good garden, a pleasant house. My brother handles the spade with great dexterity.

Wordsworth wrote to his friend William Mathews in March 1796 that they had planted cabbages. When produce was scarce, they were sometimes hungry, as Wordsworth wrote to another friend in February 1797:

I have lately been living upon air and the essence of carrots, cabbages turnips and other esculent vegetables, not excluding parsely [sic] the produce of my garden—

When Samuel Taylor Coleridge saw them working in the garden and cut across the fields to get better acquainted, it was the beginning of a magical time for all of them. They became, as Coleridge put it, "three persons, one soul." Together they rambled about the countryside, talked of humanity and nature, poetry, and gardening. Their friendship produced the *Lyrical Ballads,* the manifesto of a new poetry that established human feeling, without regard to social class, as its proper subject.

They discussed ideas, too—ideas that led to the grand scheme of the first philosophical poem in the English language—the *Recluse,* which both young men assumed Wordsworth would write. At Racedown, he began the first draft of the *Excursion* and read it to an entranced and delighted Coleridge under the trees. The poem, which was not published until 1814, became the only part of the *Recluse* he ever completed, though further attempts to do so plagued him during most of his life.

Among the discussions of philosophy and poetry, Dorothy began to keep a journal, the first of several that have established her in many people's minds as the "best unpublished writer in English." On January 20, 1798, she wrote:

The garden, mimic of spring, is gay with flowers. The purple-starred hepatica spreads itself in the sun, and the clustering snow-drops put forth their white heads, at first upright, ribbed with green, and like a rosebud; when completely opened, hanging their heads downwards, but slowly lengthening their slender stems. The slanting woods of an

unvarying brown, showing the light through the thin net-
work of their upper boughs. Upon the highest ridge of that
round hill covered with planted oaks, the shafts of the trees
show in the light like the columns of a ruin.

They continued to garden, and traveled about studying gar-
den styles. One expedition was to look at cottage gardens, and
Dorothy mentions their dislike of falseness in gardens.

This happy time came to an end. Coleridge went to Germany
to absorb the ideas of the German idealist philosophers and po-
ets. The Wordsworths went, too, but spent a miserable winter in
a town several miles from him and hardly saw him. Addicted to
opium, Coleridge was gradually lost to them over the years. In
the spring, Wordsworth and Dorothy went back to England, and
December 1799 saw them settled at Town End, Grasmere, in the
Lake District. Wordsworth considered the Vale of Grasmere the
prettiest place in the world. There, at Dove Cottage, they had at
last a home of their own.

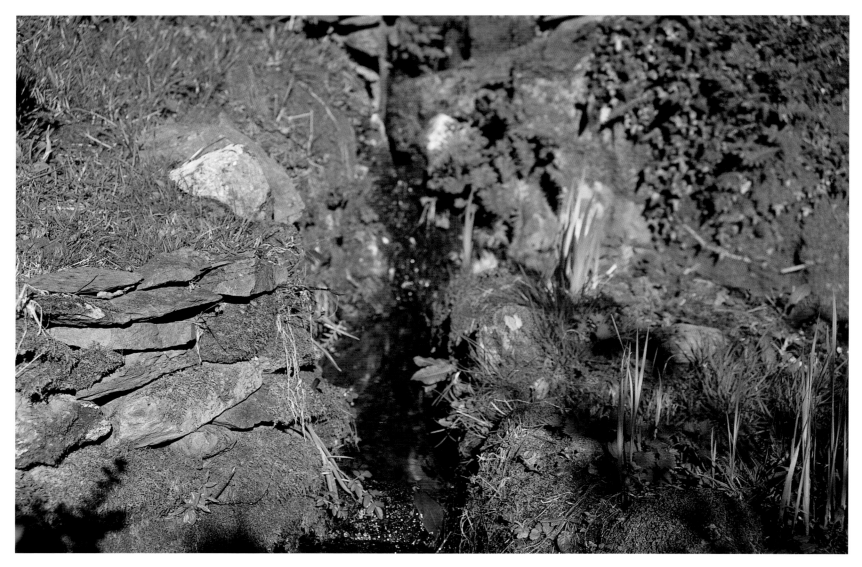

Wordsworth built pools at both the western end of Rydal Mount garden from the Farther Terrace to the edge of the property and . . .

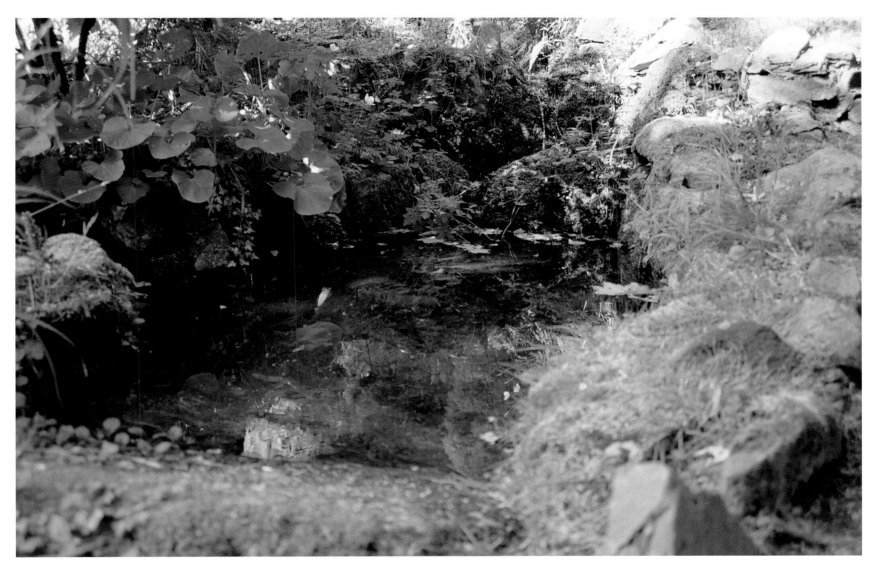

. . . at Dove Cottage close to the terraces so that he and his family and friends could enjoy the sounds of rain falling into them, and the play of light and shadow from the surrounding plants. Pools constructed like these, with closely sheltering plants at the edges, also invite birds and other small animals to drink and bathe. The sounds of birds calling and creatures splashing have a joyfully calming effect in a garden.

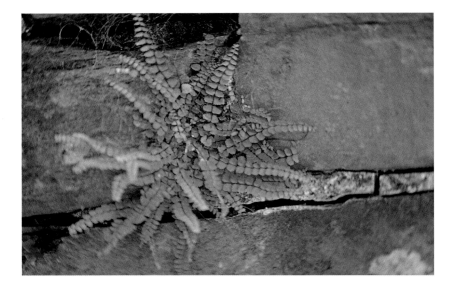

This tiny Alpine fern, no bigger than six inches across, has rooted in a stone wall, a typical sight in many of the Lake District's walls. The spores, carried in the air, will root wherever there is enough organic matter to sustain them.

Wordsworth built, and caused to be built, terraces for pacing out the rhythms of his poems. Note the similarity in the use of irregular stones in the terrace supporting wall in the Dove Cottage garden with that of the terrace wall in the photograph of the Rydal Mount garden on page 42.

Here in the garden at Rydal Mount plantings combine to contrast with the stone just as they do in the Dove Cottage garden (see p. 41). Both gardens are lively when the daffodils dance to the tunes of the breezes and brighten not only the day but people's spirits as well.

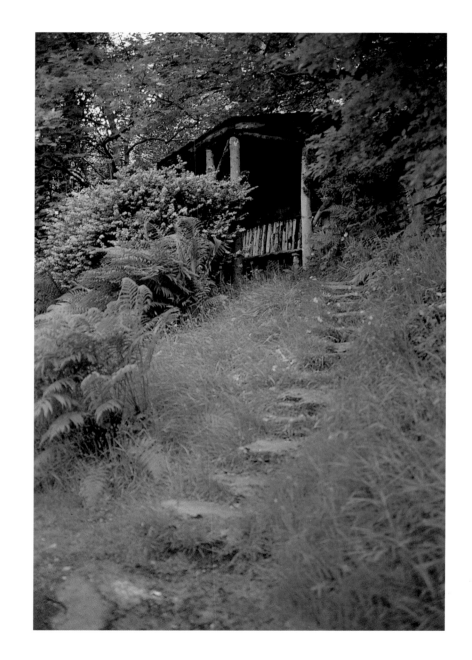

Stone steps led to elevations in all of Wordsworth's gardens. Note the thickness of the stones, and their irregular sizes.

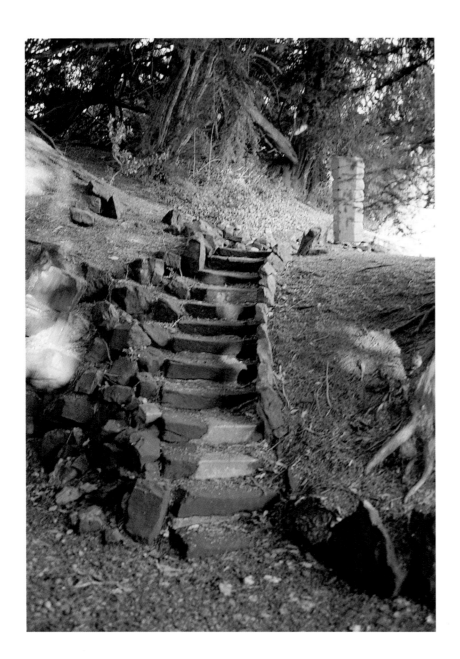

Among the fragments of the Winter Garden still visible are these stone steps that lead upward to the path along which Lady Beaumont could walk in contemplation of the beauty around her. Note the similarities in the placement and shapes of the stones and the thickness of the steps. The stones in the walls are irregularly shaped and sized, as are the steps. While stonework was hard without modern power tools, Wordsworth would have employed the help of men familiar with, if not skilled in, working with the native stone. He himself probably acquired some skill with stonework, as it has been one of the Lake District arts for centuries. There is an abandoned slate quarry on Loughrigg Fell, across from Rydal Mount, and the primary building material, particularly in Wordsworth's day, was the natural grey stone. To this day, roofs are covered in slate shingles.

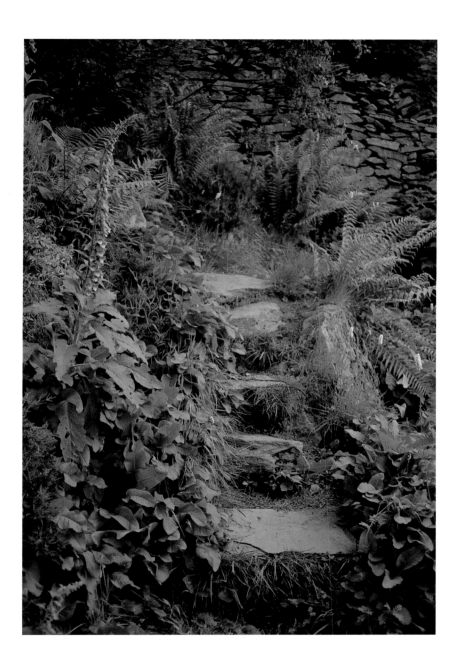

These steps, which are quite similar to those in Dora's Field and the Winter Garden, join the terrace at Dove Cottage to the lower parts of the garden. They are the unseen continuation of the steps that curve around the perennial bed in the photograph on page 31.

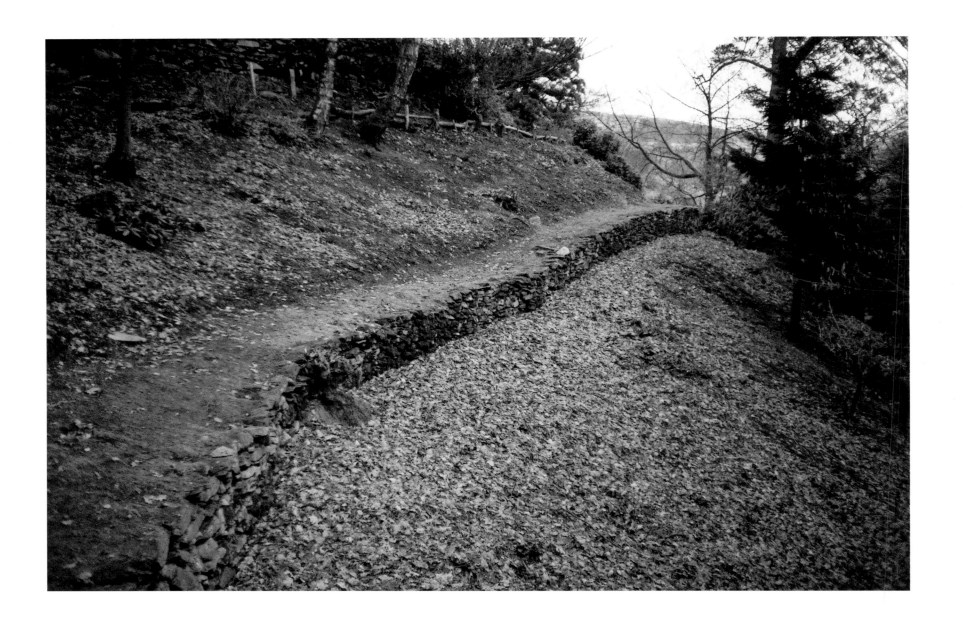

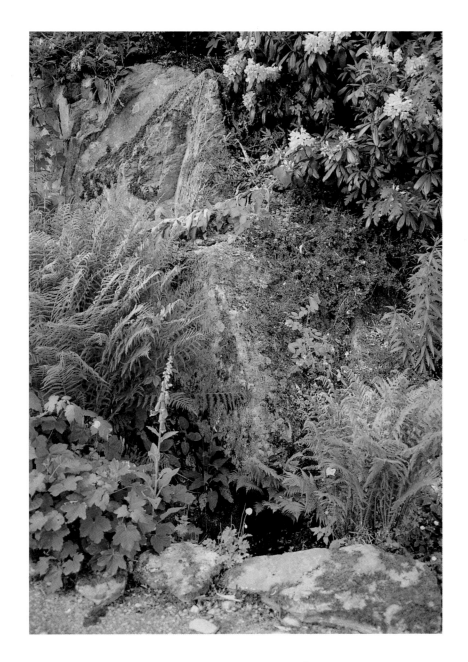

◄ The terraces were lengthy. This terrace at Rydal Mount, shown in winter the year after its discovery in 1996, and now called Dora's Terrace, might have been an extension of the Green Terrace that gave the Wordsworths nearly two miles of walks on their own property.

► At Rydal Mount, pink rhododendrons and foxglove combine with a large boulder, a pool of water, and ferns to make a beautiful combination. If this is planned, it is a jewel of garden design; if it is accidental, it is one of those wonderful happenings that a gardener would accept and appreciate.

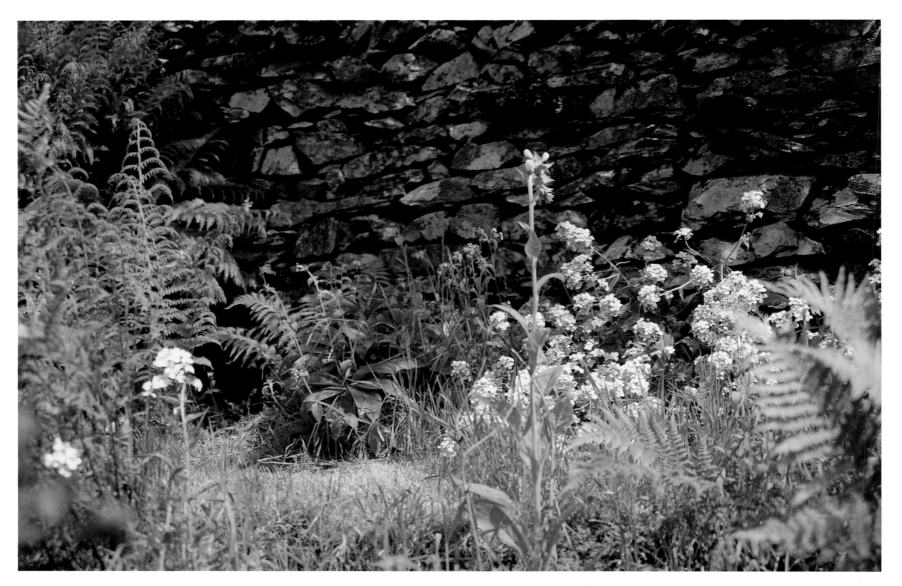

Foxglove, phlox, and Osmundine ferns contrast with Thomas DeQuincey's stone wall at Dove Cottage. Though the plantings are Wordsworthian, the wall is not, for the poet's gardens were open to their natural surroundings.

These lesser celandines grow with daffodils at Dove Cottage. As the daffodils fade, with only their leaves remaining, the celandines are in full bloom, their yellow, "mimic of the sun" (as Wordsworth said), brightens the day and warms a person's mood.

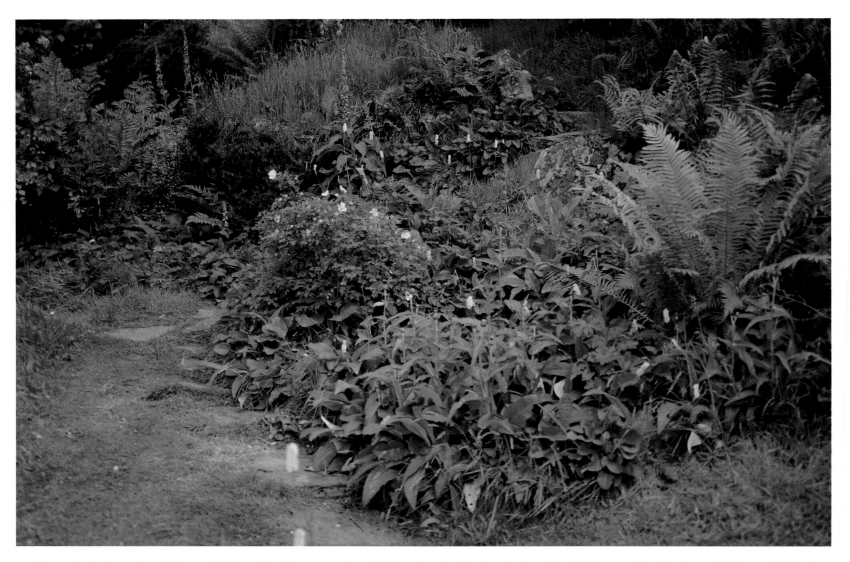

Bistort is the large-leaved plant with the white flower on the end of a spike; the foxglove is the tall pink flower. The Wordsworths knew which plant could safely be eaten, both because of their (and their neighbors') folk knowledge of plant life, and because they owned a copy of William Withering's *An Arrangement of British Plants According to the Latest Improvements of the Linnaean System* (1796). Withering was the doctor who proved the usefulness of digitalis (from foxglove) in the treatment of heart problems.

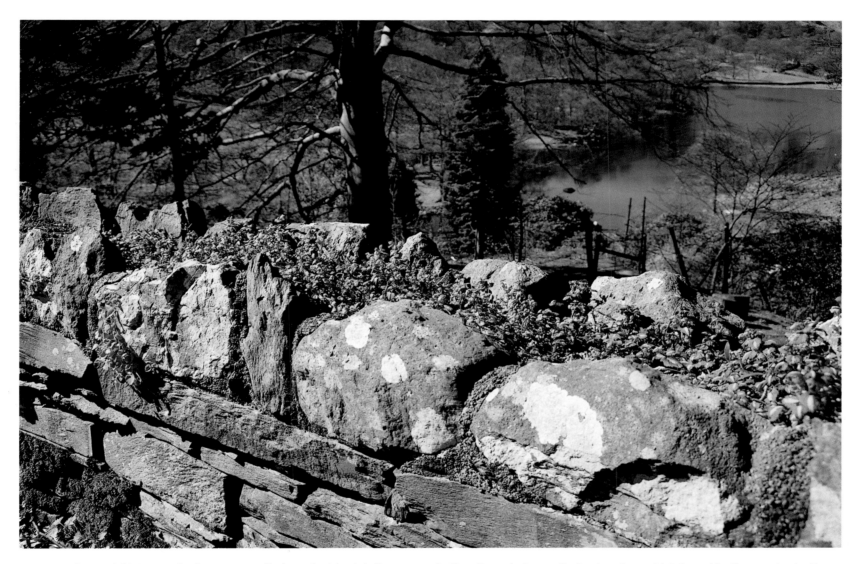

Located at Rydal Mount, this low stone wall planted with pink flowers symbolizes Dorothy's care for her brother, which he paid tribute to in the line, "But thou didst plant its crevices with flowers." The hard places are softened by the plants' beauty.

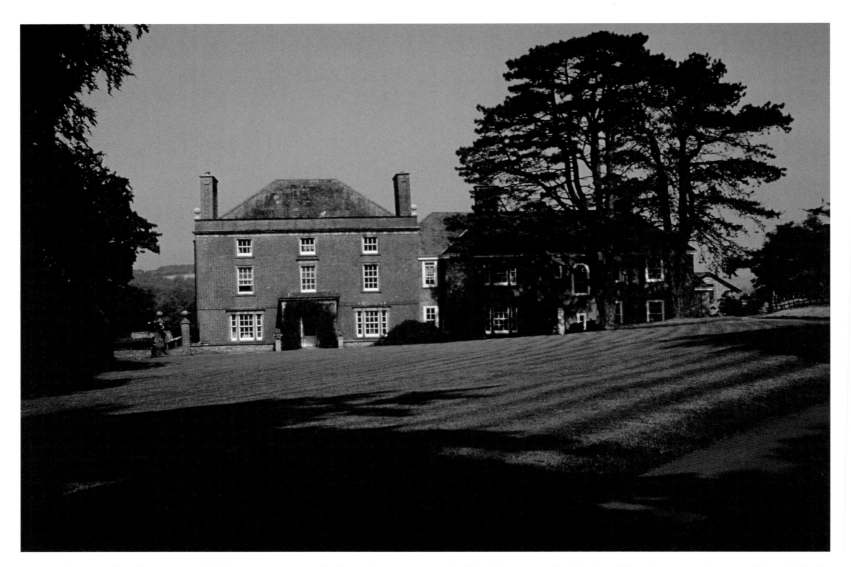

Racedown Lodge, front view. The lawn sweeping to the front door was typical of the "improving" school. Although it is not known if "Capability" Brown was ever involved in the landscaping here, when the house was remodeled in the mideighteenth century, it may have been landscaped by an admirer. The portion of the house that the Wordsworths lived in is the taller, three-story section with the two chimneys. The lower, two-story portion was added in the nineteenth century.

Racedown Lodge, rear garden. The rectangular forms of the garden and the pond echo the shape and structure of the eighteenth-century portion of the house. (Racedown photos by Richard Buchanan with the permission of Russell and Cynthia Gore-Andrews, owners.)

Viewed from Racedown Lodge, a road lies behind the stone wall that divides the length of the picture (approximately one-third of the way down). Coleridge was walking along this road when he saw the Wordsworths working in their garden. He jumped it and cut across these fields to meet them. From this impulsive act, he launched one of the most famous literary friendships in English literature. (The line of fence posts [a modern safety feature that was not considered necessary when the ha-ha was built] in the foreground mark the ha-ha. The field beyond lies some 7 feet below the level of the garden and would have effectively prevented cattle from grazing on the lawn.)

Two
THE LOVE OF FLOWERS:
DOVE COTTAGE

At last they had come home. In the early northern darkness of a snowy December day in 1799, William and Dorothy Wordsworth settled into Dove Cottage at Town End, Grasmere. As Wordsworth wrote in *Home at Grasmere,* it was

A termination, and a last retreat,
A Centre, come from wheresoe'er you will
A Whole without dependence or defect,
Made for itself, and happy in itself,
Perfect Contentment, Unity entire.

ll. 147–151[1]

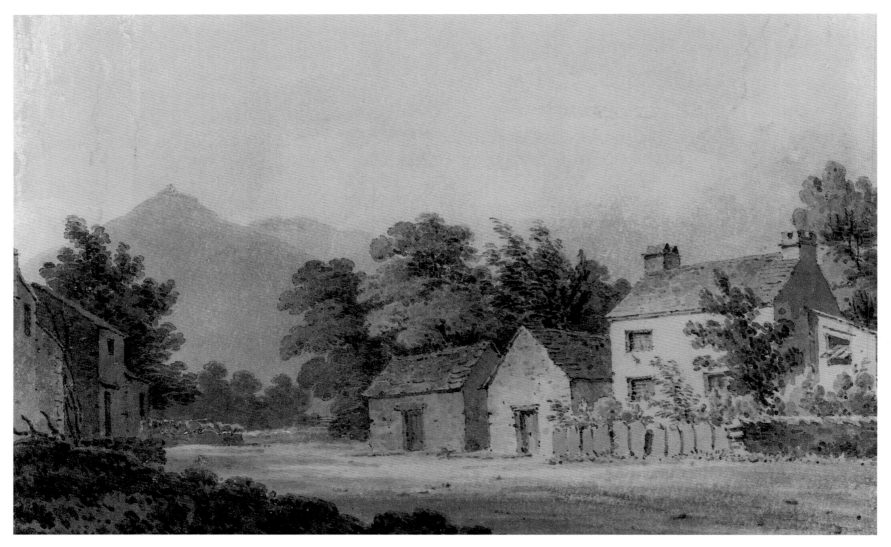

Contemporary sketch of Dove Cottage. Courtesy of Dove Cottage, The Wordsworth Trust.

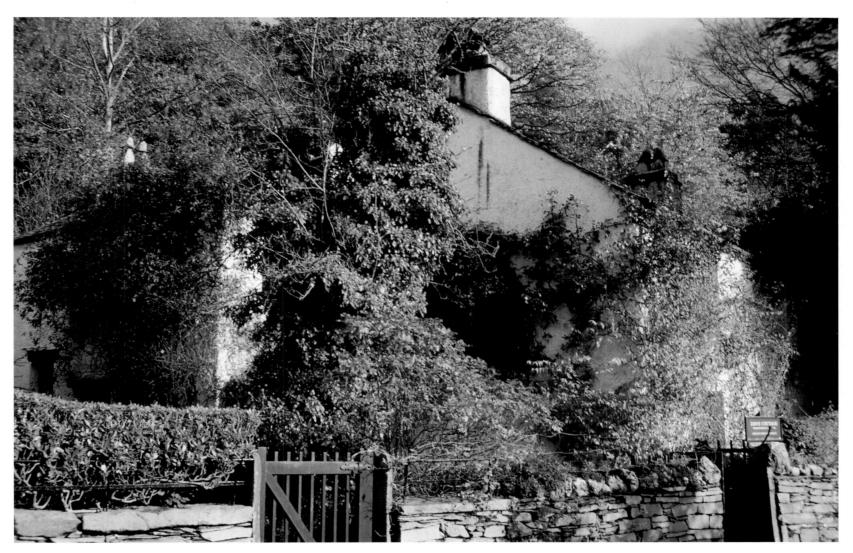

Dove Cottage on a summer's day, much as it might have been if the Wordsworths had just walked out the door for a stroll. Because of William's dislike of white houses, they encouraged climbing plants—roses, sweet peas, and honeysuckle—to grow up the walls, as we see here.

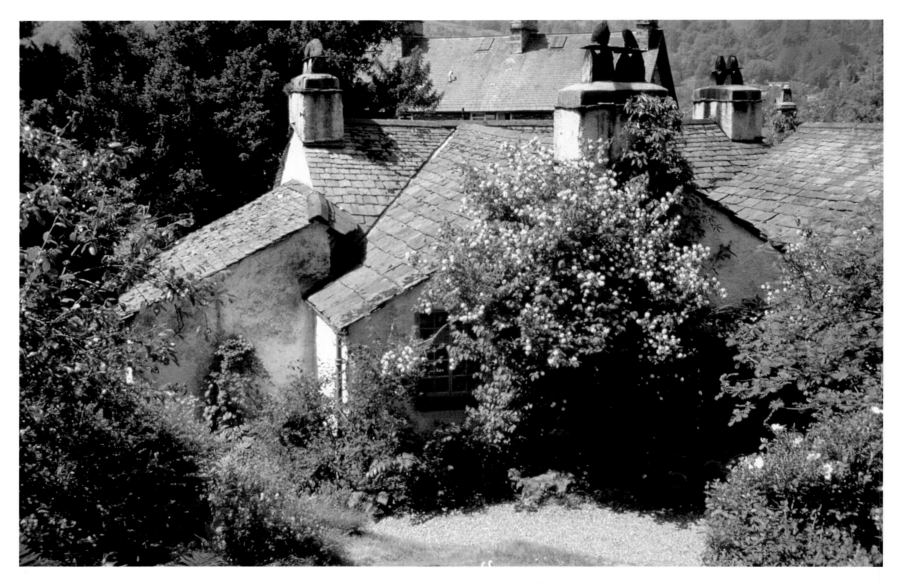

The rear of Dove Cottage from the Summer House in late spring, when the honeysuckle is in full bloom. (See p. 66 for the location of the Summer House.)

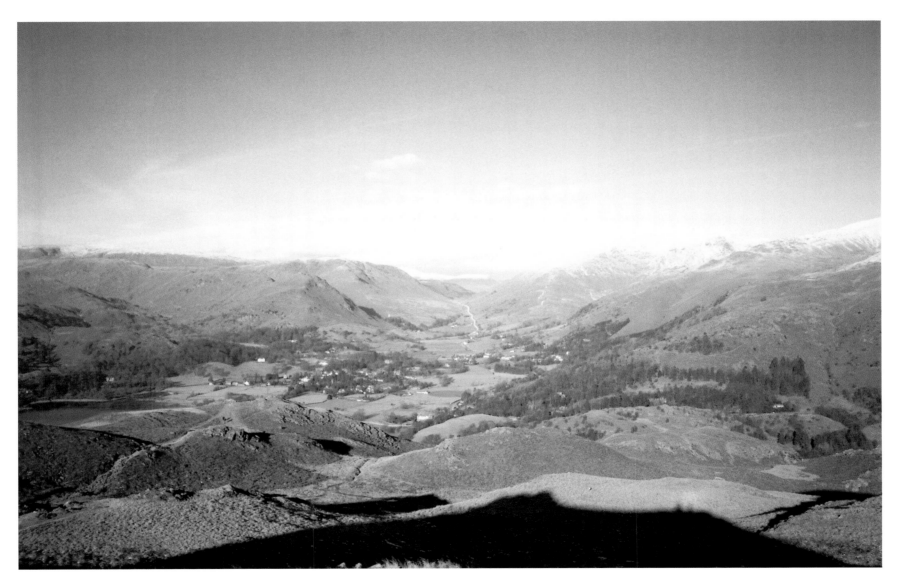

Grasmere Vale from the summit of Loughrigg Fell on a bright January afternoon. The gold color comes from the fronds of the dormant bracken fern that covers the hillsides.

Here they stayed for nine years. In that time, Wordsworth wrote much of his greatest poetry, and he and Dorothy made a garden.

They turned the rocky bit of hillside that rises from the back of the cottage into a garden. With its pathways, terrace, and sheltered seats, its views of Grasmere Lake and the surrounding fells, and its plantings, the garden was a place in which to work, live, and delight. There, striding along the pathways he had cleared, Wordsworth composed his poetry. There Dorothy sewed her shifts and made her shoes, and wrote letters or kept up her journal or helped her brother with his poetry.

As they practiced it, the art of gardening excluded neither people nor nature. Other family members, neighbors, and friends such as Samuel Taylor Coleridge, Mary Hutchinson (later Mrs. Wordsworth), and her brother Tom and sister Sara, often joined them on the pathways to talk of life and art and nature, and to gossip gently about the doings of their neighbors.

A Gardening Partnership

A garden owes its character to its owners' ideas and efforts, and both William and Dorothy Wordsworth contributed to the character of their garden. It was the expression of both their personal aesthetics and their practical needs.

The exact role Dorothy played in other areas of their partnership, the poetry and the aesthetics, can never be known. She shunned the limelight, and would never allow her own poetry or prose writings to be published, no matter how often her friends and family (especially William) sought to persuade her.[2] Despite her retiring habits, though, she was not a passive spectator at life. Her letters and journal reveal a woman who observed the world around her closely and with clear eyes. Feeling that she was by no means the poet her brother was, she may have found the garden a creative outlet, an art form in which she could participate equally with William.

Necessarily, however, there was a rough division of labor. A strong, vigorous man, William did the heavy work. With the help of a neighbor, John Fisher, he built the stone wall that supports the terrace. He also laid the steps, made the seats, and dug the well. In winter, he shoveled the path to the "necessary."

They shared the plantings, as William says in the poem, "To a Butterfly":

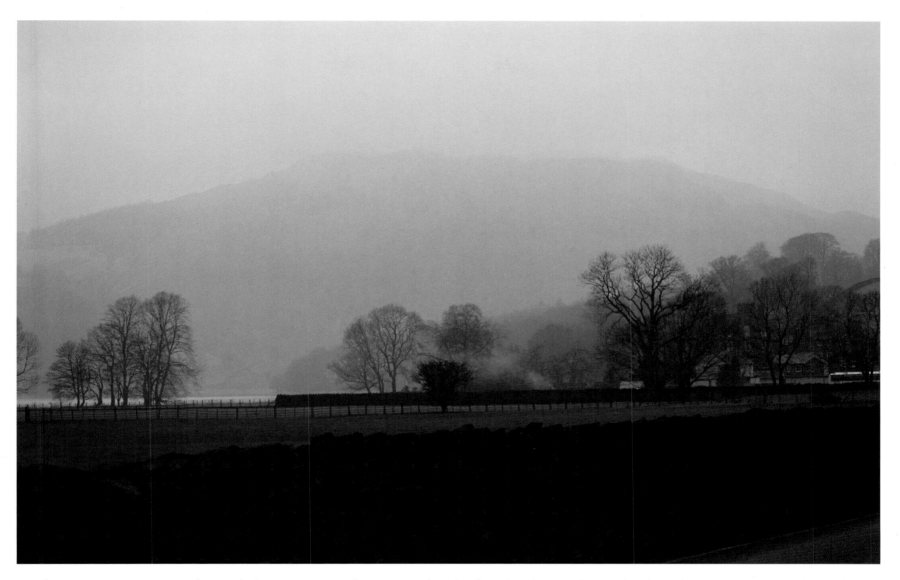

Silver How on a misty winter day—a shadowy suggestion of mass among low clouds. (This photograph was taken from the road, as modern building obscures the view of the lakeshore.)

This plot of orchard-ground is ours;
My trees they are, my Sister's flowers;
(2:10–11)

We should not take this to mean a strict division of responsibility or interest, however, for he loved flowers, too. Both of them, as Dorothy notes, "nailed up the trees," which meant staking the branches to support them. Nonetheless, Dorothy was more involved than her brother in planting flowers and devising unusual effects with them.

Dorothy grew flowers and wrote about them in her journal, which she kept specifically for William, who was delighted by both flowers and her writing. An incident she recorded about daffodils dancing by the shore of Ullswater became the nucleus of his poem, "I wandered lonely as a cloud." The joy he found in garden flowers, in the yellow celandines and marsh marigolds and roses, became symbols of a much larger meaning.

All of this—their philosophy of nature, their ideas on the purpose of a garden, and their cooperation—gave the garden its defining character, from its structure to what flowers were planted and where.

By placing seats strategically for the views, Wordsworth brought the external landscape into the garden to glory in seasonal changes along with the garden's colors, scents, and sounds. Instead of using exotics, he and Dorothy collected native plants and combined them in unusual and beautiful ways.[3] Even edible plants, such as beans and peas, contributed to the garden's beauty, for they used them as ornamentals, and planted them for effect as well as for food. Digging, planting, tending, working with the "realities of things," with rocks and plants and soil and dung, being part of the natural cycle of the seasons—in the garden they knew "perfect contentment."

Silver How rises across Grasmere Lake to the west. In this summer view, taken from the road in front of the cottage once occupied by John and Molly Fisher, the foot of the lake can be seen at the left. In Wordsworth's time, this view would have been visible from the Moss Hut, but a modern hotel built on the lakeshore now partially obscures it. In the lines quoted here, the poet refers to Silver How as an *eminence:*

There is an Eminence,—of these our hills
The last that parleys with the setting sun;
We can behold it from our orchard seat;
("Poems on the Naming of Places," 2:1–3)

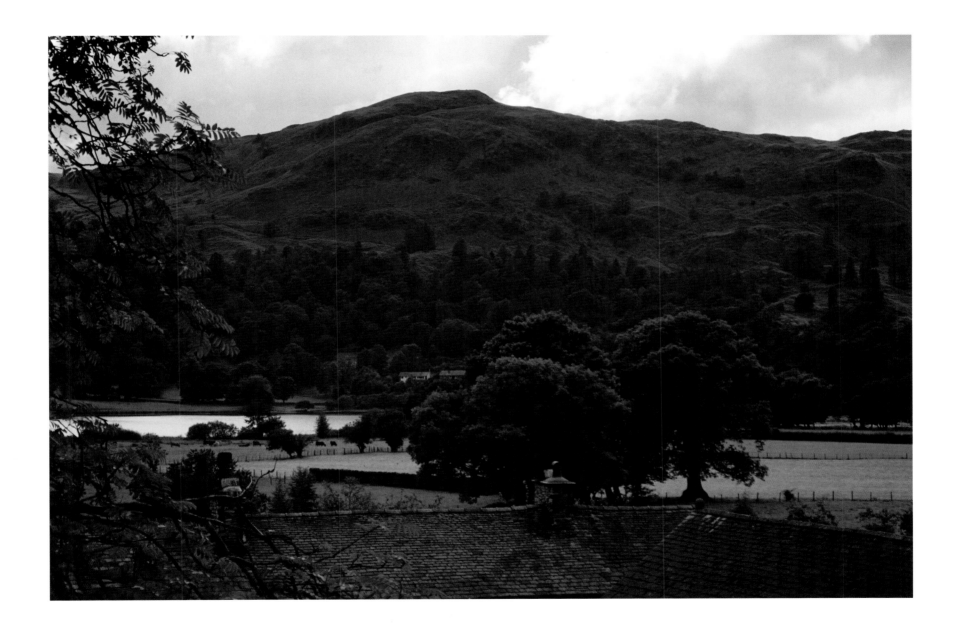

The Garden's Structure

A garden's structure comes from pathways, walls, and stonework—what landscape architects call hard details—that give shape to the gardener's vision. Often these details are set forth in a plan, but no plan of this garden was ever made in Wordsworth's lifetime, and it is unlikely that they would have begun with a plan. Instead, they followed their internal vision of what a garden should be. When it was right, they knew it. That vision appears in the garden, as reflected in the plan (see p. 66).

At Dove Cottage, William and Dorothy needed vision to see the potential for a garden in that steep, rocky site. A former public house and inn known as the Dove and Olive Branch, the cottage sits squeezed between the base of Bracken Fell and the old main road between Ambleside and Grasmere. The vertical rise of the fell begins at the roadside, so that the kitchen, on the lower floor at the rear of the cottage, is dug out of the slope. Likewise, the door that Wordsworth cut out of the back wall to escape his numerous family when he was composing is below ground level (see p. 65). When the Wordsworths lived there, the property was 85 feet wide at the roadside, and approximately 100 feet deep. In front, it was bounded by the road so closely that for privacy they enclosed a narrow strip in which they planted flowers.

The Dove Cottage property in the Wordsworths' time was bounded on the west by the road, and on the south by a stream called the Little Syke that flows down the fell and curves around the garden behind the cottage, then under the road and at last into Grasmere Lake. A line of hedges on the farther bank of the stream defined the southern boundary of the garden, 25 feet from the cottage. Approximately 30 feet up the slope from the back wall of the cottage is a rock outcropping that spans the entire width of the garden area, some 100 feet. A previous tenant had planted apple and pear trees among the rocks, but beyond them the forest stretched up the fellside and around all the way to Grasmere village.

The total garden area is some 7,000 square feet, but of that perhaps a third is stone, the Lake District's granite slate. Where other gardeners might have seen impossibilities, however, the Wordsworths saw advantages. Whereas other gardeners might have seen the rock as something to get rid of, they saw it as integral to the garden. In common with his neighbors, William used the slate as building material, but with a difference—his constructions appear at one with the natural rock formations. Wordsworth began by incorporating a rock seat into a slab of sheer granite about 30 feet uphill from the cottage on the north side of the garden (see p. 68). In addition, he needed, as he says:

A length of open space, where to and fro
My feet might move without concern or care.

Wordsworth cut this door into the back wall of Dove Cottage for an escape route from his eager and growing family. Leaving the cottage, a person must walk up two steps to gain the garden path.

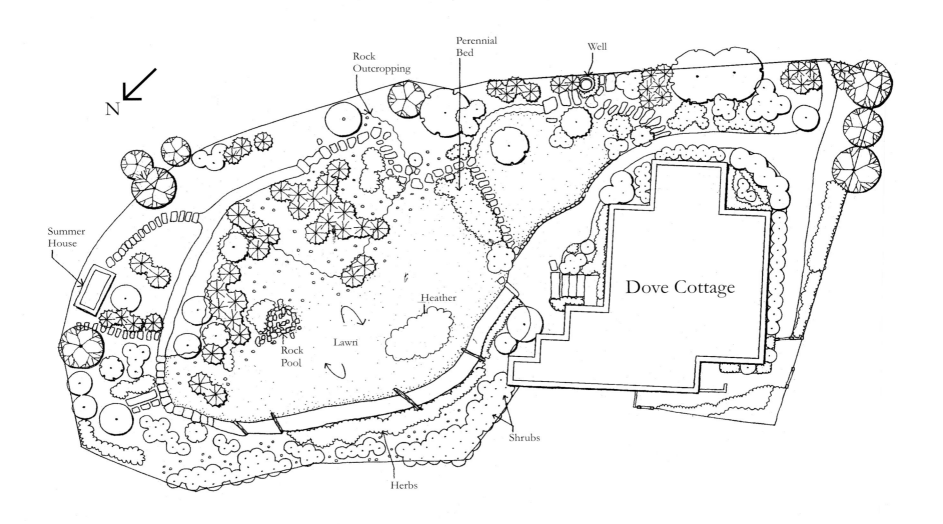

N

Rock
Outcropping

Perennial
Bed

Well

Summer
House

Heather

Lawn

Rock
Pool

Dove Cottage

Shrubs

Herbs

To support this platform, Wordsworth built a wall and joined it onto the rock outcropping near the middle of the garden (see p. 69). Together, man-made wall and natural rock form the base for a terrace roughly 10 feet wide and now 50 feet long, although in Wordsworth's day it is thought to have extended further, past the current location of the Wordsworth Museum. The fruit trees were planted both above and below the wall, so that when it was finished, it formed part of their orchard pathway:

Orchard Pathway, to and fro,
Ever with thee, did I go,
Weaving Verses, a huge store!
　　　("Orchard Pathway," 2:1–3)

After he had built the terrace, Wordsworth constructed a covered seat above it among the fruit trees (see p. 70). (The approximate location on the plan is indicated by the Summer House.) From there people had a fine view to the west of Grasmere Lake, Silver How, Helm Crag, and beyond. And William commemorated it in these lines:

There is an Eminence,—of these our hills

The last that parleys with the setting sun;
We can behold it from our orchard seat;
　　　("Poems on the Naming of Places," 2:1–3)

This is the first plan ever drawn of the Dove Cottage garden. It shows the garden's shape after Thomas DeQuincey, the cottage's second tenant, cut down the Wordsworths' beloved orchard and had a stone wall built for privacy—a garden feature the Wordsworths had not needed, and which was quite foreign to their inclusive notion of a garden. (Plan by Richard and Carol Buchanan, executed by Bonnie Pollard.)

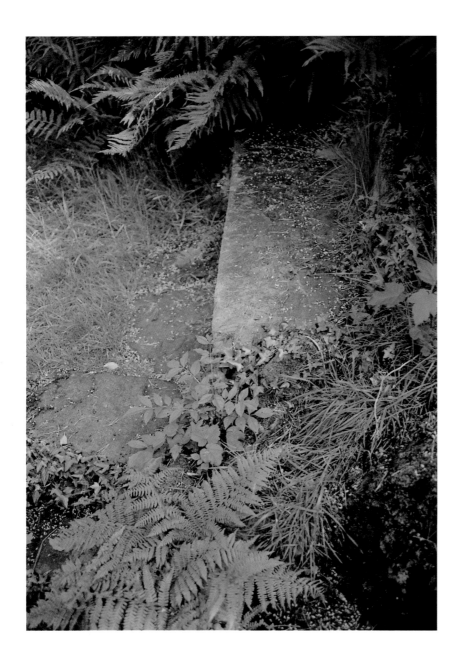

This rock seat, one of the first features that Wordsworth built into the garden, lies near the top of a steep, curving set of stone steps built into the rock of Bracken Fell.

The orchard path crossed the terrace and followed the course of the Little Syke downstream to join a path that began at the front gate. This path curved uphill around the south end of the house, along the back wall northward, and then easterly up the hill to join the northern end of the terrace. To enable people to climb up onto the terrace, Wordsworth laid stepping stones. More stepping stones zigzagged from the south end of the terrace through the rock outcropping and down the slope to finish at the path near the back door of the cottage (see p. 71).

People moving along these paths gain different perspectives on the garden, for the rock outcropping and the trees effectively block parts of the garden from sight. From the seats, today's visitors can, as did the Wordsworths and their friends, ponder the garden experience, enjoy the views, and listen to the sounds of water and birds. Dorothy describes how waterfalls and birds sounded in John's Grove (their brother John's favorite spot in the woods above the orchard):

There was not one waterfall above another—it was a sound of waters in the air—the voice of the air.

(April 29, 1802)

For even more variety in these water sounds, Wordsworth also built pools in the garden, which were hospitable to birds, whose songs and chatter added to the garden sounds and contributed to the enjoyment (see p. 71).

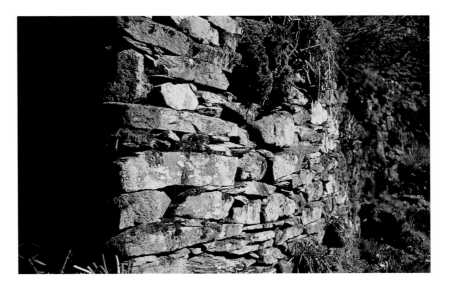

This stone wall, which Wordsworth built with the help of John Fisher, supports the level walkway where he could pace out the rhythms of his poetry. This section of wall is anchored at both ends by the outcroppings of boulders that form most of the garden. Taken in very early spring, this photograph shows the wall before the ferns have sprouted from it and all but obscured it.

This modern summer house occupies the place of honor at the top of the garden where it commands fine views over the rooftop of Dove Cottage across the valley toward Silver How.

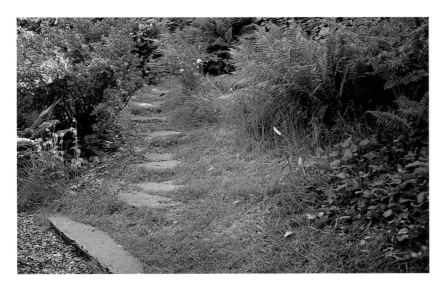

These stepping stones begin at the pathway behind Dove Cottage's back door and lead past the old *Rosa rugosa* and the perennial bed, upward to the terrace.

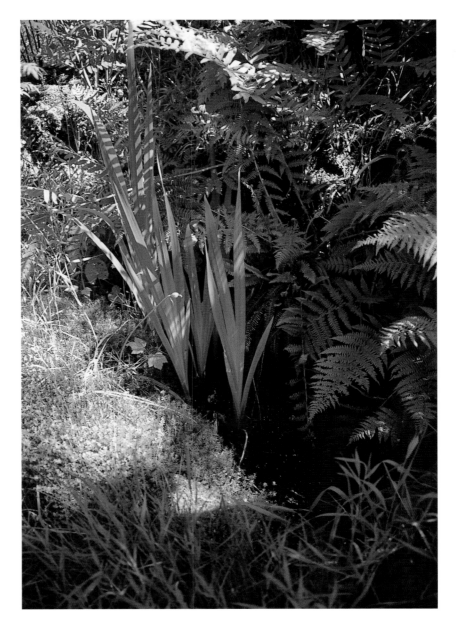

This pool lies at the base of the rock outcropping (see p. 66). From the wall, where Dorothy sat at times to read or do any of a number of portable chores (mending her shoes, shelling peas, or sewing), she could hear clearly the warble and chatter of birds as they splashed in the water.

The Love of Gardening

The Wordsworths took pleasure in the sheer labor of making things grow as much as in the aesthetic and (we hope) the culinary results. When Dorothy notes in her journal (May 15, 1800), "Hoed the first row of peas, weeded, etc.," she is expressing the gardener's satisfaction in seeing the first little green sprouts above the soil. Their garden kept them well supplied with vegetables, for they planted peas, three kinds of beans (scarlet runner, French, and kidney beans), radishes, turnips, broccoli, and, among other vegetables, bistort, which has an interesting flower, and is eaten like spinach.

Like many gardeners, Wordsworth also liked the warm soil at his fingertips and the smooth sliding of a shovel into the earth. In 1806, he commemorated this labor in a light-hearted poem, "To the Spade of a Friend," and notes that he composed the poem "while we were labouring together in his pleasure-ground." (A pleasure ground is an ornamental garden—a flower garden, perhaps, rather than a kitchen garden.)

The Wordsworths had their disappointments, as gardeners do. Insects could be a problem. Dorothy notes on June 4, 1802, "In the morning we observed that the scarlet beans were drooping in the leaves in great numbers, owing, we guess, to an insect." This might have been the greenfly, for which the remedy was (according to the late George Kirkby, chief guide and gardener at Dove Cottage, who restored the garden) lye soap and water.

The Lake District has a short growing season with approximately 90 inches of rainfall a year. There is a local saying: Never cast a clout until the May is out. In other words, do not sow seeds before the Mayflower is blooming. (The May flower is the Cuckow flower or lady's smock, *Cardamine pratensis,* a low-growing, small pink flower that blooms in early May.) Like all enthusiastic gardeners in cold winter areas, though, the Wordsworths were often impatient to begin gardening in the spring. On January 28, 1802, Dorothy notes, "William raked a few stones off the garden, his first garden labor this year." Dorothy and Molly Fisher, the neighbor who helped her in the house, were out in March, cleaning up winter debris, and Dorothy could not resist transplanting some snowdrops in bloom.

Having their own garden to populate with native plants stimulated their curiosity, and the Wordsworths quickly became dissatisfied with their level of botanical knowledge. In the first gardening entry in her journal (May 14, 1800), Dorothy refers to the "grassy-leaved Rabbit-toothed white flower," and two days later, May 16, 1800, she wishes for a book on botany. This wish led to the purchase of *An Arrangement of British Plants According to the Latest Improvements of the Linnaean System* by William Withering. After that, Dorothy's botanical knowledge becomes more certain. On May 6, 1802, she knows that the rabbit-toothed plant is stitchwort, *Stellaria holostea* L.

This happy mixture of Phlox, pinks, London pride, and buttercups is typical of the Wordsworths' informal approach to garden design, modeled on the cottage garden which they had appreciated since their days at Racedown Lodge.

(Except for Withering's medical notes, the book is written in as dry and scientific a manner as could be imagined. Its descriptions of plants led Wordsworth to write this marginal note to the common butterwort [*Pinguicula vulgaris*] in a fit of pique:

. . . in great abundance all round the Grasmere fells. This plant is here very ill described, a remarkable circumstance belonging to it is the manner in which its leaves grow, lying close to the ground, and diverging from the stalk so as to greatly resemble a starfish. The tall slender stalk surmounted by the blue flower, and rising from the middle of this starfish, renders the appearance of this plant very beautiful especially as it is always found in the most comfortless and barren places, upon moist rocks, for example.)

The Plants

The Wordsworths had two main sources of plants for their garden: the hills around them, and their friends and neighbors. From these sources they acquired a great variety, not only of flowering bulbs and perennials, but of ferns, mosses, and lichens as well. All of these resulted in a colorful and interesting garden.

Besides fulfilling their aesthetic goal of hiding art in nature, native plants had (and still have) practical advantages. For one thing, these plants were free for the taking. Second, they minimized labor: A gardener who considers a wild plant a valuable addition to the garden rather than a weed does not have to pull it. Third, native plants are already acclimated and do not need the coddling exotics must have. The chief benefit of gardening with native plants for the Wordsworths, however, was that native plants were in harmony with nature. As he writes in "A Farewell," they brought to their garden (their "Dear Spot"):

. . . chosen plants and blossoms blown
Among the distant mountains, flower and weed,
Which thou hast taken to thee as thy own,
Making all kindness registered and known;
Thou for our sakes, though Nature's child indeed,

Fair in thyself and beautiful alone,
Hast taken gifts which thou dost little need.

(*ll.* 34–40)

Among the flowering plants they gathered were daffodils, daisies (or gowans as Dorothy called them), primroses, lesser celandines, marsh marigolds, heartsease (wild pansies), globeflowers (Lockety Goldings according to Dorothy), foxgloves, and columbines, stitchwort, geum, and Herb Robert. These blended their shades of red, yellow, blue, and white in a blooming season that extended from early spring into midsummer. Flower color was not the only interest these plants held for them, however. The mixture of foliage textures, plant forms, and shades of green is a delight to the eye.

The Wordsworths collected orchids, also, specifically the early purple orchid and the spotted orchid.[4] The latter has pale pink flowers with dark spots, while the early purple orchid has purple flowers and purple blotches on its leaves. They could even have gathered some of their vegetables from the wild; particularly (although Dorothy does not mention them specifically) the vetches, or wild peas. With their pink and lavender blossoms in spring, they would have added to the cheerfulness of the garden. Dug into the soil, the common vetch was (and still is) used as green manure.

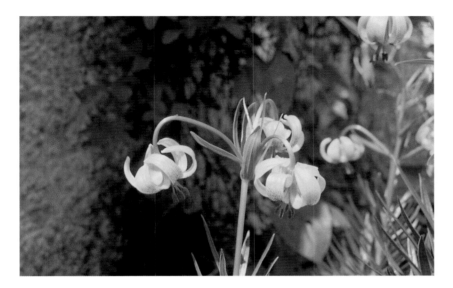

This Turk's cap lily currently grows in the Dove Cottage garden. In the strong spring sunshine of its northern latitude, its cheerful yellow flowers gleam against the white wall of the cottage.

Wordsworth's favorite flower, the lesser celandine, grows in sociable company with grasses and daffodils just now faded past their season.

Besides collecting from the wild, the Wordsworths also traded plants and produce or preserves with neighbors. From Jenny Dockeray, Dorothy got the "white and yellow lilies, periwinkle, etc." (May 28, 1800). The white lilies were probably the Madonna lily, grown in European gardens from time immemorial. Periwinkle, *Vinca minor,* is a ground cover that thrives in shady locations with acid soils and bears blue flowers in the spring. On October 23, 1801, Dorothy mentions with some excitement that William's future brother-in-law, Tom Hutchinson, brought two shrubs for them from Mr. Curwen's nursery. Unfortunately, she does not say what the shrubs were. They often traded plants with their neighbors and friends the Simpsons.

Both William and Dorothy had their favorite flowers. Dorothy's was the Turk's cap lily (*Lilium martagon* L.), which grows to 6 feet or more in acid soils in semishaded woodland locations. William's clear favorite was the lesser celandine (*Ranunculus ficaria* L.). This plant inspired two poems ("To the Small Celandine" and "To the Same Flower") because its bright yellow flowers cheer gloomy days and lift one's spirits in late winter or early spring:

Telling tales about the sun,
When we've little warmth, or none.
("To the Small Celandine," 2:31–32).

Dorothy used flowers imaginatively, planting them in interesting and different combinations instead of segregating them in such functional areas as the kitchen (vegetable) garden or the pleasure ground. Honeysuckle twined then as it does now through the *Rosa rugosa* behind the cottage. The lesser celandine and the primrose blended their foliage and shades of yellow. Scarlet runner beans and the native woodbine (or honeysuckle) climbed the house and entwined "John's rose tree," the trees in the orchard, and the yews. Foxgloves and lilies brightened the orchard, and wild strawberries made an edible groundcover if slugs, snails, or birds did not eat them first.

Dorothy collected and grew herbs for culinary and medicinal uses. She records planting wild thyme, by moonlight, and also using creeping thyme, rosemary, and various members of the mint (*Mentha*) family. Unable to afford India or China tea, the Wordsworths brewed mint tea from peppermint and spearmint, and used leaves from these plants as toothpaste.

In any creative endeavor, there are times when the work just does not come right, when the medium refuses to yield to the intent, even if the artist fully understands the intent. So it was for Wordsworth; the difficult labor of composition could make him ill with headaches, piles, or nervous exhaustion. To cope with the various health problems that plagued the Wordsworths, they may well have turned to Withering's book as a home medical guide as well as a botanical reference, for the author often includes

medical notes to the various plants. Pennyroyal, known in Westmoreland by its local name, pudding grass, had many uses, among which were to relieve flatulence and drive away fleas. Withering also recommends it for "hooping cough," and a "simple and a spiritous water" distilled from the juice of its leaves

are prescribed in hysterical affections, and are not without considerable anti-spasmodic properties.

And thyme, he writes,

yields an essential oil that is very heating. An infusion of the leaves removes the head-ach ocasioned (sic) by the debauch of the preceding evening.

A self-confessed "water drinker," Wordsworth was unlikely to have needed a remedy for hangover, although he and Dorothy both had frequent headaches.

To care for the trees, Wordsworth relied on a manual by Samuel Hays, entitled *A Practical Treatise on Planting and the Management of Woods and Coppices* (1794). Following Hays's advice, Wordsworth would usually have had success with his trees. Hays warns against letting the rootball dry out during transplanting and recommends soaking it in a preparation of water and soil of the consistency of milk. Any dead roots should be cut off as

"new ones will grow from them." Other techniques, however, such as bleeding a tree—slitting the bark vertically to let the sap flow (similar to the eighteenth-century medical practice of bleeding people)—make today's gardener shudder. Among Wordsworth's favorite trees was the rowan, or mountain ash. With its white spring flowers, bluish-green, pinnately compound leaves, and brilliant red fall berries, it offered (and offers) year-round attractions.

For the poet, it would have had symbolic value as well. Wordsworth would have been aware that in the folklore of the Lakes, the rowan was held to have magical properties, and a rowan stick was used to stir cream. It is a tree, says Geoffrey Grigson in *The Englishman's Flora,* "endowed with life, and a very active life." Besides the apple and pear trees, there were yew, laurel, oak, hawthorn, and holly, which grew wild over the fells. The hawthorn is of special significance in folklore as the May tree, "supernaturally powerful at all times and against a wide range of evil including lightning, and the malice of fairies," Grigson reports. Wordsworth had already made use of this tree in his poem, "The Thorn," written at Alfoxden.

In a climate in which winter lasts half the year, the Wordsworths used broom and ferns for color and combined them and other plants with rocks for structural interest. The bracken fern, which gave its name to the fell, is native to the Lake District. A tall fern, whose fronds grow singly from stoloniferous rhizomes,

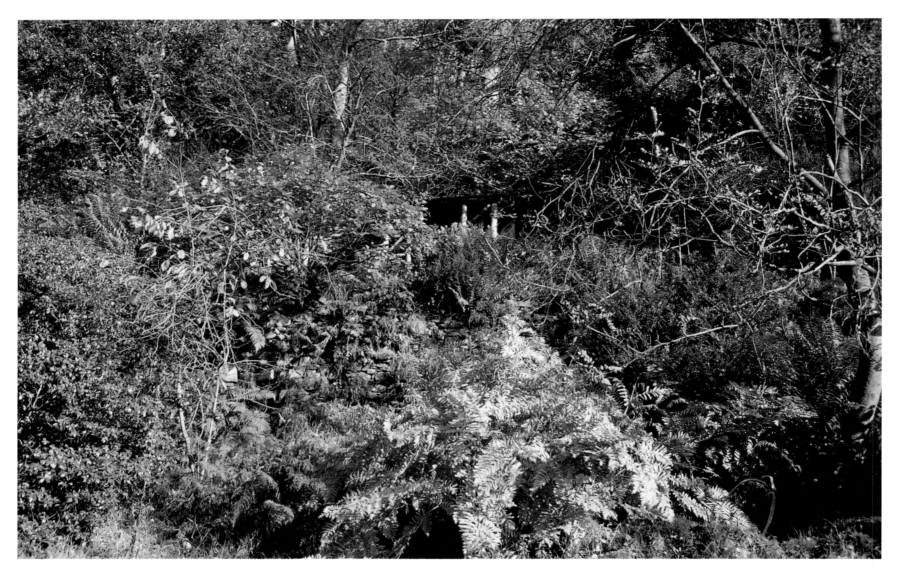

The Dove Cottage garden in autumn. The large splash in shades of gold is the Osmundine fern going dormant for the winter.

the bracken fern shades lower-growing plants and in autumn turns a bright yellow. During the winter it covers the surrounding fells with a russet tone in an agreeable contrast to the green fields. The Alpine fern is a tiny fern that seeds itself in the crevices of rocks and sprouts enthusiastically from stone walls. In areas where ferns are native, gardeners need not gather them specifically, but allow them to come up in the garden where they want them. Yet Dorothy and William so loved ferns, particularly the royal or Osmundine fern (see p. 78), that they did gather them, as Wordsworth writes in the poem Dorothy called "Point Rash Judgement." He describes how they

> . . . paused, one now,
> And now the other, to point out, perchance
> To pluck, some flower or water-weed, too fair
> Either to be divided from the place
> On which it grew, or to be left alone
> To its own beauty. Many such there are,
> Fair ferns and flowers, and chiefly that tall fern,
> So stately, of the queen Osmunda named,
> Plant lovelier, in its own retired abode
> On Grasmere's beach than Naiad by the side
> Of Grecian brook . . .
>
> *(ll. 27–37)*

In the Wordsworths' garden, ferns grew (and grow) among the rocks in the outcropping, about the well—in short, anywhere they could (and can). In winter, the Alpine ferns are the only ones still green. They add color and life to the grey rock. In warmer seasons, the other ferns overlook low-growing, shy plants, and add variety of height and motion among the breezes.

Broom is another all-season plant. Its yellow flowers in May and June brighten the hills, while its strong greens and feathery branches in winter add interest and color. But broom is also a plant that connects antiquity with modern times; it is a plant of love and romance in poetry. In British history, it has an important place, for the Plantagenets took their name from it: the *Planta genista*. With his love of English antiquity, Wordsworth may well have felt that growing broom in the garden connected modern life with ages past.

As noted earlier, stone had a special significance for Wordsworth, as being the most permanent of nature's materials, the foundation of the earth itself. He carved his and his friends' initials on the famous Rock of Names (now moved near the Wordsworth museum). Later, he would have some of his verses etched in stone. Because he never knew for sure that what he wrote for posterity would truly endure, working with rock must have given Wordsworth the satisfaction that comes from doing something that will last beyond one's self.

William and Dorothy used stone creatively by incorporating it into the plantings. They put broom, primroses, pansies, geraniums, and snowdrops among the natural rock formations, and in the crevices on the wall. They both liked the contrast of soft, colorful perennials with granite. Wordsworth liked this effect so well that it appears in more than one poem, for example, in "A Farewell": "Here, thronged with primroses, the steep rock's breast" (2:53) or in "The Seven Sisters":

Who fancied what a pretty sight
This Rock would be if edged around
With living snow-drops? circlet bright!
How glorious to this orchard-ground!
Who loved the little Rock, and set
Upon its head this coronet?

Was it the humour of a child?
Or rather of some gentle maid,
Whose brows, the day that she was styled
The shepherd-queen, were thus arrayed?
Of man mature, or matron sage?
Or old man toying with his age?

I asked—'twas whisper'd; The device
To each or all might well belong.
It is the Spirit of Paradise

That prompts such work, a Spirit strong,
That gives to all the self-same bent
Where life is wise and innocent.

(2:1–18)

An appreciation for mosses was (and is) an unusual taste among gardeners. Dorothy loved mosses because they gave her the opportunity for year-round gardening, a reason for going plant-collecting in winter. Her journal records expeditions (with and without her brother) in search of mosses throughout the winter of 1801–1802. In one of her rare poems, "A Winter's Ramble in Grasmere Vale,"[5] she wrote:

What need of flowers? the splendid moss
Is gayer than an April mead,
More rich its hues of varied green,
Orange and gold and glowing red.

Dorothy brought home a "collection of lichens," too, but does not say what she did with them or what they were. She probably collected the sphagnum moss, which grew abundantly in the Lake District, and is common throughout Britain. One species of this genus (*Sphagnum auricularum* var. auriculatum) is a bright yellow-green. With mosses, also, Dorothy exercised considerable ingenuity—she planted them on the chimney piece and lined the sheltered seat on the terrace with them. After they named this

resting place the Moss Hut, William sat there (in 1805) writing a letter to Sir George Beaumont:

> I am now writing in the Moss hut, which is my study, with a heavy thunder shower pouring down before me. It is a place of retirement for the eye (though the Public Road glimmers through the apple-trees a few yards below), and well suited to my occupations.

Life in the Garden

More than most people, perhaps, William and Dorothy Wordsworth lived in their garden. It sustained them; it fed their bodies and their spirits in ways all gardeners appreciate in their own gardens, and it fed Wordsworth's poetry. They worked hard at it, and in it, and they took pleasure in sharing it with their friends and neighbors. They also simply enjoyed it, as Dorothy noted in the summer of 1802:

> . . . Lay in the orchard all the afternoon. In the morning Wm nailed up the trees while I was ironing. We lay sweetly in the Orchard the well is beautiful the Orchard full of Foxgloves the honeysuckle beautiful—plenty of roses but they are battered.
>
> <div align="right">(July 6, 1802)</div>

William wrote of another moment in "To a Butterfly":

> I've watched you now a full half-hour,
> Self-poised upon that yellow flower;
>
> <div align="right">(2:1–2)</div>

Wordsworth may have lain watching the butterfly for half an hour, but when he composed, he was very active. He paced the terrace and the pathways, chanting his verses aloud, keeping time with his feet and altering lines to correct the rhythm, painstakingly fitting in words, and discarding them when they did not satisfy his alert and sensitive ear, or achieve the meaning he wanted. At these times, Dorothy helped, as she recounts during the writing of "Michael" (which she refers to as "the sheepfold") on October 18, 1800:

After Wm. had composed a little, I persuaded him to go into the orchard. We walked backwards and forwards. The prospect most divinely beautiful from the seat. [Probably the rock seat (see p. 66).] Wm. again composed at the sheepfold after dinner.

While William composed, Dorothy might be gardening within hearing distance, for he had a loud voice and the distance from the terrace to the house is only about 40 feet:

Wm. was composing all the morning. I shelled peas, gathered beans, and worked in the garden till ½ past 12. (Oct. 18, 1800)

When her brother had a new poem, he would try it out on her, aloud, on foot:

I went and sate with W. and walked backwards and forwards in the orchard till dinner time. He read me his poem. (Mar. 17, 1802)

They discussed changes to new poems and altered them together:

We sat in the orchard. William wrote the poem on The Robin and the Butterfly. I read [the poem of the Rover] to him in bed. We left out some lines. (Apr. 18, 1802)

Living with a brother who is also a perfectionist poet was not all bliss for an ardent spirit like Dorothy. Anxiety over Coleridge drove Dorothy to what William called nervous blubbering. And at least once, she found the orchard a haven:

William wrote a conclusion to the poem of the Butterfly— "I've watched you now a full half-hour." I was quite out of spirits and went into the orchard. When I came in, he had finished the poem. We sate in the orchard and repeated The Glow-worm and other poems. (Apr. 20, 1802)

It was an exciting life, full of creative energy as two young people set out to prove they could live the life they had in mind, that William could be the poet they both believed he could be. But in gardens as in nature, seasons come and go, and life brings

changes. William married Mary Hutchinson in the autumn of 1802. Four months after the wedding, Dorothy ceased to keep her journal, but there is no evidence that she stopped gardening. In fact, she wrote to a friend, Catherine Clarkson, in July 1806:

> William goes on rapidly with the Recluse. We are now sitting together in the Moss Hut. We have plenty of apples, and our garden has been very productive this year.

The garden remained important to family life. In "The Kitten and the Falling Leaves," Wordsworth describes how he held his infant son John as they watched their kitten play in the falling leaves. The family increased rapidly, and by the summer of 1806 they were looking for a larger house. After a temporary residence at Sir George Beaumont's Hall Farm during the winter of 1806-1807, they moved to Allan Bank in 1808, to the Grasmere rectory in 1811, and finally to Rydal Mount in 1813.

The Dove Cottage garden was left to the ravages of new tenants and to time. Thomas DeQuincey, whom Dorothy had approved of as the new tenant because she felt he would appreciate the orchard, cut it down and erected a stone wall around part of the property. Dorothy was quite irate. She could never like him so well after that. After DeQuincey, the cottage passed through several tenants until it became the property of the Wordsworth Trust.

The Garden Today

The story of the garden might be very different but for the efforts of George Kirkby, chief guide for the Wordsworth Trust. Kirkby, who died in December 1998, began restoring the garden in 1969, as he said, "to its former self."[6] In a recorded interview, he described how he found it:

> an ordinary very neat tidy garden, not at all as the Wordsworths had it because Wordsworth wanted his garden to have wild things in it, and kept his garden rather differently.

In restoring the garden, Kirkby was admittedly fortunate in having Dorothy's journal and Wordsworth's poems. Together, he said, they made it "the most well-documented quarter of an acre in English literature." His restoration of the garden was informed by his extensive readings, an intimate knowledge of the ground, and lifelong residence in the Lake District. True to the Wordsworths' intentions, he made extensive use of the types of flowers they had, and planted them as the Wordsworths would have done.

Browsing through the garden is like visiting the Wordsworths. Besides their writings, nothing so much reveals the people they were. The garden was an informal mixture of planned plantings and the happy accidents all gardeners enjoy, and in

Here the native English primrose has been allowed to take root in the stump of an old laurel, which from its size, George Kirkby thought, could have been in the garden when the Wordsworths lived there. Behind the stumps is DeQuincey's wall.

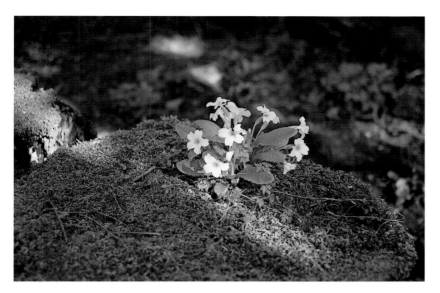

In this closeup the shy primrose illumines its shady corner.

Kirkby's time, it was presided over by a real gardener, himself unpretentious and informal, despite his exhaustive knowledge of Wordsworth's poetry and Lake District fauna. Honeysuckles entwine an old dog rose (*Rosa rugosa*) and climb the cottage walls, just as then. Ferns and other plants grow among rocks and in the crevices of the terrace wall. On the stump of an old laurel Kirkby thought could have been planted by Wordsworth, a native English primrose (*Primula vulgaris*) has been allowed to take root. A huge *Berberis* stands near the well, and Kirkby believed that because of its massive size and slow growth it, too, could have been planted by the Wordsworths.

In addition to the plantings, Kirkby also restored structural garden features such as the well, around which he replanted Osmundine fern and Lenten roses (*Helleborus orientalis*), just as in the Wordsworths' day (see p. 86). Where he was not able to acquire the same plants, such as Dorothy's geum, he used a close modern cultivar, in this case, *Geum borisii,* "Molten Fire," which has a single, smoky red blossom. Because of his care, despite time's inevitable changes, the Dove Cottage garden "moves the affections" for the modern visitor.

Wordsworth's "A Farewell," said Kirkby, is a "real gardener's prayer."[7] Let this line from the poem serve as a benediction not only on the Dove Cottage garden, but on gardens everywhere:

Sunshine and shower be with you, bud and bell!

(2:17)

The well that Wordsworth dug, which George Kirkby found and restored, and planted with ferns and hellebores. In this early spring photograph, the Osmundine fern has not yet broken dormancy, while the Lenten roses are already past their bloom time.

In this candid photograph, George Kirkby (in conical hat) is educating the author about the plants in the garden.

Three

THE GARDEN AS POEM:
THE WINTER GARDEN AT COLEORTON

The winter garden at Coleorton was the Wordsworths' labor of love—love of nature, love of gardening, and love of the Beaumonts. From this love they constructed a horticultural poem whose central theme is the joyful hope of spring even in the midst of winter. It is a metaphor for the hope of life in the midst of death when, on a damp and chilly day, a ray of unexpected sunshine between heavy clouds lights up ivy climbing a red brick chimney, brightens holly leaves, and glows on a mellow stone wall. It cheers the soul.

But how is a garden like a poem? Briefly, in its structure and in the connection of its images. Wordsworth planned eight separate compartments linked by a path. Each compartment has its own dominant metaphor life that supports the central feeling of hope. For example, the main image in one compartment is hollies; in another, an ivy-twined brick chimney, and in a third, goldfish. The ivy, hollies, and fish have in common being alive; holly berries, fish, and brick are all red in color. Living things, cheerful colors of red and green—they counter the bleak prospect of winter outside the garden, even though as an aggregate of separate items, chimney, fish, and plants would seem to have nothing more in common than the stone and the sea beast in "Resolution and Independence," which are connected by only their patient and passive endurance and their careful juxtaposition in the poem.

Wordsworth was just as careful with his placement of objects in the Winter Garden. He uses the path to limit the number of possible routes by which the observer comes upon the compartments and so controls the order in which the images are encountered.

This profoundly poetic way of thinking of garden design could hardly have been more out of sympathy with either contemporary fashion in landscape design, the Brownian mode and the picturesque. With the Brownian style, Wordsworth did not have to concern himself, but at Coleorton he was, so to speak, in the citadel of the picturesque. It came about because of the kindness of friends.

A Gift of Friendship

Sir George Beaumont burst into Wordsworth's life in 1803 with the gift of a piece of property called Applethwaite, near Keswick where Wordsworth's friend and poetic collaborator Samuel Taylor Coleridge lived. Sir George had met Coleridge and fallen under the spell of his conversation (as many people did). When Coleridge regretted not living closer to Wordsworth, Beaumont made his impulsive gift.

Wordsworth had not even met Sir George when the aristocrat announced in a letter that he had made the gift, and it put the young poet in an extremely awkward position. He was opposed to patronage in all its forms, yet he did not wish to insult Sir George, who had, after all, meant the gift kindly. After dithering for weeks, he sent a satisfactory response. Without rejecting either the gift or the giver, and acknowledging the generosity of spirit that prompted the gift, Wordsworth let Beaumont know that he was not the sort to accept patronage. His manner of acceptance earned Beaumont's respect. As their friendship progressed, Beaumont's biographer comments, "Wordsworth's independence of spirit [was] an attribute that was to save them from the usual patron–protégé relationship so often fatal to friendship."[1] When the two men met, despite the sixteen-year

difference in their ages, "for both it was a meeting of souls, and Wordsworth's capacity for joy became a most precious gift" to Beaumont, who was prone to depression.

They developed a mutual respect for each other's talents. From Beaumont, Wordsworth learned much about painting; from Wordsworth, Beaumont learned about poetry. Some of Wordsworth's poetry, for example, "Elegiac Stanzas on Peele Castle," was inspired by pictures Beaumont painted. Lady Beaumont, especially, never ceased to promote Wordsworth's career by praising his poetry to well-placed friends and urging them to buy his books.

A combination of circumstances led to Wordsworth's being in the right place at the right time to build the winter garden. In 1804, Beaumont decided to take more interest in his collieries around Coleorton and began to build a suitable house there. By late summer of 1806, the Wordsworths' housing situation was becoming impossible. The family had grown to six: William, Mary, Dorothy, three-year-old John, two-year-old Dora, and the infant Thomas. Sara Hutchinson, Mary's sister, made her home with them as well. Not only that, but the Wordsworths expected Coleridge to take refuge with them from his unhappy domestic situation (which he eventually did, together with his small son Hartley). Dove Cottage was seriously overcrowded, and the family was desperate to find housing before winter set in.

Beaumont offered Wordsworth the use of Hall Farm, his temporary Coleorton residence half a mile from the site of the new house. Gratefully, the Wordsworths accepted. In September 1806, Dorothy wrote to Lady Beaumont that they had "no other spot to turn to." Their only reservation was that they would not be able to see their friends while living in their house, for the Beaumonts, as usual, planned to spend the winter at their London house.

Beaumont House. This house was being constructed during the winter that the Wordsworths accepted the Beaumonts' hospitality.

Hall Farm. In this house, spacious though modest by comparison to Beaumont House, the Wordsworths spent the winter of 1806–1807.

Beginning of the Winter Garden

The Wordsworths arrived at Hall Farm in October 1806. Lady Beaumont had decided to establish a winter garden in an old gravel quarry, and shortly after the Wordsworths had settled in at Hall Farm, they discovered its proposed location. Wordsworth wrote approvingly of the spot to Sir George, and added that Lady Beaumont might enjoy reading John Addison's essay on winter gardens in the *Spectator* (1712, vol. 7, no. 477). In it, Addison had written:

When Nature is in her Desolation, and presents us with nothing but bleak and barren Prospects, there is something unspeakably chearful in a Spot of Ground which is covered with Trees that smile amidst all the Rigour of Winter and give us a view of the most gay Season in the midst of that which is most dead and melancholy.

Addison had also mentioned that Kensington Gardens were

at first nothing but a Gravel Pit. It must have taken a fine Genius for Gardening, that should have thought of forming such an ungainly Hollow into so beautiful an Area.

The coincidence of Lady Beaumont's proposing a former gravel quarry as the site of her winter garden with its hollow, rough, and uneven ground piqued everyone's interest. The Wordsworths may have already discussed this coincidence as well as some of its possibilities, for Dorothy wrote enthusiastically to Lady Beaumont on November 14 about "the hillocks and slopes and the hollow shape of the whole." She added that while the new wall at the north end was very handsome, she hoped her friend would not wall the entire garden around: "The natural shelving earthy fence which it has at present might be made perfectly beautiful."

Probably on November 15, after Dorothy had sent off her letter, William received an invitation from Lady Beaumont to design and build the winter garden for her. The invitation seems to have fired Wordsworth's gardening imagination. He immediately set about to plan the garden, for, on November 16, Dorothy was already reporting to their friend:

My brother . . . has frequently paced over and studied the winter garden and laid some plans, but I will not anticipate what he has to say as he intends writing to you himself.

It was a month before Wordsworth felt himself ready to write to Lady Beaumont with his recommendations. During this time, all three Wordsworths—William, Dorothy, and

Mary—had explored the site repeatedly and had talked it over. Dorothy reported to Lady Beaumont on December 22, 1806, that "his poetical labours have been at a stand for more than a week," and that her brother was just now writing to Lady Beaumont about the winter garden. Wordsworth's aversion to penmanship is well known, but for the winter garden he overcame it to write the "longest letter I ever wrote in my life." (It would remain so.)

The Design

From Dorothy's comments, Wordsworth's letter to Lady Beaumont, and a visit to the place, we can put together a description of the site before work began. It lay (and lies) approximately a hundred yards or so down the crest of the hill occupied by Beaumont House. It was irregularly shaped, but roughly rectangular, longer north to south than east to west, and about an acre in size. At the end toward the house, the new stone wall, approximately 12 feet high, held back the hillside. The lengthwise center may have been deeper then, with mounds of weed-grown rock and dirt thrown up on either side, but roughly parallel to the center. Between the wall and the house stood a cottage, which was later removed, and a wych elm (*Ulmus glabra*). On the eastern edge of the garden area stood two cottages, one of which was apparently in poor condition. On the west side were the remains of the old quarry.

In this pitted, desolate area the Wordsworths saw potential beauty. Planning the winter garden around a central feeling, which echoes Addison in the *Spectator,* Wordsworth wrote in his December 23, 1806 letter to Lady Beaumont, that it should be

The Winter Garden

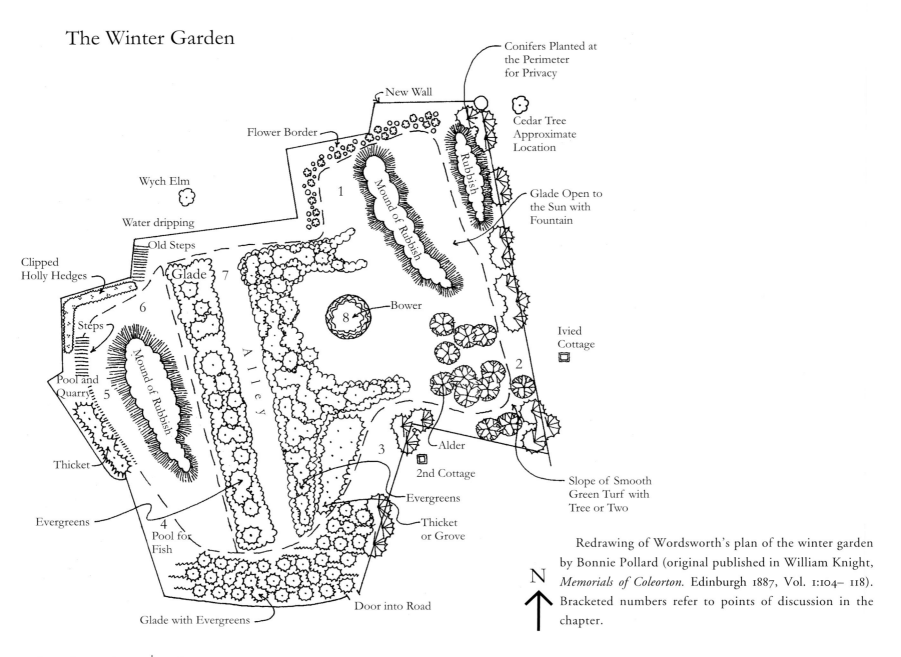

Conifers Planted at the Perimeter for Privacy

New Wall

Flower Border

Cedar Tree Approximate Location

Rubbish

Wych Elm

1

Mound of Rubbish

Glade Open to the Sun with Fountain

Water dripping

Old Steps

Clipped Holly Hedges

Glade 7

6

Bower

8

Ivied Cottage

Steps

Alley

2

Pool and Quarry

Mound of Rubbish

5

Thicket

Alder

3

Evergreens

2nd Cottage

Slope of Smooth Green Turf with Tree or Two

Evergreens

4

Pool for Fish

Thicket or Grove

Glade with Evergreens

Door into Road

N

Redrawing of Wordsworth's plan of the winter garden by Bonnie Pollard (original published in William Knight, *Memorials of Coleorton.* Edinburgh 1887, Vol. 1:104– 118). Bracketed numbers refer to points of discussion in the chapter.

a spot which the winter cannot touch, which should present no image of chilliness, decay, or desolation, when the face of Nature everywhere else is cold, decayed, and desolate.

The sentiment of the place should be one of cheer and happiness, a promise of spring on a bleak day, when the wind is raw and spirits are downcast because skies have been grey too long.

In describing his ideas to Lady Beaumont, Wordsworth provided her with a detailed plan. (See p. 96. Originally reproduced in William Knight's *Memorials of Coleorton,* this rendering is modern). On the plan, numbers 1 through 8 indicate the location of the eight compartments. The perspective of Wordsworth's letter and of the accompanying plan is from the north end of the garden, as if one stood looking down on the site from the higher ground supported by the new wall. The letter describes the garden in a circular fashion, first moving clockwise around the perimeter, and then from compartment to compartment until he finishes at the bower planned for the center.

Wordsworth recommends encircling the entire garden with a double "fence" of evergreens. The outer fence would be "a row of firs, such as were likely to grow to the most majestic height." The firs would be the outer ring of defense from the cold winter wind. The inner fence would be "evergreen shrubs intermingled with cypress," understory plantings to the firs. In order not to present anything that would remind Lady Beaumont of the desolation of winter, he excluded

all deciduous trees, whatever variety and brilliancy of colour their foliage might give at certain seasons intermingled with the evergreens, because I think a sufficiency of the same effect may be produced by other means, which would jar less with what should never be out of mind, the sentiment of the place.

A leafless tree, no matter how brilliant its fall foliage, would not contribute to providing a vision of spring in the depths of winter.

The three cottages on the perimeter of the garden presented a problem. To Dorothy's dismay, the Beaumonts decided to remove the cottage that lay between the new house and the garden (where the words *Wych Elm* appear on the plan's upper left). Dorothy wrote on November 14, 1806:

how very pretty that wych elm cottage might be made, but go it must, that I see, being so very near your house, yet I must and will mourn for it.

Wordsworth advocated retaining the two cottages (ivied cottage and 2nd cottage on the right of the plan) on the eastern border. The Beaumonts, he realized, would enjoy the picturesque qualities of the cottages. Besides, it was the eighteenth-century fashion in garden design to incorporate such structures as ruined or entire classical temples, hermits' huts, follies, and grottoes.

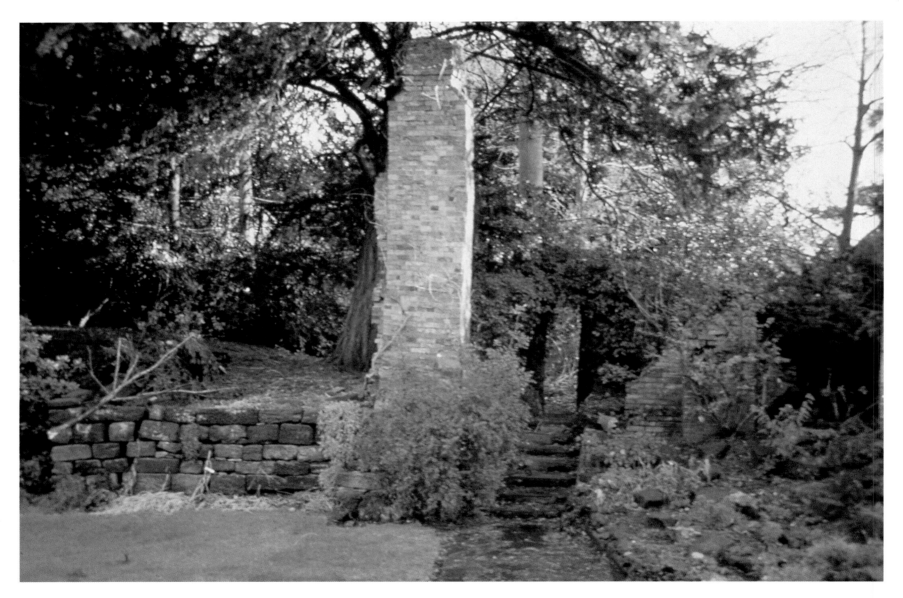

This tall chimney probably remains from the "second cottage," the shabbier of the two indicated on the right of the Winter Garden plan, p. 96.

Picturesque garden fashion took up the practice by incorporating more domestic ruins. (If the owner was not blessed with a ruin already, he often had one—or several—built.)

The Wordsworths also had sympathy for those less fortunate who lived in such little houses, as they themselves did. By appealing to the Beaumonts' fondness for the picturesque, Wordsworth succeeded in saving the cottages for the inhabitants. He incorporated them into the garden in such a way as to give Lady Beaumont privacy and to contribute to its central feeling. First, he suggests not allowing windows to overlook the garden. Second, he assures her that the double evergreen fence would both insure her privacy and

> leave visible such parts of the cottages as would have the best effect (I mean the beautiful one with ivy, and the other, which is of a very picturesque form but very shabby surface).

He recommends leaving the shabby second cottage, because of "its tall chimney in particular." The effect he has in mind makes

> a beautiful picture . . . of what it would be as a supporter to a grove of ivy, anywhere beautiful, but particularly so in a winter garden.

The cottages remained, and their warm red brick walls overhung with *Hedera helix* after some time brightened a grey winter day. Both are now gone, but the tall chimney and parts of ivy-covered walls of the second cottage remain for us to see the effect Wordsworth had in mind (see opposite). He repeats the color theme of red and green in suggestions for planting hollies (*Ilex aquifolium*) and *Pyracantha,* with their evergreen leaves and red berries. He also recommends planting any other plants that "bear scarlet berries or are rich and luxuriant in their leaves and manner of growing."

Wordsworth envisioned something he would never see, the well-grown outer perimeter of the garden. He imagined it would scale down from the tallest trees, the Scotch pines, in the background. But he would not live long enough to see the dramatic effect this planting would have on a winter day (see p. 100).

Having defined the outer perimeter of the garden, Wordsworth turns to the inside. Assuming that Lady Beaumont will enter the garden from the north end, nearest the house, he controls the order in which she enters each of the compartments by means of a path, indicated by a dotted line on the plan, that circles around the entire garden and provides the physical link between the compartments. In this way, he carefully orchestrates the progression of images that he wants her to encounter as if she were reading a poem instead of walking about a garden haphazardly.

Midafternoon on New Year's Eve, the failing light of the northern climate adds drama to the outer perimeter of the former winter garden.

Fountain in Racedown Lodge garden. The date 1795 indicates that it was there when the Wordsworths occupied the house. Its pleasant sound may have encouraged his taste for moving water, and fountains.

In the first compartment [1], Wordsworth planned a winter flower border that would provide a succession of bloom from summer to summer and deny winter with the cheerful and colorful blossoms of short-day plants. It begins by carrying over summer blooms from Traveler's joy (*Clematis vitalba*), which blooms July through September, into the winter blooming season beginning in late September and October with Michaelmas-daisy (*Aster novi-belgii*), china asters (*Aster chinensis,* now *Callistephus*), and Christmas rose (*Helleborus niger*) in December. In addition to the flowers of September through December, Wordsworth planned early flowering anemones (*Hepatica nobilis*), hyacinths (*Muscari botryoides*), and two types of primroses which reliably bloom in February—polyanthuses (*Primula × variabilis*) and auriculas (*P. auricula*). Mezereon (*Daphne mezereum*), a woody shrub that slightly resembles Japanese quince, blooms any time from February through May, and the white lilies (*Lilium candidum*) in May and June would complete the bloom cycle from one summer to the next.

Where the flower border was too narrow for all these bigger, spreading plants, he planned rows, in order of bloom, of smaller snowdrops, crocuses, daffodils, and white lilies. Nothing is more redolent of spring than the rich scent of flowers, and Wordsworth allowed for that, too. In addition to being colorful, some of these plants, such as the jonquils (*Narcissus jonquilla*) and white daffodils (*Narcissus poeticus*) are very fragrant.

Also evocative of spring is moving water, which provides an illusion of warmer seasons, pleasant sound, and visual variety. Visual variety comes from its contrast with stone and its refracted colors, as well as from what can be seen in it. In spring, when ice melts and breaks away, the streams fill the air with a happy rush and gurgle. To defeat the silence of winter, Wordsworth planned four water features, one in each compartment to capture that sound. The water feature in the first compartment is a fountain to be located near the flower border. Fountains were not fashionable in garden design in 1806. Landscape designers working in both the Brownian and picturesque styles considered them unnatural. But Wordsworth, confessing to Lady Beaumont that he was "old-fashioned enough to like even jets d'eau" (such as he enjoyed at Racedown), explained his reasons:

They certainly make a great show out of a little substance, and the diamond drops of light which they scatter round them, and the halos and rainbows which the misty vapour shows in sunshine, and the dewy freshness which it spreads through the air, are all great recommendations of them to me.

Further, the fountain would not only contribute to the general effect of overcoming winter, it would harmonize with the flowers and contrast with the evergreens around it. Wordsworth

The brick and ivy remnants in this picture may well be from the Ivied Cottage. If neither this nor the chimney on page 98 are remains of the original structures, they do show exactly what Wordsworth had in mind with the delightful contrast of red brick and green ivy.

had in mind a relatively small, simple thing, just large enough to throw out a single stream of water, and made of stone to be in keeping with the wall. Seen in the sunlight (of winter or summer), colors refracted from its sparkling drops would harmonize with the colors of the flowers and

form a lively contrast to the sober colours of the evergreens, while the murmur in a district where the sound of water is nowhere else heard, could not but be soothing and delightful.

In the first compartment, then, the primary images are moving water and the sight and scent of cheerfully blooming flowers. Wordsworth writes that this compartment is to be

characterized by ornament of architecture as in the wall, by showiness and splendour of colour in the flowers, and in the choice of shrubs.

Today, this corner is occupied by a fish pond.

Shrubs played three design roles in this garden. First, they acted as understory barriers in the "fence." Second, they separated the compartments, and third, their simplicity contrasted with the colorful flower border and the variety of shrubs in the second compartment. Wordsworth mentions laurustinus as par-

ticularly serving that purpose in his letter of February 1807. The main images in the second and third compartments are the brick cottages with ivy growing about them. In keeping with the ivied cottage near the second compartment (see [2] on the garden plan, p. 96), the shrubs and flowers would imitate the English cottage garden. Wordsworth intends this compartment to

contrast to the preceding one, to present the most delightful assemblage of English winter shrubs and flowers, mingled with some foreign shrubs, as are so common in English cottage gardens as to be almost naturalised.

The true cottage garden (not its fashionable twentieth-century imitations) is characterized by abundance and a haphazard planting style. In this compartment, Wordsworth would defeat winter by the sheer number of plants vigorously growing there, and incorporate the cottage into the garden by using the cottage garden idea as a transition between the cottage and the rest of the garden. Both the second and third compartments had brick and ivy, red and green. He seems to have intended the third compartment [3] primarily as an echo to the second, for the letter rather skips over it to concentrate on the fourth compartment.

In this compartment [4], Wordsworth planned a fish pond with only two goldfish, which he called "the 'genii' of the place." He is precise about the effect he has in mind:

The enclosure of evergreen, the sky above, the green grass floor, and the two mute inhabitants, the only images it should present, unless here and there a solitary wild-flower.

Wordsworth planned for Lady Beaumont to see not only life in the water, but also the greatest of all symbols of conquered death. The path would wind along to the fifth compartment [5], with the eventual quarry pool, so that she could see reflected:

the rocks with their hanging plants, the evergreens upon the top, and, shooting deeper than all, the naked spire of the church.

Yet the man who ice-skated well into old age enjoyed winter for itself, and although he wanted running water to give the illusion of a warmer season, in the event of a freezing winter, water plants encased in ice, he writes, "form one of the most enchanting appearances of winter."

Water in the garden had another function, too. It attracted birds. By installing water features and planting holly and pyracantha, along with other plants that bear fruit in the winter, Wordsworth ensured that the garden would be "enlivened by birds." The return of birds is one of the surest signs of spring, yet many species winter over instead of flying south. By encouraging birds in the winter garden, Wordsworth ensured that they would

provide another sign of spring, and of the ruling metaphor— life in the midst of death.

The sixth compartment [6] is a transition between the image of the church spire and the alley where Lady Beaumont would be free to walk up and down and contemplate the images she had just enjoyed. The alley [7] was planned for the middle of the garden, between rows of laurels (*Prunus laurocerasus*). With their big shiny leaves and dense habit, the laurels would sparkle in the winter sunshine and provide shade in summer, or on the occasional hot days of spring. The alley connected the path at either end, but Wordsworth does not suggest that Lady Beaumont enter it from the south; he wants her to see the church spire before she enters the alley. To encourage a spirit of quiet meditation, he intends this alley, as it became mossy, to provide a view of greens only, "soothing and not stirring the mind, or tempting it out of itself." There Lady Beaumont could allow herself to feel the emotional effects of what she has seen and heard, and be led by nature to understanding. Now in this alley, the "eye would be made quiet," and her "affections could gently lead [her] on." Then would she have the opportunity to "see into the life of things."

Off to the left of the alley would be a small bower [8]. Its purpose was to provide a sheltered resting place after walking around the garden. It was to be paved with white pebbles to contrast in a lively fashion

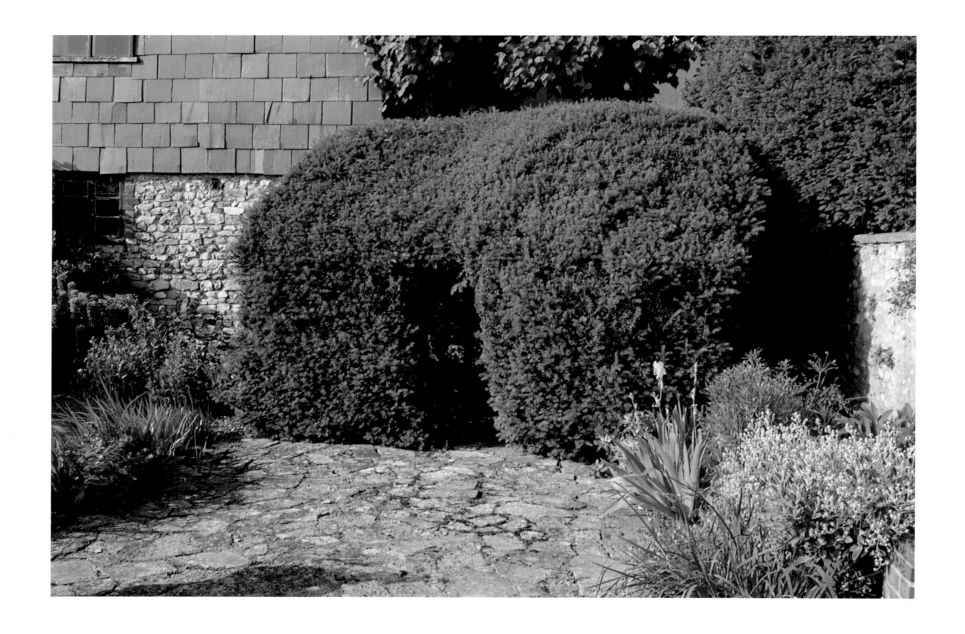

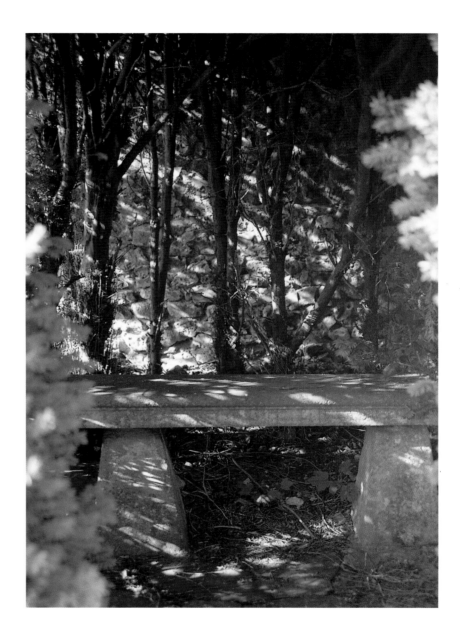

◄ The exterior of the yew arbor at Racedown Lodge. This is one of two such arbors there. Though this particular arbor might not have been there when the Wordsworths lived at Racedown, such garden features were popular at the time, and Wordsworth may have had this or a similar structure in mind when he planned the yew arbor in the Winter Garden.

► The interior of the yew arbor at Racedown Lodge. It was not unusual to provide a seat where a person could sit and wait out a sudden shower. Properly pruned, the thickly growing leaves would keep the interior quite dry and protect the visitor.

with the evergreen walls and ceiling of this apartment. All around should be a mossed seat, and a small stone table in the midst.

Wordsworth confesses that he is at a loss as to how this bower should be planted. He prefers hollies, which he adds would be "clipped in the inside so that the prickles would be no annoyance." Unfortunately, hollies "grow so slowly."

We can see what he had in mind from the yew arbors at Racedown (see pp. 106–107). While their age cannot be determined, they are in keeping with the eighteenth-century character of the house. An adult must stoop slightly to enter them, but once inside, there is a stone bench for sitting, and on a sunny day, the dappled shade is lovely. Although they offer little shelter from rain, there is room inside to raise an umbrella, should a person want to.

The images of the garden lead the observer from the hope of spring in the midst of winter to the larger image of hope of life in the midst of death, and follow that with a place to walk in calm thought and meditate on the meaning of what one has seen. But as Wordsworth was making the garden, he was composing poetry as well. This sonnet tells Lady Beaumont what was happening in his mind as he worked on the garden in January and February 1807:

To the _____

Lady: the songs of Spring were in the grove
While I was shaping beds for winter flowers;
While I was planting green unfading bowers,
And shrubs—to hang upon the warm alcove,
And sheltering wall; and still, as Fancy wove
The dream, to time and nature's blended powers
I gave this paradise for winter hours,
A labyrinth Lady! which your feet shall rove.
Yes! when the sun of life more feebly shines,
Becoming thoughts, I trust, of solemn gloom
Or of high gladness you shall hither bring;
And these perennial bowers and murmuring pines
Be gracious as the music and the bloom
And all the mighty ravishment of Spring.

(3:1–14)

The songs of spring Wordsworth heard during those cold months were the ones he wanted to recapture in the winter garden.

The Winter Garden Today

In 1808, Wordsworth and Sir George planted a cedar tree just outside the area encompassed by Wordsworth's plan, and Wordsworth wrote an inscription commemorating it. The tree was there as late as 1875, but is now gone, although the plaque with its inscription, the stone steps leading to it, and the monument that holds it remain. The lines read:

The embowering rose, the acacia, and the pine,
Will not unwillingly their place resign;
If but the Cedar thrive that near them stands,
Planted by Beaumont's and by Wordsworth's hands.

(4:1–4)

Wordsworth retained an interest in the winter garden all his life. After the Beaumonts died, changes wrought by the Beaumont heirs dismayed him.

An observer writing in 1875 in the *Journal of Horticulture and Cottage Gardener* describes it this way:

The "labyrinth" has gone, and the "winter flowers" are overgrown by the "green unfading bowers," save a few old spring herbaceous plants and bulbs which fringe the shrubby beds; but the "perennial Pines" are vigorous, almost majestic, and are living memorials of the poet's love and labours.

The Coleorton grounds were at that time under the care of Montgomery Henderson, who had become head gardener there in 1838, and was famous chiefly for growing grapes. Henderson's was a much different aesthetic than Wordsworth's, and while the gardens were considered very fine and beautiful, Wordsworth's concept of the winter garden had already been lost.

Now, after nearly two hundred years, only fragments exist. Most of the plantings, except perhaps some yews and Scotch pines and hollies, are gone. Yet it still carries Wordsworth's garden trademarks—changes in levels, rock steps to long pathways for walking, and winter colors (shades of green in laurel and holly leaves and conifer needles, in mosses and ivy; grey stone, red brick). A ruined brick structure twined with ivy is all that suggests the ivied cottage of Wordsworth's plan. A tall chimney, perhaps from the 2nd cottage, still stands.

The center of the garden is a level lawn, where shadows from the surrounding conifers play. Where Wordsworth had planned the flower border there is now a formal rose garden and terrace. Surprisingly, there is a fish pond, where large brightly colored fish swim in rather slow motion because of the cold, but they add to the garden's life and color. Just as Wordsworth had planned.

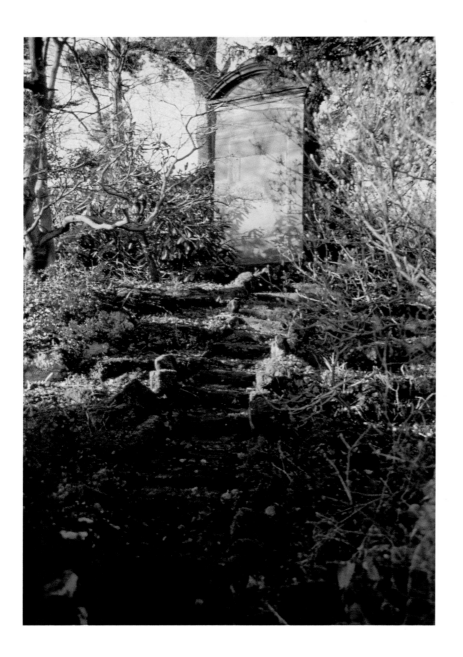

The engraved lines to the embowering rose are on a plaque in the monument at the top of these steps, which were probably built by Wordsworth with the help of the Beaumonts' gardener. See plan on page 96 for an approximate location.

The hollow Mary and Dorothy helped dig out of the rock is still there, as Wordsworth had hoped:

This little Niche, unconscious of decay,
Perchance may still survive.—And be it known
That it was scooped within the living stone,—
. . . by an industry that wrought in love,
With help from female hands. . . .
("In a Garden of the Same," 8–14)

Crumbling, it yet carries reminiscences of Sir Walter Scott, another friend of the Wordsworths and the Beaumonts. Sitting here, he is said to have planned the battle scenes in *Ivanhoe*. A dry fountain stands where Wordsworth had planned a fish pond for the fourth compartment. The pedestal made famous by a picture John Constable painted reminds us that Beaumont consecrated the garden to the memory of Sir Joshua Reynolds. And next to the modern house, which is built across the southern end of the garden, is an old stone entrance that may be part of the original garden. It is in a different corner from that indicated on Wordsworth's original plan, but gardens do not always turn out exactly as planned.

On the last day of the year, blowing on his fingers, the photographer sets up his camera and says, "He was here. You can feel it." So you can. Despite change, despite death, despite time, this garden yet has the stamp of a Wordsworth garden, a distinctive feeling:

. . . These walks and bowers
Were framed to cheer dark winter's lonely hours.
("In a Garden of the Same," 15–16)[2]

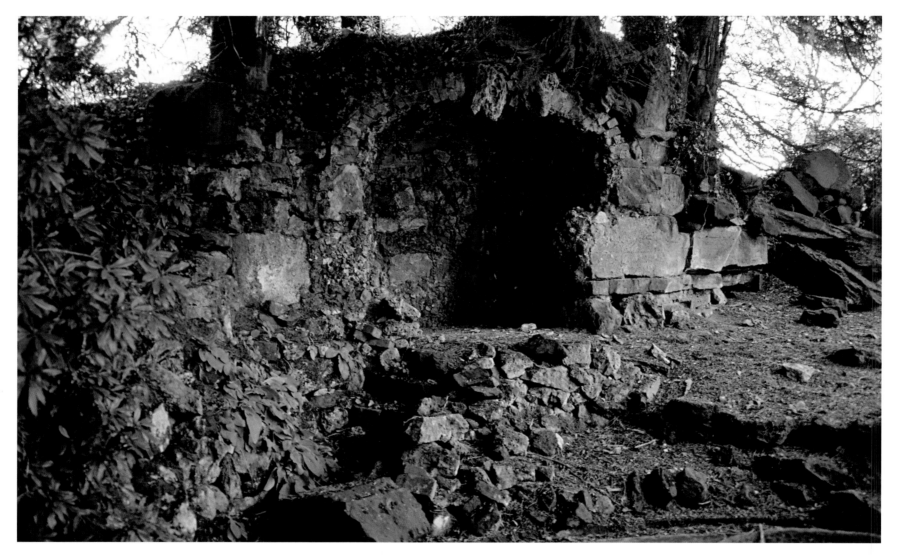

Scott's seat. This is the alcove Mary and Dorothy Wordsworth hollowed out of the rock and lined as a seat in the perimeter of the garden. While it is not on the plan, it was a happy inspiration, as more people than Sir Walter Scott must have thought.

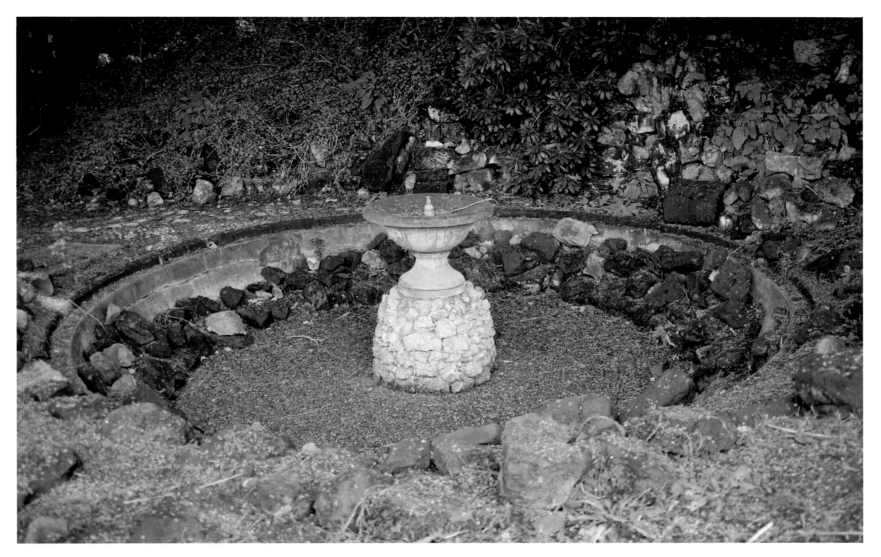

In this corner at the base of the steps up to the "embowering rose" monument, Wordsworth planned a fish pond. The little fountain in the circle of tumbled stones is all that remains of that idea.

This entrance to the garden may have been a later thought, or a more modern addition, but its age and appearance are in keeping with what Wordsworth envisioned for the winter garden.

Four

ROCK OF AGES:
THE RYDAL MOUNT GARDEN

Rydal Mount was the Wordsworths' home from the spring of 1813 until their deaths—William in April 1850, Dorothy in 1855, and Mary in 1859. The house and the village of Rydal lie some 60 miles south of Scotland, in an area that for centuries was the scene of raids and skirmishes between English and Scottish tribes. (When the young Wordsworth wanted a colorful and dramatic subject, he turned to this local history for his poem, *The Borderers*.) When an invasion from the north threatened, people lighted great bonfires as signal beacons in a chain from the Scottish border. Over time, the ashes from these fires formed huge

Rydal Mount in early spring before the honeysuckle has broken dormancy. Stretching before it is the present main lawn. To the left, the fern-leaf beech is just coming into leaf.

mounts (or mounds as they are called today) that became over-grown with vegetation and merged into the topography of the land. One of these gives Rydal Mount its name. The Mount, or Mound, to give it its modern spelling, lies 100 feet from the front door of the house.

In summer, wisteria and jasmine blankets the front entrance to Rydal Mount and part of the wall, much as in Wordsworth's day.

The Situation of the Property

To borrow a metaphor from Wordsworth's *Guide to the Lakes,* Rydal Mount is situated at the hub of a wheel. If we stand on the Mound and begin facing northward, we can see the steep slopes of Rydal Fell rising behind the house. To the east lie the ridges of Wansfell. Turning more to the south and slightly east, we can see the northern tip of Lake Windermere, which lies about 5 miles away. Directly southward, and clearly visible from both the Mound and the parlor windows, Loughrigg Fell looms up. At the bottom of the slope to the west lies Rydal Water, but to see it we must walk along the terraces, long pathways built as at Dove Cottage on rock walls incorporated into the fellside. Coming around the top of the wheel, to the west and north, almost directly behind the house, lies Nab Scar, another of the Lake District fells.

Before the lower road around the lakes was built, the northern boundary of the Rydal Mount property lay on the edge of the main traffic between Ambleside and Grasmere. (Refer to the garden plan, p. 131.) This ancient track, known as the Coffin Trail, was named for the funeral processions when the Grasmere church was the only church—and hence the only churchyard (graveyard)—in the area, before churches were built at Winder-mere and Ambleside during the Victorian era. Over this track, now a popular walking trail, the distance to Grasmere is less than 3 miles. In 1825, the traffic shifted to the bottom of the hill, along a new north–south road (the A591). This road takes people along the River Rothay, the shores of Rydal Water and Grasmere Lake, to Grasmere and over Dunmail Raise to Keswick.[1]

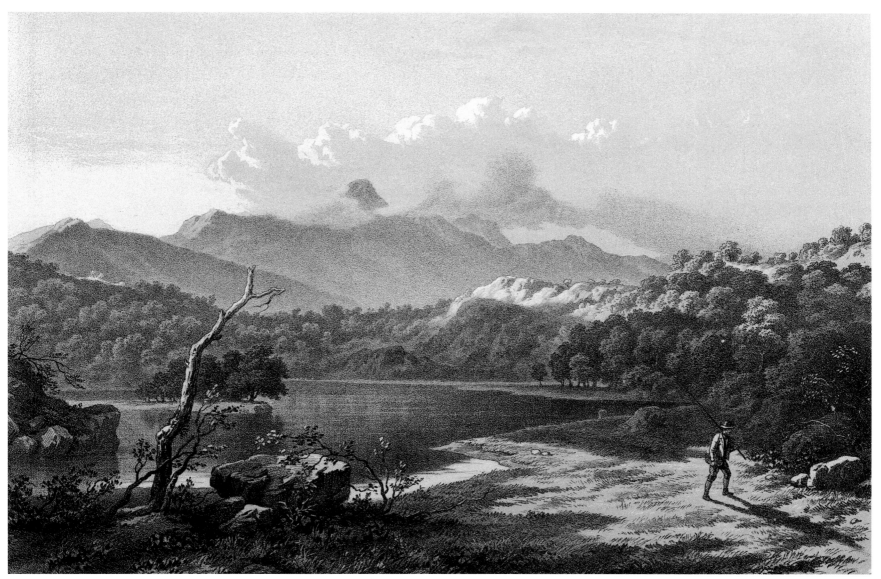

Engraving of Rydal Water by J. B. Pyne. Published June 1, 1859, by Day & Son, London.

The Traumatic Years

Wordsworth family tradition says that the Wordsworths were happy at Rydal Mount, despite the usual challenges of family life. Financial burdens were eased, and the house was the most comfortable they had lived in since Racedown Lodge and Alfoxden. The poet's fame and reputation grew, and they made so many new friends that they often had to house overflow guests in the old coaching inn at the bottom of the hill. But this happy sociable life was preceded by nearly a decade of misery and trauma.

Wordsworth's glorious, productive early years at Dove Cottage began to give way in 1805 with the death of their much loved brother John (and young Johnny's namesake). In the years that followed, one disaster after another assaulted the family.

Despite Wordsworth's best efforts, which resulted in some of the finest poetry in the English language, the family sank deeper into poverty as their dependents and obligations increased. Dorothy, particularly, and Mary, too, pressured William constantly to earn money. Hopeful of recouping the family finances, Wordsworth published his collected *Poems, in Two Volumes* in April 1807. The reviews were vicious. Francis Jeffries, the influential critic of the *Edinburgh Review*, did his best to destroy Wordsworth's career.

Bad reviews led to the humiliation of poor sales, and no money. Wordsworth appears to have fought hard against the fear that his literary career was at an end. If not for the support of his family and friends such as Sir George and Lady Beaumont, who believed in his genius, Wordsworth might have lost faith in himself. Instead he adopted the belief that he wrote for posterity, and not the current market. Adversity stiffened his resolve and his will to write.

Yet Wordsworth did make an attempt to write for the market. His great friend Sir Walter Scott was able to pay off his mountain of debt from bad investments by writing extremely popular works. So Wordsworth, mindful that dramatic works in verse about medieval times were (as we would say these days) best sellers, wrote a dramatic poem called *The White Doe of Rylstone*. Unfortunately, it was not a successful effort, and Wordsworth did not allow it to be published until 1815. Although he admired Scott for being able to write works that sold well, he could not write like Scott. He wrote like Wordsworth trying to write like Scott. His own literary voice was so strong that he could only write like himself. And fashionable critics, primarily Jeffries, catering to ephemeral current trends, led popular taste away from him.

Despite their own penury, the Wordsworths helped the Coleridge family as much as they were able, and never turned down any other appeal for assistance that they could give. When they moved temporarily to Coleorton in the winter of 1806–1807,

they took Coleridge with them in an unsuccessful attempt to help him cure his addictions to opium and brandy. When George and Sarah Green died on the snowy fells in March 1806, it was a shock to the whole neighborhood. The Wordsworths helped to arrange for the care of their eight young children, one of whom, Sally, they had already taken in service with them.[2]

Worst of all, in 1812 the Wordsworths lost two of their own children. Catherine, age four, died of convulsions in June, and Thomas, age six-and-a-half, died of measles in December.

When Thomas died, the Wordsworth extended family, including Mary's sister, Sara Hutchinson, was living in the Grasmere parsonage, a cold and very damp habitation. During rainy periods, it stood in a bog. Wordsworth was desperate to rescue Mary—and indeed his whole family—not only from depression and discomfort, but from poverty itself. He bent his pride enough to write to Lord Lonsdale, the most powerful man in the Lake District, and ask for help finding a job that would enable him to continue writing poetry.[3]

Upon investigation, Lord Lonsdale learned that the Wordsworths were truly desperate. He offered Wordsworth 100 pounds per year until a suitable position could be found. Because of this generosity, in the spring of 1813 the family was able to move to Rydal Mount, a roomy house situated under Nab Scar, just 2 miles from Dove Cottage. Although Wordsworth gratefully accepted the allowance for the sake of his family, he was happier when Lonsdale offered him the position of Distributor of Stamps, which enabled him to continue writing and at the same time earn a living. He wrote to his friend Francis Wrangham in August 1813:

My employment I find salutary to me, and of consequence in a pecuniary point of view, as my *Literary* employments bring me no emolument, nor promise any.

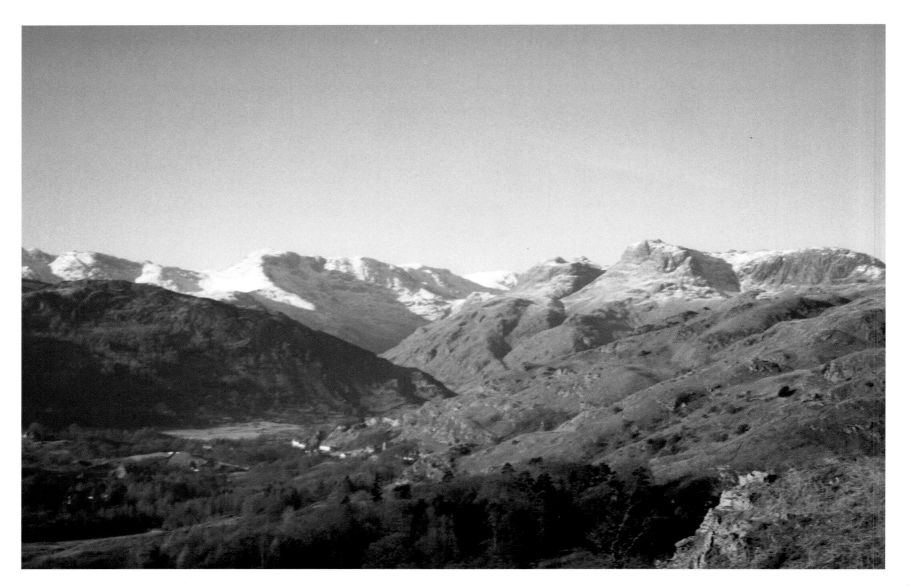

Winter in the Lake District. Although the fells do not top 3,000 feet, their steep and rocky crags make them treacherous for anyone who ventures out on them when the clouds settle low on their slopes and hide the safe routes. Even today, a small army of volunteers are prepared for mountain rescue at any time.

J. B. Pyne engraving of Lonsdale estate, 1859.

Poetry of the Rydal Mount Years

Ever since Matthew Arnold said that Wordsworth's greatest poetry was written between 1799 and 1808, scholars have debated the question of whether his later poetry is as good as his early works. Certainly, he continued to write very respectable and sometimes great poetry well into old age. (The *River Duddon* sonnets and *Yarrow Revisited* are examples.) Not only did Wordsworth experiment continually with new subjects and explore such verse forms as the sonnet, he continued to revise the *Prelude*, the "poem on my own life," until sometime in 1839.

Nonetheless, he ceased to write the poetry that has primarily made his reputation, as if the source of that inspiration were gone. Though his biographies document many possible explanations, it may be simply that life interfered with Wordsworth's creativity.

Besides working conscientiously at his job,[4] Wordsworth found family concerns occupying more of his attention. Having lost two children, he became a very involved, perhaps overprotective, parent of the other three, John, Dora, and William. Dorothy fell ill, and, though she survived her brother physically by five years, her mind gave way in 1835. Through the succeeding twenty years of her dementia, she was cared for at home with love and concern.[5]

Beginning in 1815 with the publication of *Poems,* a new edition with revisions and new poetry, William's reputation began to improve, as did his popularity. After years of being vilified and ridiculed in the press, he would not have been human if he had not taken time to enjoy it. The Wordsworths were sociable people and made new friends in their later years, so that they were always surrounded with people.

Wordsworth, Mary, and Dorothy were also inveterate travelers while their health lasted. There were visits to London, to Coleorton, a tour of the Hebrides, and a memorable tour to the Continent to revisit the Alps, the scene of so much imaginative importance, as Wordsworth described in the *Prelude.*

The new poetry of Rydal Mount differs from what Wordsworth wrote at Dove Cottage and during the traumatic years. He wrote much very fine poetry, but not so large an amount of great work. Departing more from the unrhymed blank verse characteristic of his greatest poetry and using a wider variety of different poetic forms and themes, Wordsworth continued to find inspiration in and respond to natural beauty. "Composed Upon an Evening of Extraordinary Splendor and Beauty," he noted, was "felt and in a great measure composed upon the little mount in front of our abode at Rydal."

Had this effulgence disappeared
With flying haste, I might have sent,

Mary Wordsworth, by Margaret Gillies, 1839. Courtesy of the Wordsworth family.

Among the speechless clouds, a look
Of blank astonishment;
But 'tis endued with power to stay,
And sanctify one closing day,
That frail Mortality may see—
What is? —ah no, but what 'can' be!
Time was when field and watery cove
With modulated echoes rang,
While choirs of fervent Angels sang
Their vespers in the grove;
Or, crowning, star-like, each some sovereign height,
Warbled, for heaven above and earth below,
Strains suitable to both. —Such holy rite,
Methinks, if audibly repeated now
From hill or valley, could not move
Sublimer transport, purer love,
Than doth this silent spectacle—the gleam—
The shadow—and the peace supreme!

 (4: 1–20)

This poem shows how Wordsworth's love of the outdoors bubbles up as before in poetry, but a major shift in his spirituality would not only produce the Ecclesiastical Sonnets but give his response to nature a spiritual cast and have a distinct effect on the garden.

Spiritual Shift

Poets of the younger romantic generation decried Wordsworth's loss of revolutionary zeal, and the political conservatism of his later years. Increasingly, he has been seen as the prototypical young radical who became conservative in his old age.

Wordsworth did become more conservative as he grew older, but there were at least three compelling reasons for this change. First, England was as much under attack during the Napoleonic Wars as it was in World War II and did not defeat Napoleon until the battle of Waterloo in 1815. During such a major conflict, a nation generally puts its differences aside to meet the common danger.

Second, his successful request for Lord Lonsdale's assistance, combined with his friendship with Sir George Beaumont, changed his opinion of the aristocracy for the better.

Third, under the crush of events, both personal and political, Wordsworth's spirituality shifted its center from nature to Christianity, and he gave it expression as a member of the Church of England. Bound by faith to the publicly supported church of state, and sharing in the national fear of Napoleon, Wordsworth came to support the government.

He came to support the Church as part of the spiritual shift from faith in nature to faith in Christ. His faith in nature—"Nature never did betray the heart that loved her"—proved inadequate to sustain and comfort him during the traumatic years. The comfort he could not find in nature when he grieved for his children he found in Christianity. Between the 1805 and 1850 versions of the *Prelude,* one can see how his spiritual point of view changed, but his poetry shows how his heart had moved away from faith in nature between 1805, when his brother John was drowned at sea, and 1813, when his daughter, Catherine, died.

After John's death, he wrote, "Elegiac verses in memory of my brother John W.," which affirms his faith in nature:

V

That was indeed a parting! oh,
Glad am I, glad that it is past;
For there were some on whom it cast
Unutterable woe.
But they as well as I have gains; —
From many a humble source, to pains
Like these, there comes a mild release;
Even here I feel it, even this Plant
Is in its beauty ministrant
To comfort and to peace.

(4:41–50)

By 1807, however, his heart had apparently moved toward Christianity, as he wrote in the conclusion to a poem titled "The Force of Prayer":

Oh! there is never sorrow of heart
That shall lack a timely end,
If but to God we turn, and ask
Of Him to be our friend!

(4:65–68)

After Catherine's death he wrote "Maternal Grief":

For such, by pitying Angels and by Spirits
Transferred to regions upon which the clouds
Of our weak nature rest not, must be deemed
Those willing tears, and unforbidden sighs,
And all those tokens of a cherished sorrow,
Which, soothed and sweetened by the grace of Heaven
As now it is, seems to her own fond heart,
Immortal as the love that gave it being.

(4:74–81)

In these three poems, we can see how the center of his spirituality in a flower's beauty as "ministrant/To comfort and to peace" has given way to the comfort of "God as a friend" and "the grace of Heaven." He also became a regular church-goer—"for the sake

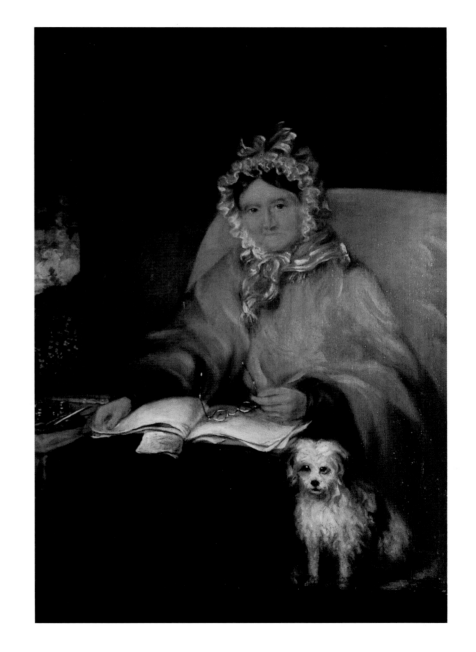

Dorothy Wordsworth, by S. Crosthwaite, 1833. Unfortunately, no portraits exist of Dorothy as a young woman. Courtesy of the Wordsworth family.

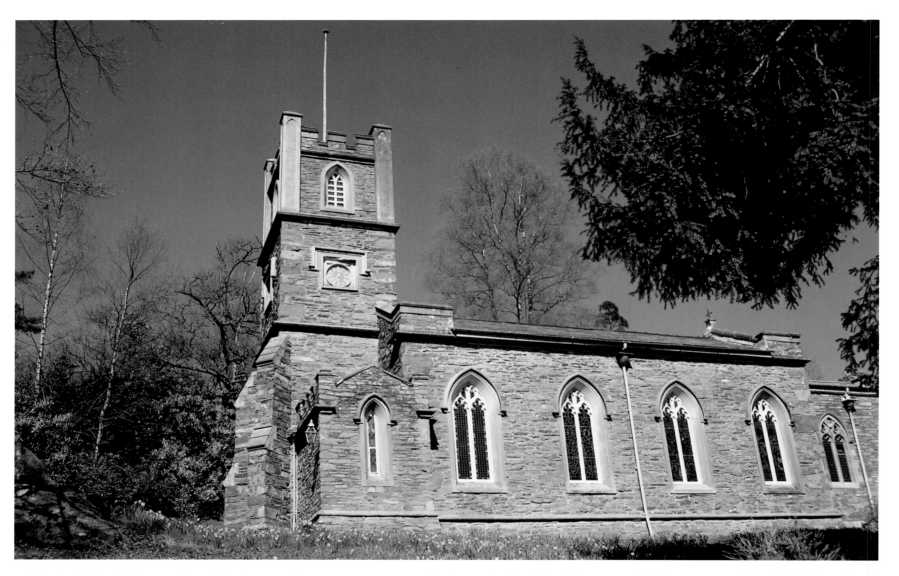

The Rydal church that Wordsworth built—or at least was very instrumental in having built. Although he reportedly did not care much for the building when it was completed, he continued to attend regularly.

of the children," Dorothy said—but he continued until his death. So firm were his Christian convictions that he collected funds, was involved in the plans, and donated land in Dora's Field for the Rydal church.

Throughout the years, Wordsworth continued to write poems in and about the garden as he had done at Dove Cottage and at Coleorton. But it was at Rydal Mount that he carved his faith—literally—into the garden's stone.

The Symbolism of Stone

Rock was symbolic to Wordsworth. At least from the time the young poet and his friends carved their initials into stone, the famous Rock of Names, he had associated rock with immortality. Human life is fleeting, and memory fades rapidly, but stone endures, as Wordsworth was well aware. At Sir George's request, he composed two short poems to be inscribed on plaques mounted on the Beaumonts' estate. Even in the poet's lifetime, Sir George's heirs were changing (destroying) the garden, but the monuments remain yet.[6]

Epitaphs, encapsulating a life and carved in stone, express Wordsworth's awareness that life on earth is short, compared to eternity. Stone, in his view, was a metaphor for eternity because it is the most enduring natural thing on the planet, and an epitaph preserves a person's reputation, for good or ill, long after death—almost to eternity. In 1835, after the death of his good friend Charles Lamb, he composed these lines:

To a good Man of most dear memory
This Stone is sacred

(4:1–2)

And, in 1836, Wordsworth wrote this epitaph for Thomas, who had died nearly a quarter of a century before:

Six months to six years added he remained
Upon this sinful earth, by sin unstained:
O blessèd Lord! whose mercy then removed
A Child whom every eye that looked on loved;
Support us, teach us calmly to resign
What we possessed, and now is wholly thine!
(4:1–6)

Wordsworth, being a poet aware of his mortality and of the ephemeral nature of all earthly things, built the garden at Rydal Mount with eternity in mind. Just as his poems connect to each other thematically, his gardens connect through their stonework. At Rydal Mount, as at Dove Cottage, rocks support the terraces, form pools and waterfalls, and bear inscriptions that Wordsworth intended to endure as long as stone.

Dora's Rock

At Rydal Mount, however, the symbolism of rock takes on an extra dimension because of the shift in his spirituality. In the Winter Garden, Wordsworth had expressed his feeling that people are never far from the awareness of death in the midst of life. But after he turned to a more explicit Christianity, the symbolism of rock became connected with faith, especially as he aged, and time took away more of his friends and family. In 1835, the family experienced two catastrophes. During that year Mary's beloved sister, Sara Hutchinson, died, and Dorothy's illness led to senile dementia. The sparkling and energetic Dorothy became, as Wordsworth said, "my dear Ruin of a sister."[7]

Faced with ever-present reminders of how transitory life's joys can be, in 1838 the poet had an inscription carved into a boulder in Dora's Field,[8] which Wordsworth connected to the garden by means of a terrace pathway. (See [12] on the garden plan, p. 131.) Aware that once he was gone, the garden would be open to change by the next tenants (as indeed it was), Wordsworth had the inscription carved into property that he owned, where it remains to this day. In this verse, as well as in the medium—the boulder itself—he connected rock with the Christian faith, carving as it were his declaration of faith into the very bones

The Garden at Rydal Mount

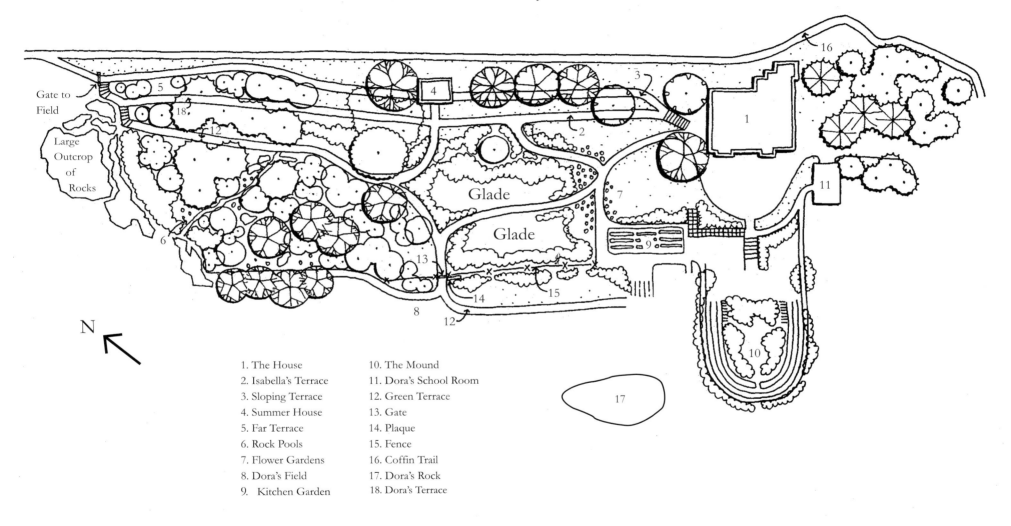

Gate to
Field

Large
Outcrop
of
Rocks

Glade

Glade

N

1. The House
2. Isabella's Terrace
3. Sloping Terrace
4. Summer House
5. Far Terrace
6. Rock Pools
7. Flower Gardens
8. Dora's Field
9. Kitchen Garden

10. The Mound
11. Dora's School Room
12. Green Terrace
13. Gate
14. Plaque
15. Fence
16. Coffin Trail
17. Dora's Rock
18. Dora's Terrace

Plan of the garden as it might have been in Wordsworth's day. Between the Green Terrace [12] and the chain of rock pools, which are still there, subsequent owners of the property cut deeply into the fellside to install a level croquet lawn.

The inscription on Dora's Rock.

of the planet. The boulder, known as Dora's Rock, bears these four simple lines ("Inscription in a Rock at Rydal Mount"):

Wouldst thou be gathered to Christ's chosen flock,
Shun the broad way too easily explored,
And let thy path be hewn out of the Rock,
The living Rock of God's eternal Word.

(4:1–4)

The approach to Dora's Rock, with stone steps laid by Wordsworth, or under his direction, is a short but difficult and twisting climb, the very "path hewn out of Rock" that the inscription describes. (Dora's Field is now owned by the National Trust.)

The Healing Garden

When the Wordsworths arrived at Rydal Mount, they had been severely battered by circumstances. We can imagine their relief at finally having a comfortable house to live in and some economic stability. They were still, of course, grieving over the loss of the children, but slowly they began to heal. The garden was a large part of what we might call their therapy.

In the family's letters, the many references to walking on the terraces, and to working in and enjoying the garden, show how central the garden was to family life. As Dorothy wrote to her friend Catherine Clarkson in 1820, "We are all gardeners." Mary often sent her friends and absent family news of the garden. Her letters refer to shrubs planted by little Johnny, to herself "tying up plumbs," to her husband having gone out with the children to burn leaves on the terrace, to John raking the cut grass with James. She enjoyed the roses because they were "so affectingly beautiful," and remarked one year that their kitchen garden was uncommonly successful because they had peas "seven weeks running." They were even able to grow apples and potatoes for less than they could buy them in the market: "two and a half bushels for two pence."

In the letters, one can see, little by little, the pain of the traumatic years easing, although the family never ceased to miss Catherine and Thomas. As the Wordsworths built the garden, they remade their lives, with an effect that gardeners have known since people began to keep gardens: gardening heals people.

Building the Garden

As the plan on page 131 shows, the house stands on a level place at the top of the Rydal Mount property. From the Coffin Trail, the fellside slopes downward until at the western rim, about where the [6] is on the garden plan, the ground drops steeply away among boulders.

Most gardens are a work in progress. To a gardener's delight, there is always something more to do, with new plants to put in, or the results of last season's work to anticipate. The phrase "something evermore about to be" might well have been written about a garden. Wordsworth never ceased working on the garden, whether building or improving the terraces, or acquiring new plants.

On this larger property, landscape gardening seems to have become more important than ever to Wordsworth. He had always believed that it was one of the callings for which he was most suited. For the first time, at Rydal Mount, Wordsworth had scope for his landscape design efforts, every gardener's dream—a large garden of his own and enough time and money to work on it, or to hire others to carry out his plans.

Although Wordsworth drew no garden plan as he did for the garden at Coleorton, this garden is as well documented as the Dove Cottage garden. The documentation comes from several sources: the family's letters, Christopher Wordsworth's description, Wordsworth's statements in the *Guide to the Lakes,* his comments to Isabella Fenwick, and Dorothy's Rydal Mount journal.[9] In addition, there is the 1831 watercolor painted by William Westall in Dora Wordsworth's album. From the letters and Dorothy's journal, we can understand how the garden came together over time. After Wordsworth's death, his nephew Christopher Wordsworth, Jr. (whom the family called Chris) wrote his *Memorials of William Wordsworth* (published in 1851), in which he described the main parts of the garden as it looked then.

In old age, Wordsworth dictated notes to Isabella Fenwick, his great friend whom the family had met perhaps in 1828, on how many of his poems came to be, or the circumstances in which they were written. From these collected reminiscences, too, we understand how integral the garden remained to his life and work.

What the *Prelude* is to the canon of Wordsworth's poetry, this garden was to his theory and practice of gardening. In 1835, he published the fifth and definitive edition of his major work of prose, *A Guide through the District of the Lakes,* which had first appeared in 1809 as the introduction to Wilkinson's *Select Views of Cumberland, Westmoreland and Lancashire.* Not only a guidebook to a popular tourist attraction, it is his gardening manifesto.

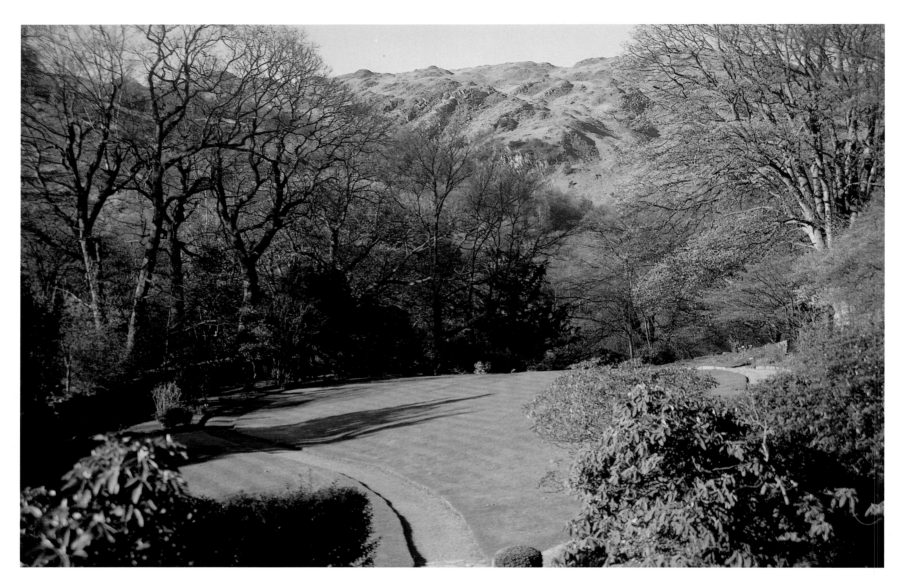

This view of the present main lawn from the house shows how the ground slopes away. The fell in the background is Loughrigg, across the river Rothay (spelled Rotha in Wordsworth's time). Because Wordsworth preferred lawns as open spaces among trees—*glades* he called them—this part of the garden on the plan (see p. 131) is shown as glades, which are smaller, with shrubberies, and perhaps trees, around them.

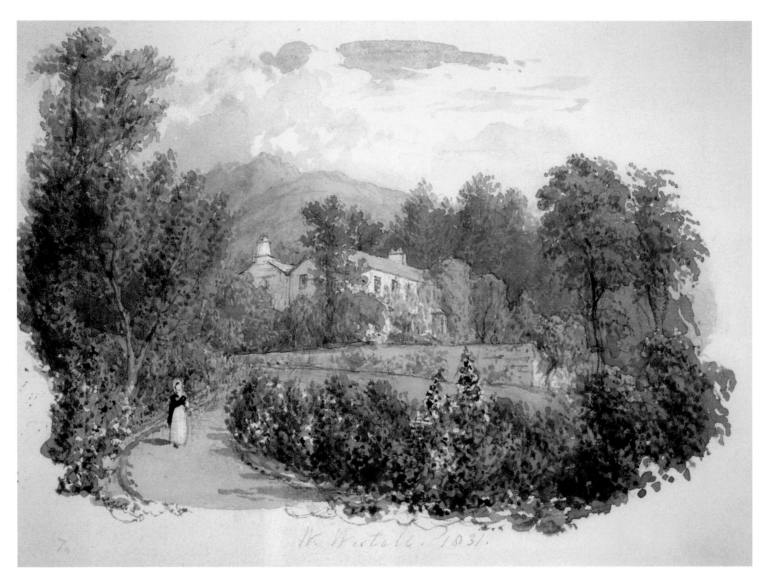

Rydal Mount, by William Westall, watercolor © Wordsworth Trust. Courtesy of Dove Cottage, The Wordsworth Trust.

Not merely a theorist, Wordsworth continued to be very much a hands-on gardener. Assisted by a succession of gardeners, among them first John Carter and later James Dixon,[10] the poet worked at building this garden for thirty-seven years, almost half of his long life. In the rockwork we can read the authentic Wordsworth "handwriting." The primary features are the terraces, built for his habits of composition; the chain of rock pools he put in with stones placed strategically to vary the sound of water; the stone steps, and inscriptions on stone.

The Terraces

There were four long, interconnected terraces that, as Dorothy wrote to her friend Sara Jane Jewsbury in March 1829, gave them "a very great length of walk with constant variety of slope and level, and prospect." The first three lie at the top of the garden slope, parallel to the Coffin Trail. The fourth began in Dora's Field, and ultimately may have connected the Farther Terrace with the church. (Refer to p. 131, the garden plan, throughout the succeeding discussion.)

Wordsworth probably began work on the first terrace, called the Sloping Terrace ([3] on the plan), as soon as the family moved in. It extends from the house some 250 feet, according to Chris Wordsworth. It rises fourteen steps from a level graveled area immediately outside the door of the former library (which gave William an easy escape from visitors or family when the poetic impulse overtook him; see p. 140). It ends at what Wordsworth called the summer house [4]. Now it is a small stone hut with a bench, open on both sides. In Wordsworth's day, it was lined with pine cones and had a latched door on the western side, from which a person could enter onto the Farther Terrace. Like the Moss Hut at Dove Cottage, it overlooks the garden, and is the

only point with a view of both Rydal Water and Lake Windermere. It also has a spectacular view of Loughrigg Fell, which appears so close a person might almost touch it.

The Farther (or Far) Terrace was probably the second terrace to be built. This terrace, with its beautiful views of Loughrigg Fell and Rydal Water, curves around the fellside and ends at the fence separating the neighbor's property from Rydal Mount. A gate, as in the Wordsworths' time, connects with pathways through the adjacent fields and woods to the Coffin Trail. (See the place on the far left of the garden plan marked Gate to Field. Although Wordsworth preferred to leave the garden open to the countryside, the fence kept neighboring farmers' sheep from munching on garden plants.) Wordsworth told Isabella Fenwick that he had "murmured out many thousands of verses" on the Far Terrace. Both the Sloping Terrace and the Farther Terrace were completed before 1825.[11]

The third terrace is the Level Terrace, also known as Isabella's Terrace, because, as Chris Wordsworth wrote, it was "constructed by the Poet for the sake of a friend," so that she could walk there without straining her weak heart. The friend was Isabella Fenwick, and the terrace was complete by 1830. This terrace was also a great comfort to Dorothy when her illness had so weakened her that she could no longer tramp about the fells, or even walk on the Sloping Terrace. In extreme old age, Wordsworth himself walked it without undue exertion. Of course, in his seventieth year he had climbed to the summit of Helvellyn, the third highest peak in the British Isles at 3118 feet.[12] The Sloping Terrace and Isabella's Terrace connect not only by the fourteen steps but also at the summer house, where another flight of stone steps leads from one to the other.

These terraces were not the only ones, however. In 1994, curator Peter Elkington was clearing Japanese knotweed and overgrown shrubberies that were choking the hillside below the Farther Terrace when he found a level pathway carved into the slope and supported by rockwork of the sort Wordsworth often used. (On the garden plan it appears between the Farther Terrace at [5] and [12], the extension of the Green Terrace.) He named this pathway Dora's Terrace in memory of the poet's daughter. The eastern end begins now at the steps leading upward to the summer house, and it parallels the line of Isabella's Terrace around the fellside to stop at a large outcropping of rock near the boundary of the property.

Yet another terrace, which extends from the gate between the Rydal Mount property and Dora's Field below the current boundary fence around the hillside, and upward nearly to the western end of Dora's Terrace. It may be that this terrace is what Wordsworth called the Green Terrace. On the garden plan the gate between Dora's Field and the Rydal Mount property appears at [13]; the Green Terrace is labeled [12]. There is some evidence in the Wordsworths' letters that the Green Terrace may have been

The fourteen steps that may have provided Wordsworth easy escape from the house appear at the right of this photograph. Behind the rock wall at the top of the picture lies the Coffin Trail. In the foreground is the stump of a sycamore that was still standing from the Wordsworths' day until it reached the end of its life cycle and had to be cut down.

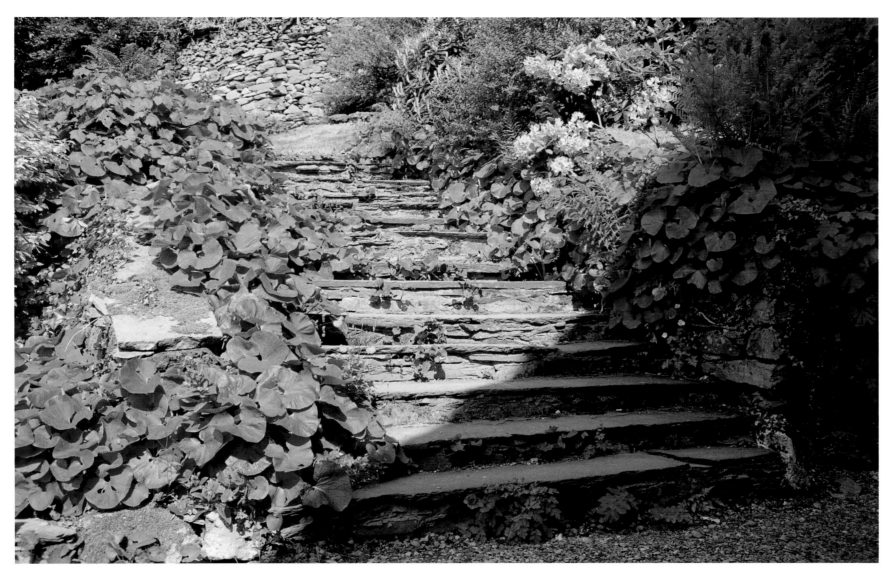

In this closeup view of the steps to the Sloping Terrace and Isabella's Terrace, plantings sweeping over and growing among the stones soften the hard stonework.

one long, curved, connecting pathway of which Dora's Terrace was once a part.

In March 1830, when Wordsworth began work on the terrace that he would turf over with grass, Dorothy wrote to a friend that her brother was:

> making another new terrace—at the head of his own little field—the same terrace that was to have been at the point of his house—and he is delighted with it. . . . There will be a little gate opening upon this new terrace from the Garden—

The gateway is still in the wall that separates the Rydal Mount garden from Dora's Field. On April 6, 1830, the day before his sixtieth birthday, Wordsworth was still working on this new terrace, which he mentions in a letter to a friend:

> I am draining sprungy ground, and in the field where this goes on, I am making a green Terrace, that commands a beautiful view over our two lakes Rydal and Windermere, and more than two miles of intervening vale with the stream visible by glimpses, flowing through it.

The Green Terrace was complete by June 1830. In the autumn of that year Wordsworth wrote to John Kenyon:

> Under the shade of some Pollard Oaks, and on a green Terrace in that field, we have lived no small part of the long bright days of the summer gone by.

The Green Terrace began in Dora's Field, near the gate, and curved around the hillside upward to connect with the other Farther Terrace by means of steps. On it, a person could climb a few steps to the Farther Terrace or continue on to the steps leading to the summer house. From there, the way led across the fellside later excavated for the croquet lawn and downward to the gate into the field, or perhaps across to the house. Though its complete route is not yet known, it may have curved around the garden to the west. Elkington reports that Dora's Terrace had grass when he found it, so it may well be part of the Green Terrace. It is possible that extending the present main lawn and digging out the fellside to install the croquet lawn destroyed a great portion of this terrace.

Wordsworth foresaw what might happen to the terraces in these verses of the inscription written in 1825:

> The massy Ways, carried across these heights
> By Roman perseverance, are destroyed,
> Or hidden under ground, like sleeping worms.
> How venture then to hope that Time will spare

This humble Walk? Yet on the mountain's side
A POET'S hand first shaped it; and the steps
Of that same Bard—repeated to and fro
At morn, at noon, and under moonlight skies
Through the vicissitudes of many a year—
Forbade the weeds to creep o'er its grey line.
No longer, scattering to the heedless winds
The vocal raptures of fresh poesy,
Shall he frequent these precincts; locked no more
In earnest converse with belovèd Friends,
Here will he gather stores of ready bliss,
As from the beds and borders of a garden
Choice flowers are gathered! But, if Power may spring
Out of a farewell yearning—favoured more
Than kindred wishes mated suitably
With vain regrets—the Exile would consign
This Walk, his loved possession, to the care
Of those pure Minds that reverence the Muse.

 (4:1–22)

This poem is prophetic as far as the Green Terrace and Dora's Terrace are concerned. Though part of it lies under ground like a sleeping worm, the walk is in the care of people who respect and admire the gardens and the poetry of Wordsworth.

But as Wordsworth also knew, stonescaping outlasts human life, and in the "bones" of the garden we can see his authentic mark. Besides building the walls that support the terraces and separate the Coffin Trail from the Rydal Mount property, Wordsworth built terraced beds for plantings. The same stonework that upholds the Dove Cottage terrace appears at Rydal Mount. Stones are shaped little or not at all, in the manner farmers have used for centuries in constructing the stone walls that crisscross the fells.

The terraces became one of the family's more important centers of recreation when they were at home. They walked on them in fine weather to enjoy the views and talk to each other and to their many visiting friends and acquaintances. Mary wrote of her husband being "out on the terrace with the children to burn dead leaves." References to one or another of them pepper their letters and Dorothy's journal. On December 20, 1824, shortly after she began to keep her journal, Dorothy records that she walked on "the [Sloping] terrace" before the rain came on in the evening. In May 1825, she wrote in her journal that she had been walking on the western terrace (perhaps the Far Terrace) and enjoying the fine moonlight. After church on October 10, 1830, she stood on it looking down at Rydal Water. The lake was profoundly still, she writes, and a bull's bellow echoing from the "bowels of Nab Scar [was] exquisitely musical."

Even when she was too ill to walk out, her brother never ceased to bring her progress reports. After she could no longer walk at all, a member of the family would take her out in a wheeled cart. One of the men—Wordsworth, Willie, young

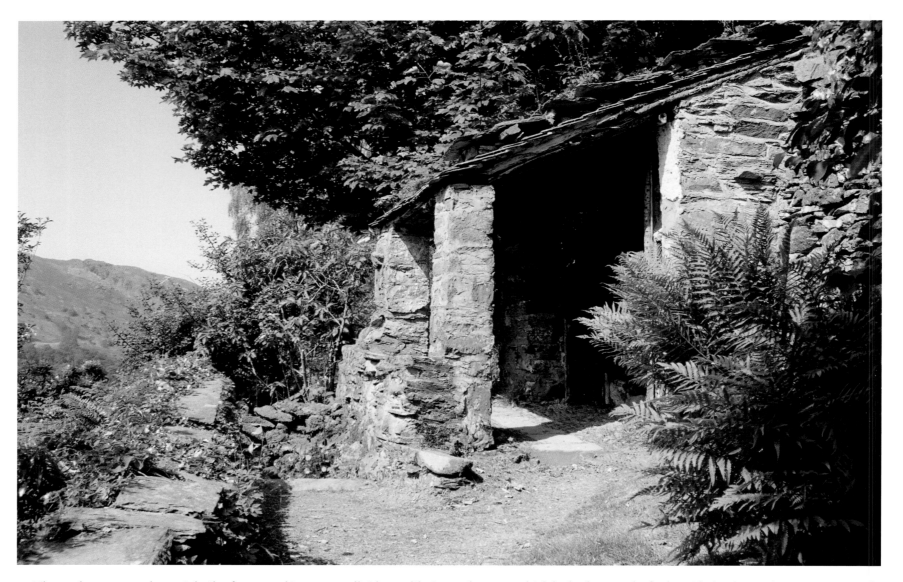

The modern summer house is built of stone and is open on all sides, unlike its predecessor, which had a door on the farther side (to the west). But it occupies the position of the original summer house, with the same commanding views.

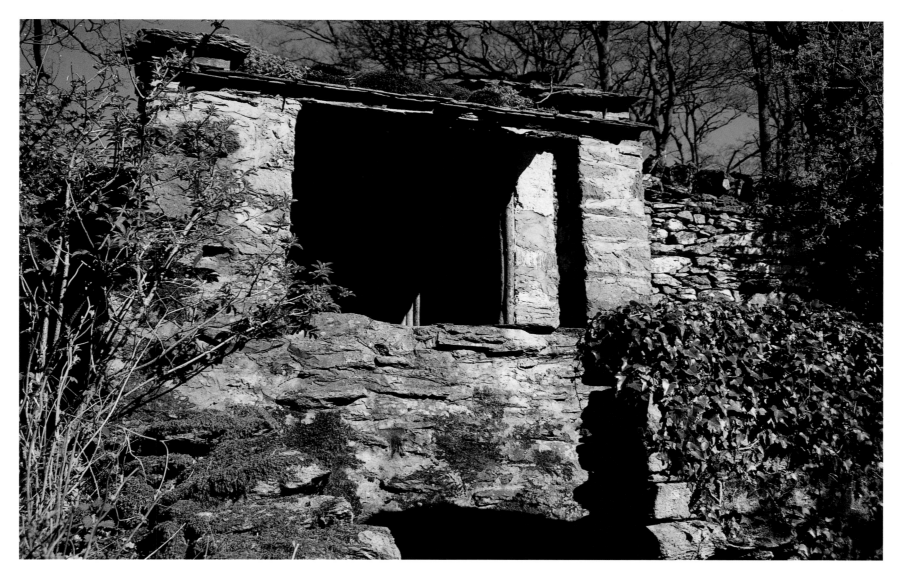

The summer house seen from Isabella's Terrace, prior to climbing the steps.

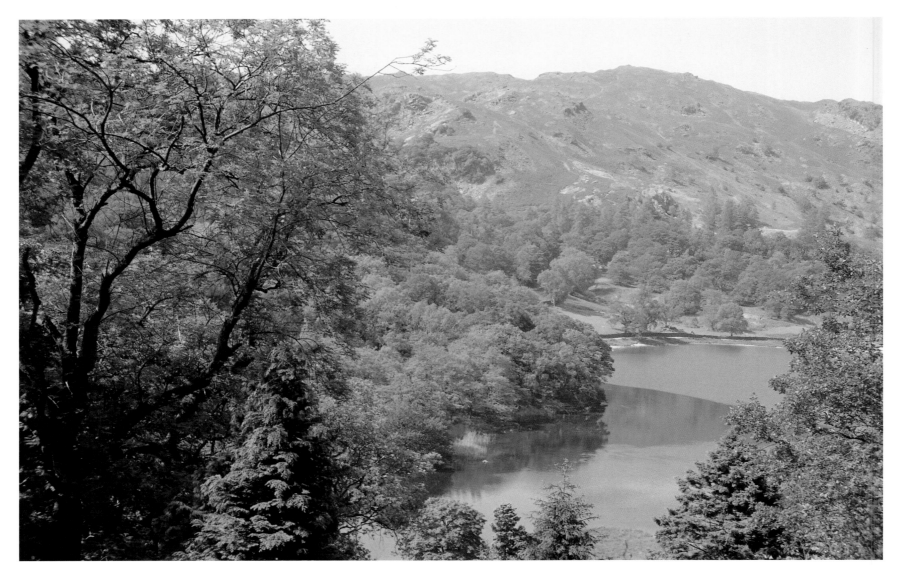

Loughrigg Fell in summer green, with Rydal Water at its foot. This view is from the end of the Farther Terrace.

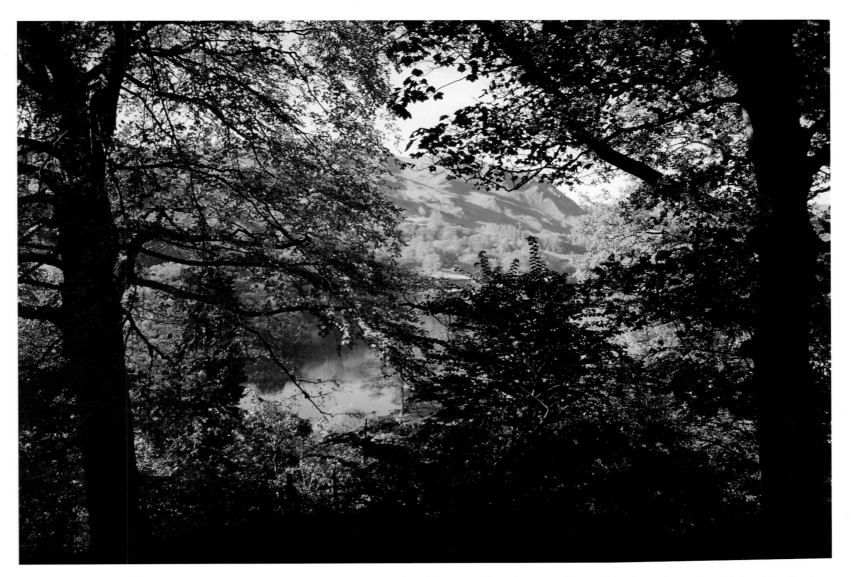

In autumn, Loughrigg Fell glows through the trees and in the face of Rydal Water. This photograph was taken from about the middle of the Farther Terrace.

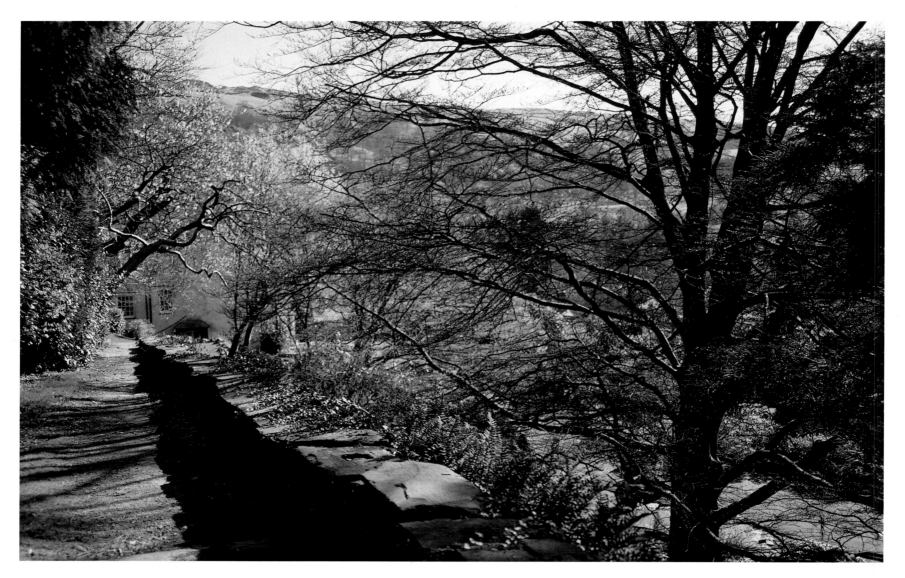

The Sloping Terrace in springtime, looking toward the house, with the fern-leaf beech beginning to leaf out, overhanging the walkway. To be surrounded by beauty as he composed his poetry, Wordsworth had only to walk outside his own doors.

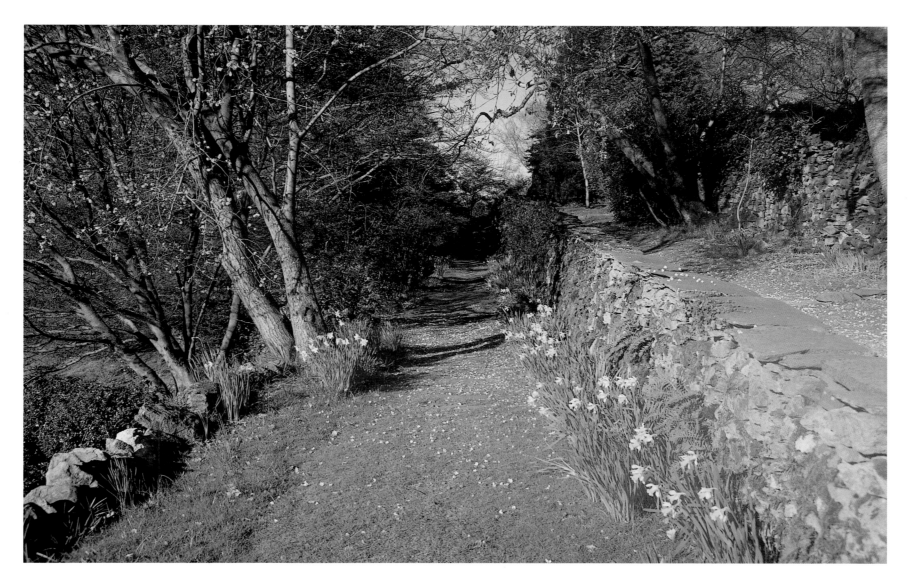

The Sloping Terrace (above) and Isabella's Terrace, lined with daffodils, in early spring.

The Sloping Terrace and Isabella's Terrace later in the spring, when the trees have leafed out and are shading both terraces. At the far end of Isabella's Terrace rise the stone steps that connect it with the Sloping Terrace.

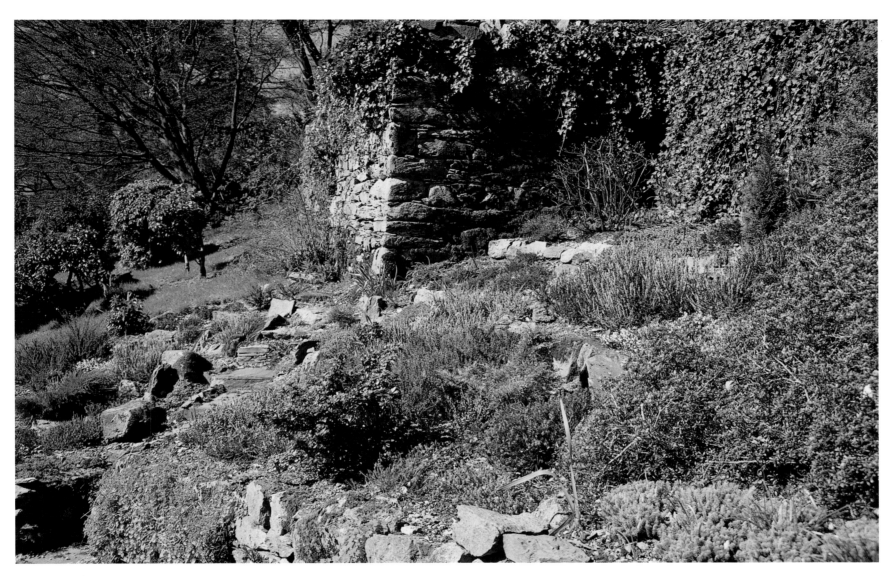

The protruding rock wall in the upper left of this photograph supports the summer house, and crowns a rock garden planted with azaleas, heather, daffodils, and other seasonal plants that are waiting to break dormancy on this brilliant early spring day.

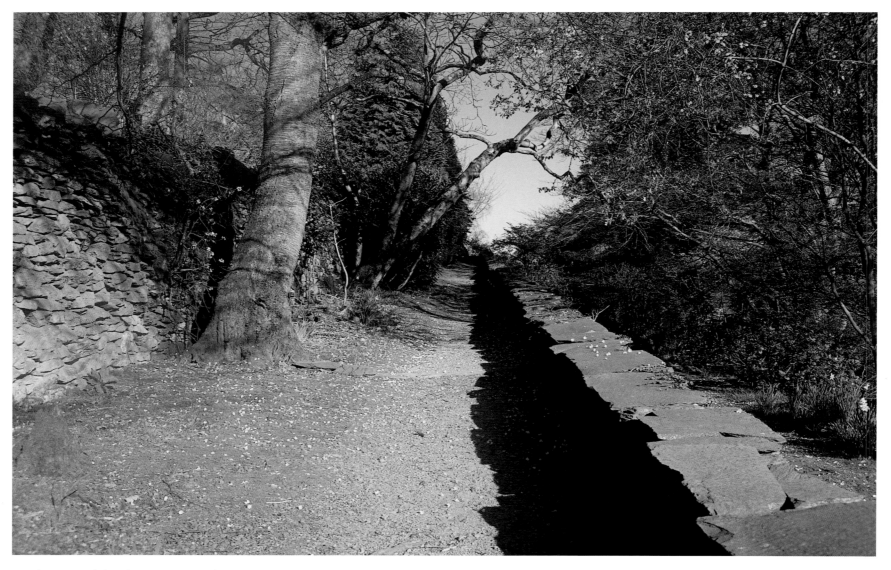

This view of the Sloping Terrace shows the trademark rockwork that divides the Coffin Trail (left) and makes a type of railing on the right.

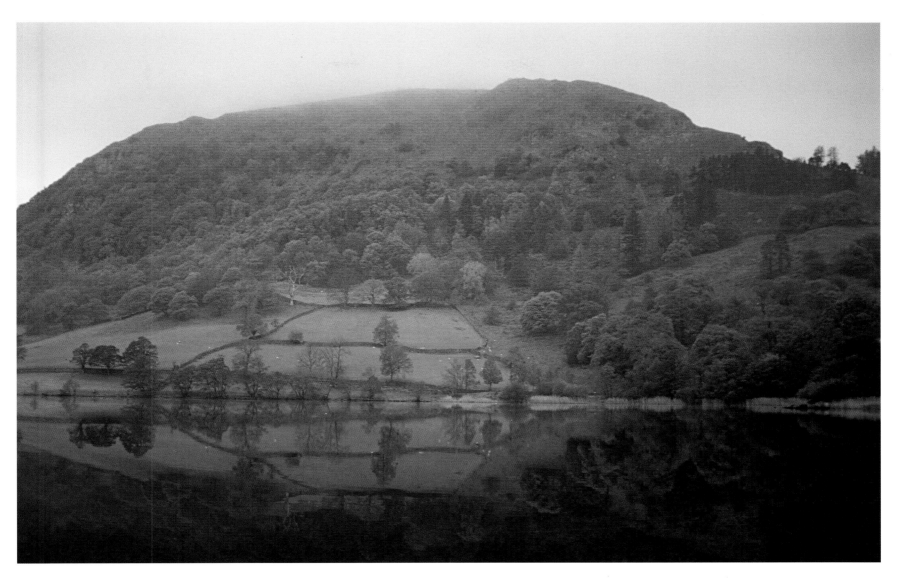

View from the southern shore of Rydal Water in autumn. The lines across the lower slopes of this fell are walls made of the Lake District's natural fencing material—rock.

John, or James—was always available and willing to push or pull the cart about the terraces. Wordsworth once or twice proposed carrying her out in his arms to see the work being done. In April 1834, Dorothy wrote to Catherine Clarkson that she had been out on the Green Terrace in her little cart.

As at Dove Cottage, the terraces are leveled and smoothed for pacing off the rhythms of Wordsworth's poems. Passersby, especially on the Coffin Trail lying just the other side of the wall, could clearly hear him in the throes of poetic composition as he paced along, loudly chanting the words in time with his feet, in his Westmoreland accent.

As Wordsworth's fame grew in the 1820s and 1830s, people from England, Europe, and America wanted to visit the great man. Some were new friends, for the Wordsworths were increasingly sociable, but some people had only a letter of introduction or their own love of his poetry to recommend them. Chris Wordsworth recounts how a stranger who walked around the gardens asked Ann, one of the servants, for permission to see the poet's study. As Mary had instructed her, Ann showed him a room and said, "This is my master's library, where he keeps his books, but his study is out of doors." (Mary writes that she told Ann to say that. So many Americans, particularly, were making the pilgrimage to Rydal Mount that Mary remarked in another letter, "It seems as if America [has] broken loose.")

The Voice of Waters

Pools built of rock and water are another signature Wordsworth feature of the Rydal Mount garden. He used rock to orchestrate the sounds of water. One pool, below Isabella's Terrace, occupies a position against the terrace wall similar to that of the pool in the Dove Cottage garden.

He was accustomed to using the flow of water, among other sources of natural music, to balance with the ear what he referred to in the *Prelude* as the domination of the eye. There was no natural stream on the Rydal Mount property; undaunted, he dug a series of rock pools ([6] on the garden plan) on the slope below Dora's Terrace. These he connected with a trench, in and along which he placed stones strategically to vary the sounds. Then, to get enough water to flow down the little stream, he diverted water from Nab Well, above and outside the garden.

Over time, this man-made watercourse has become a lovely little seasonal stream, located in a woodsy (and the still more natural) part of the garden. Like the Mound, it has so naturalized with the surrounding terrain that it appears to have been original. The water flows, sometimes in a torrent and sometimes in a trickle, over rocks and splashes into pools. Ferns and other shade- and moisture-loving plants have sprung up amid the rocks that define the banks.

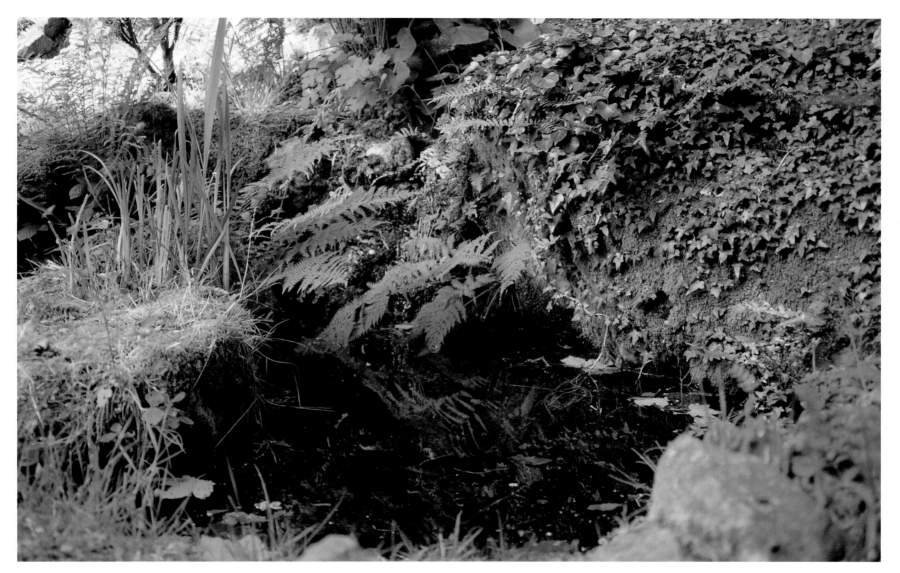

This delightful rock pool lies at the base of Isabella's Terrace.

Wordsworth made a second pool to liberate some fish in a glass vase that were a gift to Dorothy. In 1829, he wrote two poems about them: "Gold and Silver Fishes in a Vase," and the sequel "Liberty." The first poem admires the fish swimming in their "transparent cell," but the second poem has this note: "the gold and silver fishes (have) been removed to a pool in the plea-sure-ground of Rydal Mount." The location of the pool is not known for certain now, but it may have been in the vicinity of [14] on the garden plan. Wordsworth related this story about the fishes to Miss Fenwick:

> The fish were healthy to all appearance in their confinement for a long time, but at last, for some cause we could not make out, they languished, and, one of them being all but dead, they were taken to the pool under the old Pollard-oak. The apparently dying one lay on its side unable to move. I used to watch it, and about the tenth day it began to right itself, and in a few days more was able to swim about with its companions. For many months they continued to prosper in their new place of abode; but one night by an unusually great flood they were swept out of the pool, and perished to our great regret.

In his letter to John Kenyon, quoted earlier, he mentioned that the pollard oaks were near the Green Terrace, in Dora's Field.[13] It is likely that the boundary between the two properties

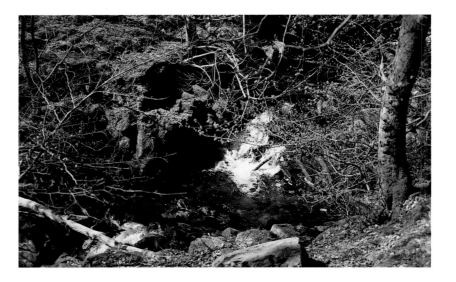

This tumbling stream flows along the farther boundary of Fleming Hall, east of Rydal Mount, much like the Little Syke at Dove Cottage. Wordsworth would have missed the sound of falling waters when he came to Rydal Mount, and did his best to replicate them with the series of connecting pools.

bisected a grove of pollard oaks, and that the location of this pool lies on the Rydal Mount side, a few feet above and to the left of the gate [13], as one faces it, where a shallow depression in the ground can be plainly seen.

 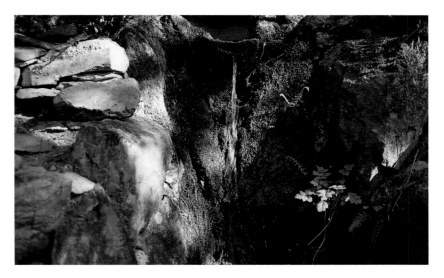

Both photographs on this page as well as that on page 158 were taken in early spring, before the vegetation could obscure the rock work. At this upper end of the series of rock pools ([6] on the garden plan), the rocks are larger, and the pool is deeper. When Peter Elkington dug debris out of this pool, he found it to be nearly 4 feet deep.

This photograph shows how Wordsworth placed a boulder strategically to let water fall into the pool from a height for a different sound than that produced by the water flowing through the pool in the photograph opposite.

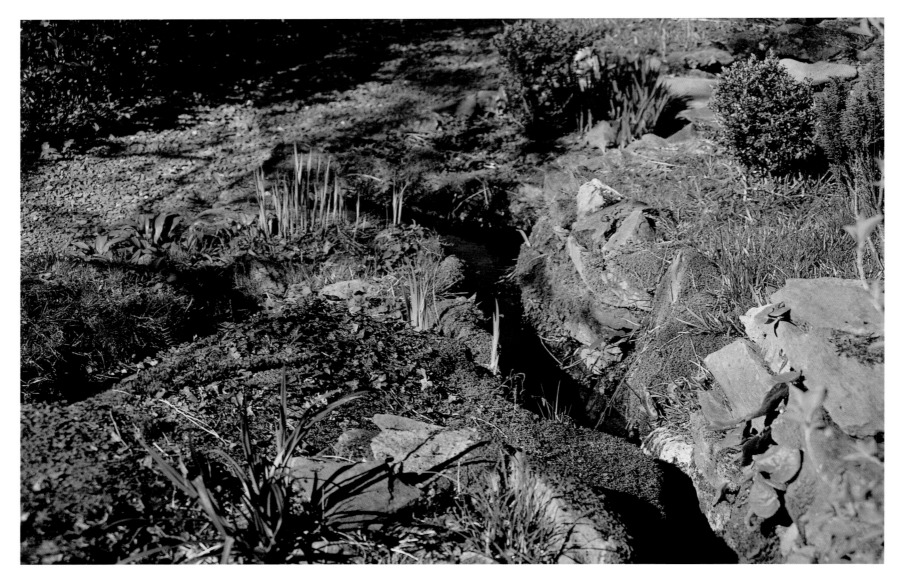

At the lower end of the series, the stream comes to a stop at the path and drops out of sight, perhaps into the rock outcroppings below. Note the placement of stones to bend the stream along a more interesting course rather than letting it flow straight down.

The Plantings

At Dove Cottage, Wordsworth would not hear of using exotic plants in his garden, but this ban had relaxed considerably by the time he came to write the *Guide to the Lakes.* In this work, he made his famous recommendation to use exotics close to the house and gradually blend them with natives so that at the edge of the property the plantings would be altogether natural. So it is at Rydal Mount. Nearer the house are rhododendrons, but at the western end of the property, the plantings are primarily natural.

When the Wordsworths moved in, rhododendrons had already been planted, probably by a previous tenant. Members of the Knott family, who held title through the late seventeenth and eighteenth centuries, lived in it until it sold for 2,500 pounds in 1803 to Mr. Ford-North, from Liverpool. Mr. Ford-North in turn sold it to Sir Michael Le Fleming in 1812. The Knotts and Ford-North appear to have been fashionable people, and rhododendrons came into fashion during the late eighteenth and early nineteenth centuries. Though we do not know which species—hybrids being for the most part unknown—were in the garden when the Wordsworths arrived, Appendix D lists those that were imported into Britain prior to 1850.

When Wordsworth died, the rhododendrons were still there. As Chris Wordsworth wrote, the glades were overhung with rhododendrons in most luxurious leaf and bloom. Near them is a tall ash-tree in which a thrush has sung for many years. Not far from it is a laburnum, in which the osier cage of doves was hung.

Wordsworth left them, perhaps because the family loved their beauty, and they still grow abundantly in the garden. Yet his dislike of exotics remained. He wrote to a friend in November 1837 regarding the hollyhock, which grew abundantly at Rydal Mount:

It is scarcely to be borne that the Dhalia, and other foreigners recently introduced, should have done so much to drive this imperial flower out of notice.

His dislike of white houses also endured. Rydal Mount was a white house, but according to his nephew Chris Wordsworth, it was "mantled over here and there with roses and ivy, and jessamine and Virginia creeper."

As before, the Wordsworths continued to collect wildflowers selectively for the garden. After one expedition with Sara Hutchinson in June 1829 to collect one of her favorite wildflowers, the birdseye primrose, Wordsworth wrote to a friend that it was identified "mistakenly by Withering" as "Mountain Auricula," and gave its botanical name as *Primula farinosa* L. Wordsworth was right. The Auricula primrose, *Primula auricula,* is a distinctly different plant. Both rise on stems from a basal rosette of leaves,

but the birdseye primrose flower is pink. Not only is the flower of the Auricula primrose bright yellow, its leaves are larger and more rounded, giving rise to its other common name, the bear's ear.

As always in a Wordsworthian garden, flowers were planted among the rocks and even in the crevices of the wall. Chris Wordsworth described wild geraniums (known as Poor Robin) and yellow lakeland poppies growing in the stone steps near the house leading up to the Sloping Terrace. The watercolor in Dora Wordsworth's album shows flower beds between the house, with pathways intersecting as they do today, and as they are shown on the garden plan.

The Sloping Terrace, he wrote,

on the right side is shaded by laburnums, Portugal laurel, mountain ash, and fine walnut trees, and cherries; on the left it is flanked by a low stone wall, coped with rude slates, and covered with lichens, mosses, and wild flowers. The fern waves on the walls, and at its base grows the wild strawberry and foxglove.

Wordsworth's fondness for laurels can be seen in this sonnet, which he wrote in the summer of 1833:

Adieu, Rydalian Laurels! that have grown
And spread as if ye knew that days might come
When ye would shelter in a happy home,

On this fair Mount, a Poet of your own,
One who ne'er ventured for a Delphic crown
To sue the God; but, haunting your green shade
All seasons through, is humbly pleased to braid
Ground-flowers, beneath your guardianship, self-sown.
Farewell! no Minstrels now with harp new-strung
For summer wandering quit their household bowers;
Yet not for this wants Poesy a tongue
To cheer the Itinerant on whom she pours
Her spirit, while he crosses lonely moors,
Or musing sits forsaken halls among.

("Itinerary Poems," 4:1–14)

Trees, too, were important in a Wordsworth garden. In the family's time, fir trees and thick shrubberies grew at the entrance, shown below [16] on the plan. (A car park occupies part of that area now.) A winter view of the entrance published on a postcard by H. R. Hulbert, who occupied the house after the Wordsworths, shows the house peeking up between firs, with a sycamore towering in the background. That sycamore stood near the corner of the house, and in the Wordsworths' time the fourteen steps up to the terraces would have passed under its branches. Unfortunately, by the time the house passed back into the ownership of Wordsworth's descendents, the tree had been cut down. Its stump is nearly 4 feet in diameter. Another sycamore located at the edge of the wild area appears to be old enough to have been

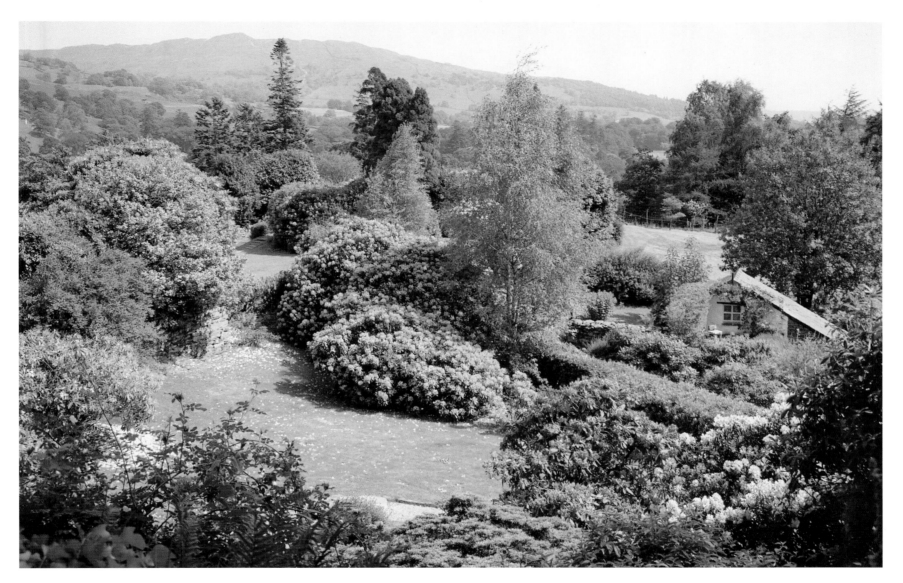

From the Sloping Terrace, we can see the rhododendrons in full bloom. They are big enough to hide the gardener's hut from a person standing on the lawn.

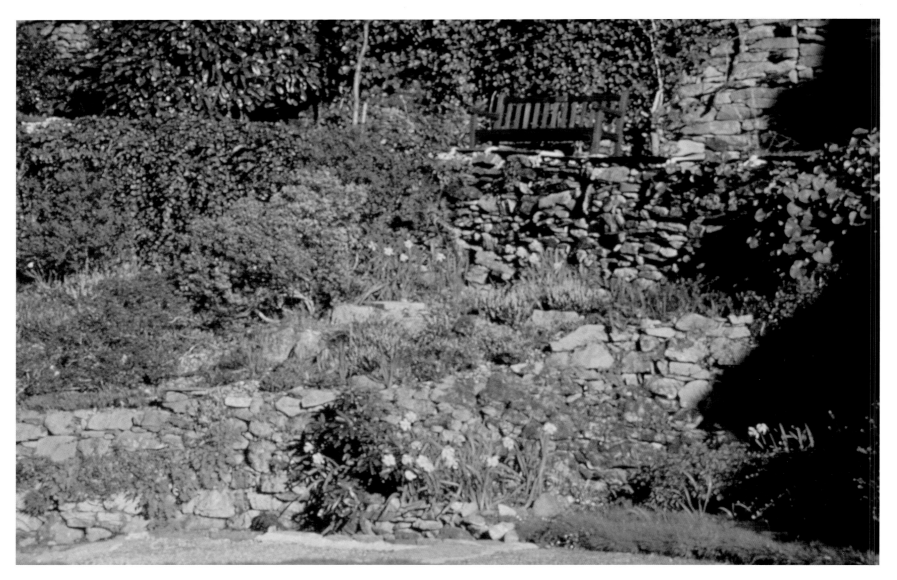

The Wordsworths planted heather, daffodils, and other flowering plants in these beds and among the rocks that support Isabella's Terrace.

These laurels, in full bloom in early spring, grow in the wilder part of the garden, beyond the steps between the summer house and Isabella's Terrace. In bloom, they are alive with the hum of bees and give off a sweet scent.

The trunk of the sycamore supposedly planted by Wordsworth and growing above the modern croquet lawn.

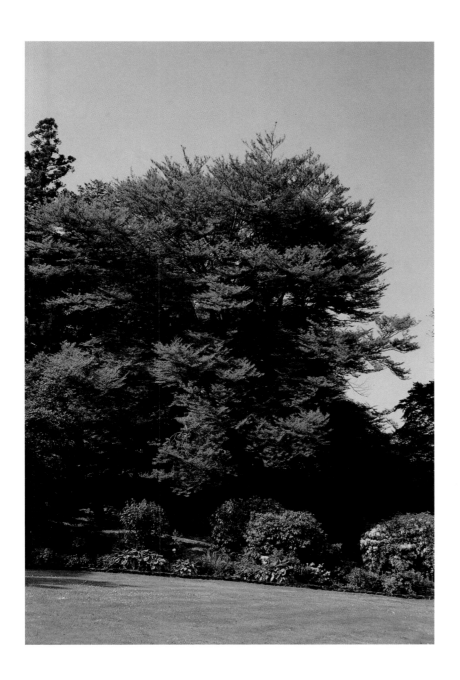

The rare fern-leaf beech in full foliage towers above its neighbors in high summer.

The Japanese maple in summer shows off its red foliage.

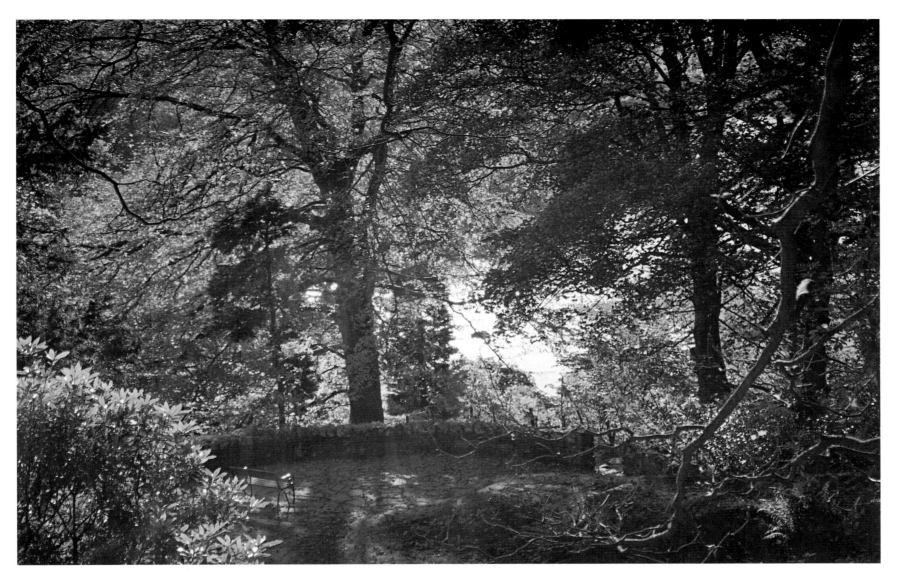

Though trees block or partially obscure some views from the garden, their autumn colors are a view in themselves, particularly when the air is heavy after a recent shower.

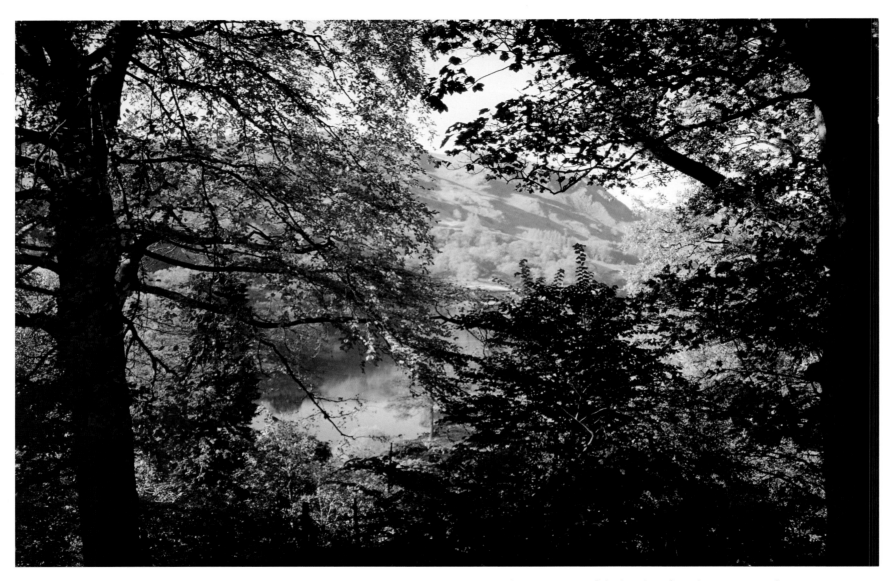

Through the trees one glimpses Loughrigg Fell in the background, in its own autumn colors, courtesy of the bracken fern that covers its slopes.

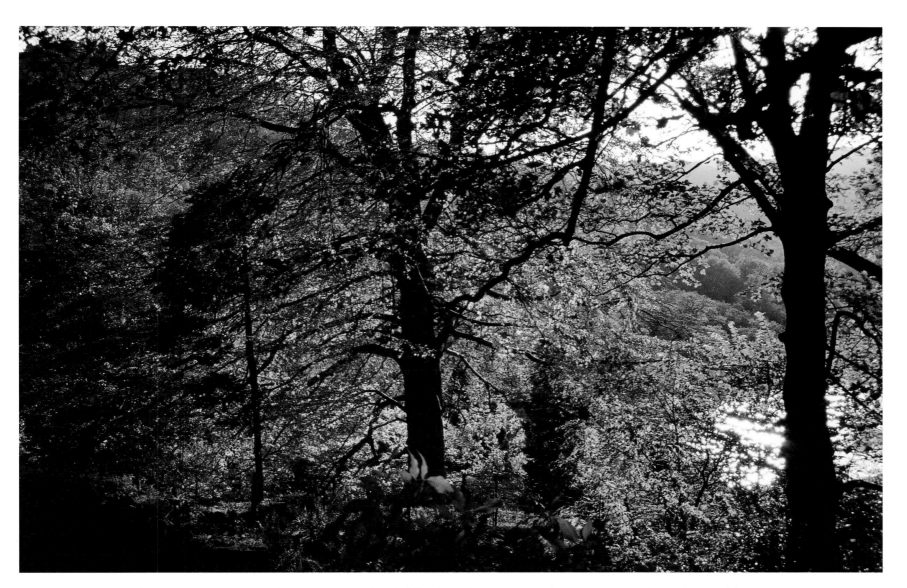

Rydal Water glimmers through the autumn foliage. Combined with fall colors, these are views that any visitor to the garden would appreciate, along with the Wordsworths.

planted by Wordsworth. Its huge trunk is gnarled and corded from supporting the tree, which towers nearly 60 feet high.

Another beauty of trees the Wordsworths would have enjoyed is their foliage. The red of the fern-leaf beech planted below Isabella's Terrace is still an exciting garden accent, particularly with its finely incised leaves, and sunlight through autumn foliage can be breathtaking.

In 1845, Wordsworth ordered Scotch firs from T & W Christie, Ltd., a nursery in Forres, Scotland. Donald W. Williamson, former owner of the nursery, kindly furnished a photocopy of the letter Wordsworth wrote to the founder, John Grigor. The letter, in which Wordsworth informs Grigor that the trees had arrived in good condition, was reprinted in Grigor's 1868 book, *Arboriculture*. The letter is dated February 20, 1845:

Dear Sir, —Your plants were received with much pleasure, and you will be glad to learn that they are not injured. My garden lies in something of a hollow, and is yet covered with snow, but they are placed in a sheltered plot in front of the house, and will be transplanted to the garden as soon as the snow will permit.

You were quite right in inferring that the fir tree was a favourite tree with me, indeed, as perhaps I have told you before, I prefer it to all others except the oak, taking into consideration its beauty in winter, and by moonlight, and in the evening.

Accept my sincere thanks for this mark of your attention, and even still more for your good wishes so feelingly express. —I remain, dear Sir, faithfully yours obliged,

Wm. Wordsworth

Wordsworth planted the firs, according to his nephew Chris, on the western side of the summer house, close to the door.

Close to this arbour-door is a beautiful sycamore, and five fine Scotch firs in the foreground, and a deep bay of wood, to the left and front, of oak, ash, holly, hazel, fir, and birch.

We cannot be sure which of the trees now in existence were there at the time the Wordsworths moved in, which he planted, and which were planted later. None of the rhododendrons now in the garden would have survived from Wordsworth's time or before, for they do not live longer than eighty or ninety years, even in their own habitats, at considerably higher elevations than the Lake District.

Because documentation of anything other than the large trees is so scarce, it is tantalizing to read in the Wordsworths' letters and

in Dorothy's journal about a shrub being planted, or about roses being beautiful, or that the rhododendrons were in bloom. We want to ask, "What roses? Which rhododendrons? Which shrubs?" Among the plantings, some very large trees—sycamores and a fern-leaf beech (*Fagus sylvatica purpurea*)—are said to have been planted by Wordsworth, and several large conifers, among them one or two Scotch pines near the summer house, appear to be of great age.

William Wordsworth, by H. Inman, 1844. Courtesy of the Wordsworth family.

The Kitchen Garden

Other than a place for William to compose his poems, the most immediate and important practical need for the family was a kitchen garden, where they grew most of their own food. Although the position of the kitchen garden is not known for certain, its location on the plan [9] is based on three factors. First, Chris Wordsworth mentions: "the regular garden, not parted off from the rest, but blended with it by parterres of flowers and shrubs." By regular garden he means the kitchen garden. Among tall flowers such as foxglove or flowering shrubs such as roses or rhododendrons, this mundane portion of the garden as a whole would have been nearly unnoticeable, and the rhododendrons would have screened it from view near the house.

At the time, the kitchen garden was not considered decorative. It would have included a compost heap where kitchen scraps and rejected vegetables and fruit were tossed to rot before being worked into the soil to enrich it. Tucked behind a screening bank of rhododendrons and other shrubs was (and is) the gardener's shed, within easy reach of the kitchen garden. The view on page 161 shows how the rhododendrons intervene between the gardener's hut and the main garden.

Second, the surmised location, in an open area on a south-facing slope, receives as much sunshine as is possible to have in the Lake District.

Third, gardener Tony Braithwaite and Peter Elkington, in 1996, uncovered some stone steps of undetermined age leading upward to the Mound from the present gardener's hut, near where we speculate the kitchen garden might have been. He conjectures that these steps would have allowed James Dixon (and others) to care for the plantings on the Mound without having to walk all the way around by the house, a convenience that would surely have been appreciated in the kitchen garden.

The Garden Today

After Mary Wordsworth's death in 1859, other people occupied the house, and their ideas of gardening have differed from Wordsworth's. J. R. Hulbert, the next tenant, who was fond of saying that he lived there longer than the poet, made many "improvements" to the garden, yet was proud that the property retained its Wordsworthian appearance. He destroyed part of the terracing and the natural area to dig out a level area for a croquet lawn and installed a rock wall that separates and holds back the upper lawn from this sunken level area.

After he died, the property passed into other hands and, over the years, fell into considerable neglect. In 1968, Mary Wordsworth Henderson bought it and began to refurbish both the house and the garden. The terraces were repaired, and many of the overgrown portions of the garden were weeded and mowed. Mrs. Henderson noted that the current look of the garden is mostly due to Hulbert, who enlarged the lawn and rhododendron plantings, planted the laurels on the mound, and installed benches in pleasant nooks. After Mary Henderson's death, the property passed to her heirs and into the care of the present curators, Peter and Marian Elkington.

Under Elkington's care, in 1999 the garden won first prize in a competition to identify the best gardens in the Lake District.

Yet Wordsworth's legacy remains very much in evidence: People still walk on the terraces and enjoy the garden, as always, each according to his or her own perspective. The rock pools still trickle or tumble with water, according to the season. And in Dora's Field every spring one of the Wordsworths' legacies blooms and carpets the slopes with their nodding, happy flowers. It is the season of the daffodils, and it happened because of another unhappy event in the Wordsworths' lives. Their much-loved daughter Dora died of tuberculosis at the early age of forty-two. Her grieving parents, then in their seventies, went down on their hands and knees and planted daffodils throughout the slope as a testimonial to her and to their faith. Over the years, the daffodils have naturalized and multiplied until they carpet the ground with sun yellow and remind visitors how Dora's father wrote of these flowers' cheeriness as being able to lift depression.

Writing on the value of antiquity in the *Guide*, Wordsworth said that over time the human becomes the natural, and so it is after this length of time not only with the Mount, but with Wordsworth's garden as well. For this garden invites us to walk, linger, and enjoy the unsurpassed natural beauty that surrounds it. And, perhaps, to consider the unity of the human and the natural, as Wordsworth apparently did, as part of the same Creation.

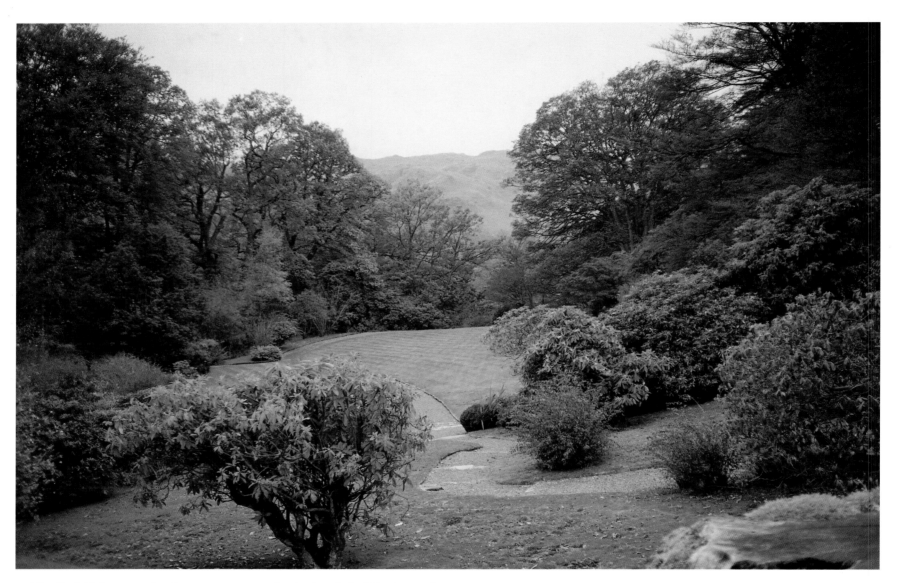

The Rydal Mount garden in 1996 won second prize in a Lake District garden contest.

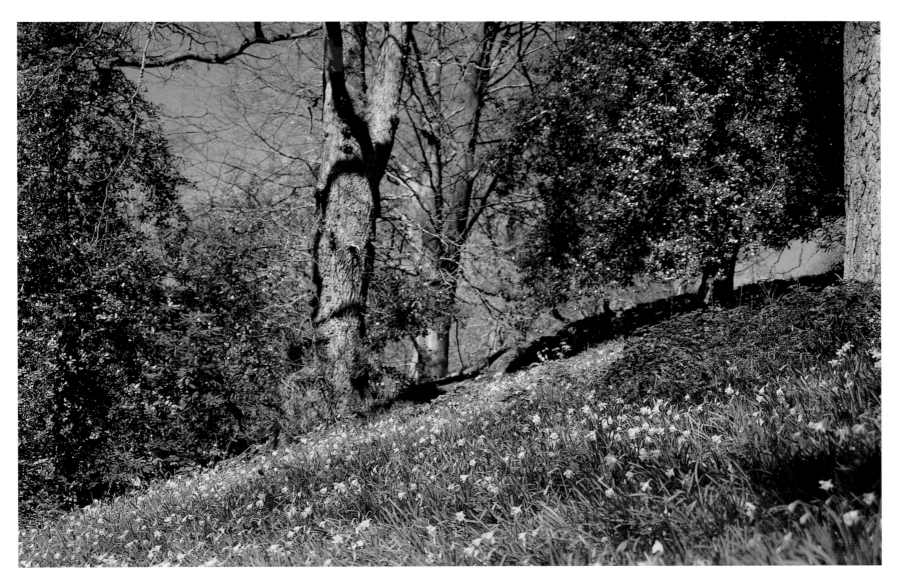

The daffodils in Dora's Field memorialize both the young woman and her parents' love. They have naturalized so well that they blanket the slope as naturally as the native bluebells that come after them.

Every spring the daffodils precede the spectacular display of native bluebells.

Five

WORDSWORTH'S GARDEN LEGACY

In Dora's Field are two inscriptions, one carved into Dora's Rock that testifies to Wordsworth's Christian faith, and the other on a brass plate set into the wall by the gate into the Rydal Mount garden. Engraved in 1830, while the poet was away from home, the latter inscription memorializes his efforts at saving the native forest trees.

In these fair vales hath many a Tree
 At Wordsworth's suit been spared;
And from the builder's hand this Stone,

For some rude beauty of its own,
 Was rescued by the Bard:
So let it rest; and time will come
 When here the tender-hearted
May heave a gentle sigh for him,
 As one of the departed.
(4:1–9)

Wordsworth was, more than a century before the term entered the English language, an environmentalist. As we recognize the danger to the planet from common gardening methods, we can learn from Wordsworth's writings and from his gardens how to garden in the spirit of nature, so as to do no harm.

Perhaps the first principle of gardening is this:

The invisible hand of art should everywhere work in the spirit of Nature and of Antiquity, her sister and co-partner.
(*Guide to the Lakes,* p. 74)

The second principle would be to use plants native to the immediate area in which the garden is located. Wordsworth recommended keeping exotics near the house, and blending them with natives in such a way that the natives predominated until they merged completely into the wild areas. This would, he wrote in the *Guide to the Lakes,*

leave undisturbed that peaceful harmony of form and colour which has been through long lapse of ages most happily preserved.

A third principle in Wordsworth's landscape gardening practice was to make the garden hospitable to wildlife. He wrote:

But this sense of life in nature is most fully borne in upon him where a constant change of expression passes over the countenance of immutable loveliness, or where ceaseless motion wages a war with unruffled tranquillity.

The principle of life itself makes a great garden, in his view, not merely a static arrangement of plants. And life comes from change of expression, from sunlight and shadow, rain and snow, brightness and darkness, and from changes of season that alter the quality of light shining on leaves, on flowers, on water. Life also comes from the constant motion of the breezes, and from the congregation of live creatures in motion among the plants—from bees amid flowers, birds in trees, small mammals scurrying about and running along branches. Life is motion, and running water gives motion to a garden, too.

In nature, plants mingle and intertwine. Wordsworth often planted to emulate that effect; for example, the honeysuckle that entwines the *Rosa rugosa* at Dove Cottage. At Rydal Mount, he

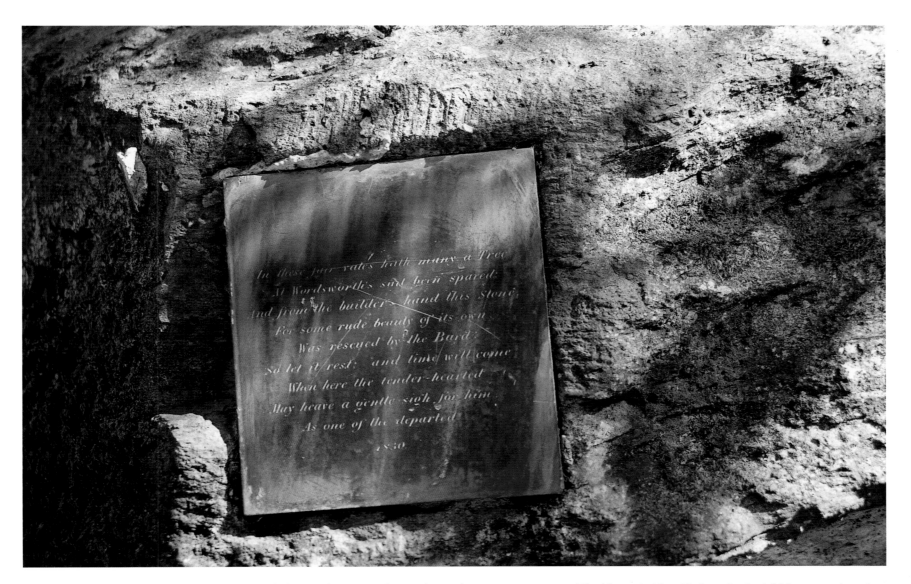

Wordsworth's preservationist legacy extended not only to trees, but rocks, as this inscription states. The plaque is identified on the Rydal Mount garden plan on p. 131, as [14].

replicated, with the series of rock pools, this model described in the *Guide*:

> There is a powerful Brook, which dashes among rocks through a deep glen, hung on every side with a rich and happy intermixture of native wood; here are beds of luxuriant fern, aged hawthorns, and hollies decked with honeysuckles; and fallow-deer glancing and bounding over the lawns and through the thickets.

To Wordsworth beauty in a garden consisted in the "multiplicity of parts uniting in a whole":

> Sublimity is the result of Nature's first great dealings with the superficies of the earth; but the general tendency of her subsequent operations is towards the production of beauty; by a multiplicity of symmetrical parts uniting in a consistent whole.

We are no longer concerned with defining the differences between the sublime and the beautiful, but Wordsworth's distinction between them is relevant for today's gardener. He is saying that the sublime belongs to mountains, rivers, and oceans, but the beautiful comes from blending many different components into a larger whole. For gardeners, this means that although we might not be able to recreate a mountain in our gardens, we can make a beautiful garden by inviting nature in. If we are fortunate enough to have a view of mountains or ocean, we can, as the Japanese do, "borrow" the vista to include in the garden. If we plant native plants, wild creatures will know how to find them, and nature will do the rest.

There will be life, motion, and change—all the qualities of beauty—in a small space. There will be, as Wordsworth wrote, "endless melting and playing into each other of forms and colours" to be enjoyed by a "mind at once attentive and active."

Even in his day, Wordsworth was sensitive to the issue of importing and using exotic plants. Having been an avid collector himself, he came to understand the risk of overharvesting native plants for relocation. Nowhere is his concern for plants more evident than in the 1845 poem "Love Lies Bleeding," also known as the Pheasant's-eye (*Adonis annua* L.):

> You call it, "Love lies bleeding,"—so you may,
> Though the red Flower, not prostrate, only droops,
> As we have seen it here from day to day,
> From month to month, life passing not away:
> A flower how rich in sadness! Even thus stoops,
> (Sentient by Grecian sculpture's marvellous power),
> Thus leans, with hanging brow and body bent
> Earthward in uncomplaining languishment,
> The dying Gladiator. So, sad Flower!
> ('Tis Fancy guides me willing to be led,

Though by a slender thread,)
So drooped Adonis, bathed in sanguine dew
Of his death-wound, when he from innocent air
The gentlest breath of resignation drew;
While Venus in a passion of despair
Rent, weeping over him, her golden hair
Spangled with drops of that celestial shower.
She suffered, as Immortals sometimes do;
But pangs more lasting far, 'that' Lover knew
Who first, weighed down by scorn, in some lone bower
Did press this semblance of unpitied smart
Into the service of his constant heart,
His own dejection, downcast Flower! could share
With thine, and gave the mournful name which thou wilt
 ever bear.

 (2:1–24)

This flower is not native to England, though it has been known and naturalized there at least since the sixteenth century. As Wordsworth noted about this poem:

Every month for many years have we been importing plants and flowers from all quarters of the globe, many of which are spread through our gardens, and some perhaps likely to be met with on the few Commons which we have left. Will their botanical names ever be displaced by plain English appellations, which will bring them home to our hearts by connection with our joys and sorrows?

In this note, Wordsworth is mourning the loss of traditional favorites whose old English names connect a person with the deep past. Names like dog rose or Madonna lily that connect not just this decade or century with the last, but this third millennium with the second—or the first, because they have been in cultivation throughout recorded Western history.

By 1845, the flood of exotic plants, especially from across the Atlantic, and also from Asia, threatened to swamp the British Isles. The Douglas fir (*Pseudostuga menziesii*), native to the Pacific Northwest (U.S.) and discovered by the Scottish plant hunter David Douglas in the 1820s, threatened to overtake the native British timber trees and displace them in the forests.

Wordsworth's approach has even more relevance now. As populations increase and natural resources shrink, as species disappear under the onslaught of aggressive exotics, gardeners find increasing satisfaction from working with nature and not against it. Native plants, for instance, are already acclimated to local conditions. Local bees instinctively know how to pollinate them; indigenous birds and other animals know them as food. Water conservation is instinctive to native plants. They have adapted to periods of drought that occur in their areas.

Native predators recognize native pests and assist in pest control, but when agriculture is threatened by a pest with no native

enemies, everyone is in danger. *The Garden,* the journal of the Royal Horticultural Society, has repeated warnings about nonnative insects or worms that threaten gardening and agriculture.

The heritage Wordsworth left the world is threefold: a vast and varied body of poetry, writings and recommendations on the principles of landscape gardening, and the gardens themselves.

As a preservationist, his message is even more timely now. To think of the garden as the point at which nature and humanity come together is to think more carefully about garden practices and their effects on the planet. Whether, like Wordsworth, we experience intense unity or see the handiwork of God and feel ourselves spiritually one with the Creation, to understand Wordsworth's gardens is to understand gardening in the context of nature.

Portfolio of Lake District Scenes

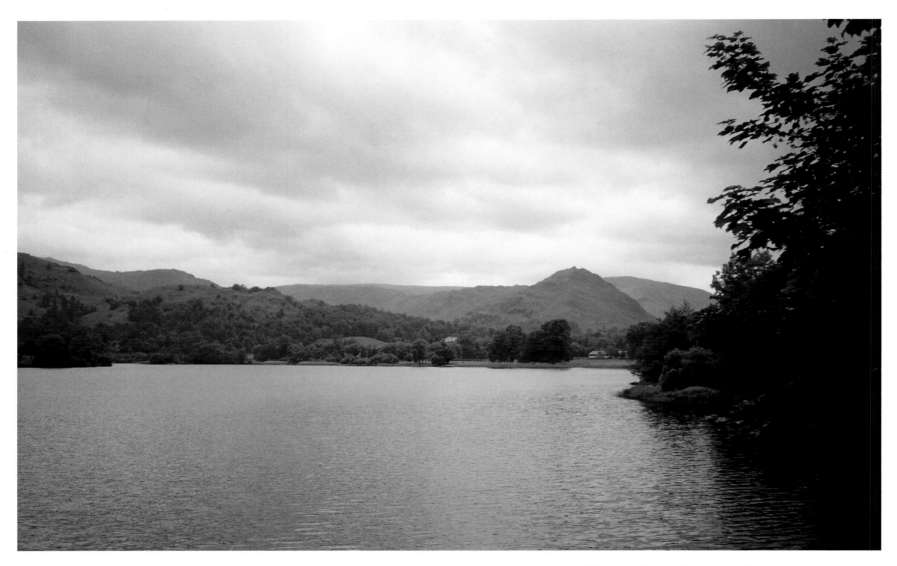

The triangular shape of Helm Crag is clearly visible at the bottom of Grasmere Lake. The 1,300-foot fell has its feet in Grasmere village.

The rock formation known as the Lion and the Lamb at the summit of Helm Crag.

Silver How in the fog. On days like this, the fells can be very dangerous to climb.

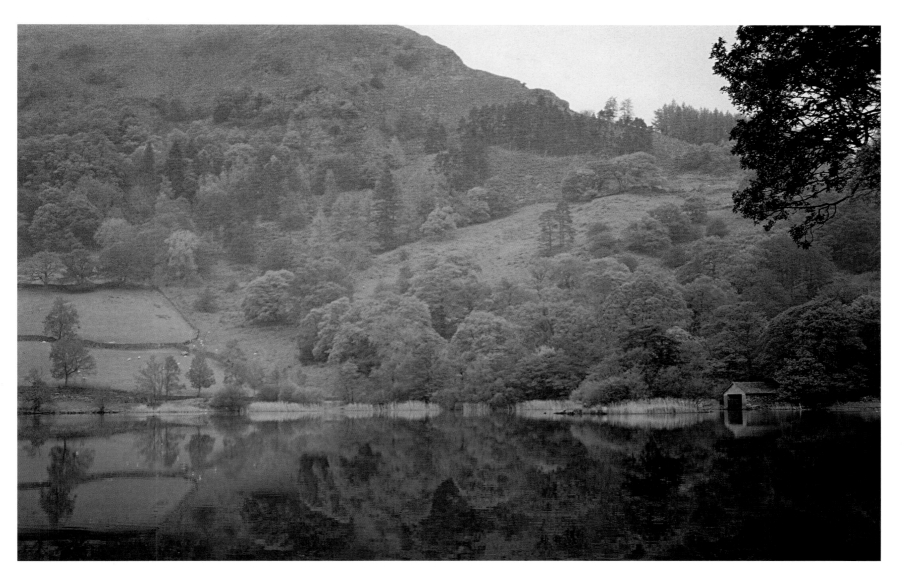

Rydal Water in autumn, with the old boathouse, a local landmark for many years.

The top of Hard Knot pass. Compare with the view opposite, from the bottom of the pass.

The bottom of Hard Knot pass, looking back from the ruins of a Roman fort.

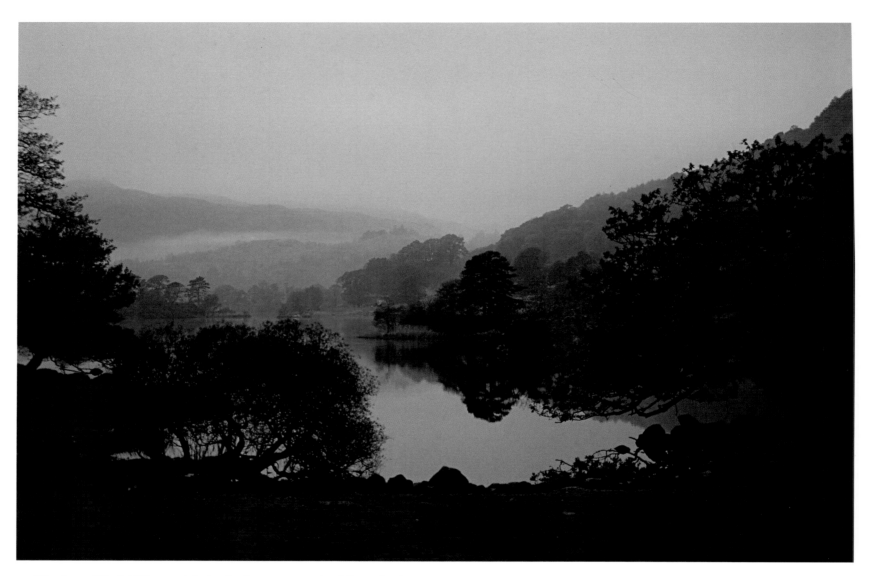

The foot of Rydal Water, with the fog lying among the fells in the distance.

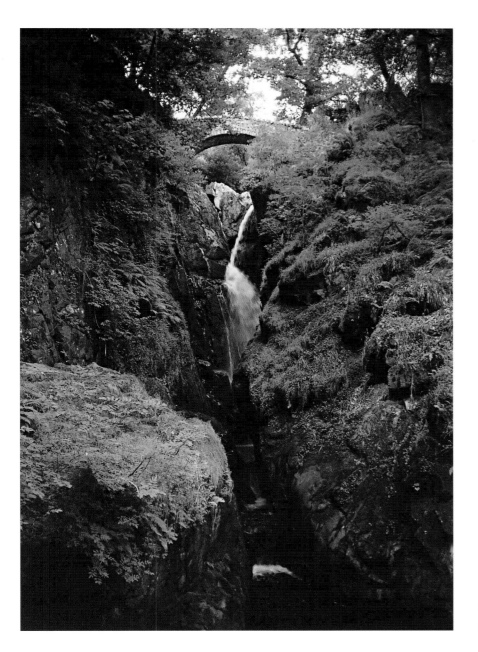

Aera Force, a waterfall commemorated in Wordsworth's poem "Airey-force Valley." The poet treasured the sounds of waterfalls such as this one and sought to replicate varied sounds of waterfalls in his gardens.

Ullswater, scene of the famous wind-tossed daffodils of Wordsworth's poem "I wandered lonely as a cloud."

The back of Loughrigg Fell, with Loughrigg Tarn in the lower left corner. From this point it is a short walk around the fell (or a fairly stiff climb over it) to the village of Rydal.

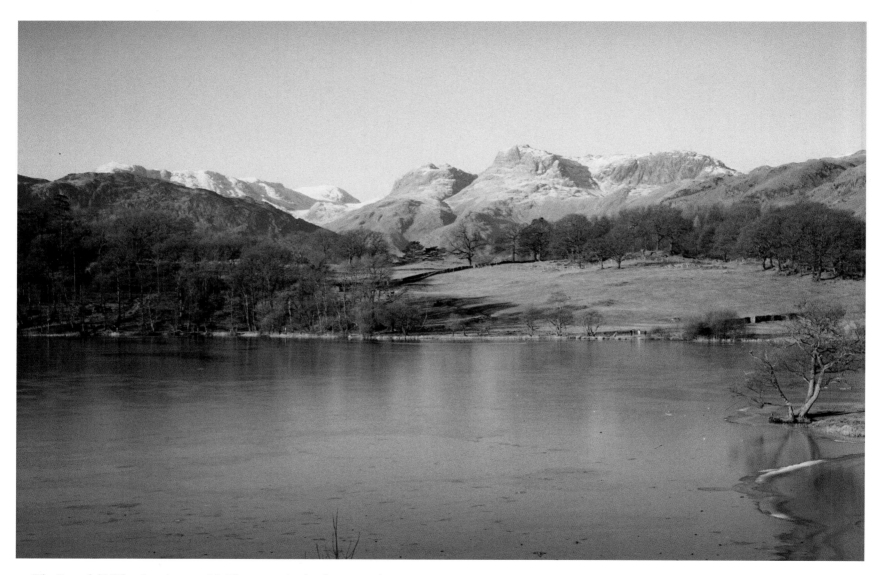

The Langdale Pikes in winter, with Elterwater in the foreground.

Appendix A

These lists are an attempt to organize Wordsworth's garden poems thematically. The basis of their organization, like the discussion in the text, comes from the notes the poet dictated to Isabella Fenwick, remarks in the family's letters, Dorothy Wordsworth's journal, and textual evidence within the poems.

Poems Composed in or Worked on in the Garden

The Glow-Worm
Foresight
The Tinker (perhaps)
The Celandine

To the Same Flower
The Emigrant Mothe
Michael
Point Rash-Judgment IV
Alice Fell

Poems Based on Observations in the Garden

The Redbreast
Wild Redbreast
In the Woods of Rydal
The Redbreast Chasing the Butterfly
The Thorn (the moss description in verse iv)
French Revolution
To a Skylark
The Haunted Tree
Aerial Rock
To Sleep
Sonnet XXVI
Sonnet XI (In the Woods of Rydal)
Evening Voluntaries VIII
To the Moon
Lines Written in Early Spring
To a Redbreast

Poems Specifically about the Garden or Set in the Garden

To a Butterfly
The Orchard Path
The Redbreast Chasing the Butterfly
A Farewell

The Longest Day
III (OUP 117)
VI
When to the Attractions of a Busy World
A Flower Garden (at Cole Orton)
The Green Linnet
Who Fancied What a Pretty Sight
The Kitten and Falling Leaves
To the Cuckoo
Devotional Incitements
To Lady Beaumont
Sonnet XXV
Sonnet XLII
Adieu, Rydalian Laurels
To the Spade of a Friend
This Lawn, a Carpet All Alive
There Is an Eminence
The Orchard Pathway

Poems (possibly) about the Garden or Set in the Garden

A Wren's Nest
Rural Illusions
Vernal Ode
Sonnet XIV To the Cuckoo
Sonnet XXX

Poems about Individual Plants

To the Small Celandine
To the Same Flower

Primrose
The Waterfall and the Eglantine
The Oak and the Broom
The Primrose of the Rock
XIII ('Thou Eglantine')
A Whirl-blast
The Waterfall and the Eglantine
To the Daisy
Love Lies Bleeding
Companion to the Foregoing
To a Snowdrop
Poor Robin

Poems that Refer to the Garden or to Plants in the Garden

The Triad
The Wishing-Gate
Sonnet XXXV
Sonnet II
Sonnet XIX
Sonnet XXI
At the Grave of Burns 1803
Elegiac Musings

Poem on a Lady's Garden

When Wordsworth was asked to write a poem about a garden he had never seen, he wrote a poem on the impossibility of writing poetry about someone else's garden.

To a Lady

Garden Elements in Poems Not about Gardening

In addition to all the poems about the gardens, Wordsworth included garden imagery in poems whose main theme had nothing to do with gardening.

Water

Lines Written a Few Miles Above Tintern Abbey
On the Power of Sound
Sonnet VII
Sonnet XXXI
Sonnet XXXII
Sonnet XXXIII
Sonnet XXVII
The River Duddon
To the River Greta
To the River Derwent

Stones and Rocks

Sonnet X
Humanity
Sonnet XLII
Inscriptions
Inscription on a Rock at Rydal Mount (1838)

Antiquity

The White Doe of Rylstone
Sonnet XXI

Appendix B
THE PLANTS

The plants in this appendix are listed alphabetically by both their English or common names and their scientific names.

Scientific names are always in Latin, italicized, with the genus first, capitalized, and then the species. The initial L. or a name such as Miller that follows the Latin designates the botanist credited with identifying the plant and placing it correctly in its family or genus. The letter L stands for Linnaeus, or Carl von Linné, the great Swedish botanist who developed the binomial system of nomenclature in the eighteenth century. Before Linnaeus, the confusion in scientific names was great.

We use scientific names to know which plant we are really talking about. However, since the binomial system came about, botanists have continued to reclassify plants as more is learned about them, so that many of the scientific

names Wordsworth knew are not the same today. For example, the scientific name for broom (*Planta genista* in the time of the Plantagenets), was *Sarothamnus scoparius* (L.) Wimmer as late as 1955, but is now *Cytisus scoparius* L. While every effort has been made to ensure the accuracy of scientific names, some changes may have occurred since this book was written.

To add to the confusion, common and local names vary widely, so that people in different English-speaking places can refer to the same plant by different names, or to different plants by the same name. In *The Englishman's Flora*, Geoffrey Grigson lists seven different local names for columbines in Somersetshire alone. Both the columbine and the marsh marigold (as well as fourteen other plants) have been called bachelor's buttons, and the marsh marigold and the daisy have both been known as gowans in Cumbria. Besides changing from place to place, common names have changed over time to the extent that some common names Wordsworth used can no longer be linked with certainty to current common or scientific names. Common names in this list are from several sources: Withering; Grigson; Blamey and Grey-Wilson; Dorothy Wordsworth's Grasmere Journals and the notes to Pamela Woof's edition of *The Grasmere Journals;* the recollections of George Kirkby; and the knowledge of other lifelong Lake District residents.

The Dove Cottage Garden

Aaron's rod; *Verbascum thapsus*

Anemone nemorosa L.; windflower

apple tree; *Malus sylvestris* subsp. *mitis* (Wallr.) Mansf. [Wordsworth may have known this as *Malus domestica* Borkh.]

Aquilegia vulgaris L.; columbine

Aster novi-belgii L.; Michaelmas daisy (Wordsworth also uses *Aster novae-angliae* L., a North American native)

auricula primrose; *Primula auricula*

bachelor's buttons (Withering: *Centaurea cyanus* L.; also bluebottle, knapweed, cornflower, hurt-sickle)

barberry; *Berberis vulgaris*

beans, scarlet runner; *Paseolus cocineus*

Bellis perennis L.; daisies, gowans

Berberis vulgaris L.; barberry

bird cherry; *Prunus padus*

birdseye primrose; *Primula farinosa*

bog-myrtle; *Myrica gale*

broom; *Cytisus scoparius*

buttercup; *Ranunculus repens*

butterwort; *Pinguicula lusitanica*

Caltha palustris L.; marsh marigold

Centaurea cyanus L.; bluebottle, cornflower, knapweed, also, possibly bachelor's buttons, hurt-sickle

columbine; *Aquilegia vulgaris*

crab apple; *Malus sylvestris*

Cretaegus monogyna Jacq.; hawthorn, May blossom, May flower

crowfoot; various *Ranunculus* species, e.g., *Ranunculus ficaria* L. (formerly *Ficaria verna* Hudson), common pilewort, lesser celandine; *R. lingua* L., great spearwort, or crowfoot; *R. reptans* L., narrow-leaved crowfoot; *R. auricomus* L., sweet wood crowfoot, goldilocks; *R. scleratus* L., round-leaved water crowfoot, celery-leaved crowfoot; *R. parviflorus* L., small-flowered crowfoot; *R. hederaceus* L., ivy-leaved crowfoot; *R. aquatilis* L., water crowfoot

Cytisus scoparius L. (formerly *Sarothamnus scoparius* (L.) Wimmer); broom

Dactylorhiza maculata (L.) Soó (formerly *Orchis maculata* L.); heath spotted orchid, spotted orchid

daffodil; *Narcissus pseudonarcissus*

daisy; *Bellis perennis*

Digitalis purpurea L.; foxglove

dog rose; *Rosa canina* L.

early purple orchid; *Orchis mascula*

English laurel; *Prunus laurocerasus*

English oak; *Quercus robur*

English primrose; *Primula vulgaris*

foxglove; *Digitalis purpurea*

ferns, see Osmundine fern; sword fern

Fragaria vesca L.; strawberry

Galanthus nivalis L.; snowdrops

gale; *Myrica gale*

Geranium robertianum L.; herb-Robert

Geum reptans L.; strawberry flower. (This plant may have been *Geum rivale* L., the water avens, or *G. urbanum* L., herb bennet. For none of these does Grigson list the common name "strawberry flower," and herb bennet looks more like a tall buttercup.)

ginger mint; *Mentha*, various species

globeflower; *Trollius europeaeus*

gooseberry; *Ribes uva-crispa*

gowan; *Bellis perennis*

great mullein; *Verbascum thapsus*

hawthorn; *Cretaegus monogyna*

heartsease; *Viola tricolor;* wild pansy

heath spotted orchid; *Dactylorhiza maculata*

heckberry; *Prunus padus*

Helianthemum canum (L.) Baumg.; hoary rockrose, rock rununculus

herb Robert; *Geranium robertianum*

holly; *Ilex aquifolium*

honeysuckle; *Lonicera periclymenum*

hyacinth; *Muscari comosum*

Ilex aquifolium L.; holly

laurel, see Portugal laurel, English laurel

lesser celandine; *Ranunculus ficaria*

lesser periwinkle; *Vinca minor*

lichens (These pages are largely uncut in Vol. IV of the Wordsworths' copy of Withering, indicating that they did not attempt to identify any lichens.)

Lilium candidum L.; Madonna lily, white lily

Lilium martagon L.; Turk's-cap lily

lily, see Madonna lily, Turk's-cap lily

lockety goldings; *Trollius europeaeus*

London pride; *Saxifraga × urbium*

Lonicera periclymenum L.; woodbine, honeysuckle

loosestrife; *Lysmachia nemorum*

Lysmachia nemorum L.; loosestrife, yellow pimpernell

Madonna lily; *Lilium candidum*

Malus sylvestris Miller; crab apple

marsh marigold; *Caltha palustris*

May blossom; *Cretaegus monogyna*

May flower; *Cretaegus monogyna*

Mentha various species; ginger mint

Mentha × piperita L.; peppermint

Mentha pulegium L.; pennyroyal

Mentha spicata L.; spear mint

Michaelmas daisy; *Aster novi-belgii*

mint, see ginger mint, pennyroyal, peppermint, spear mint

moss campion; *Silene acaulis*

moss wythan; *Myrica gale*

mother of thyme; *Thymus praecox* subsp. *britannicus*

mountain ash; *Sorbus aucuparia*

mullein; *Verbascum thapsus*

mullen, see mullein

Muscari comosum (L.) Miller; hyacinth, tassel hyacinth. This plant could
 also have been *Muscari botryoides* (L.) Miller, the small grape
 hyacinth; or the common grape hyacinth *M. neglectum* Ten.

Myrica gale L.; bog-myrtle, gale (called moss wythan in Cumbria)

narcissus; *Narcissus pseudonarcissus*

Narcissus pseudonarcissus L.; narcissus, daffodil

oak, English; *Quercus robur*

orchids, see early purple orchid, heath-spotted orchid, spotted orchid

Orchis mascula L., early purple orchid

Oxalis acetosella L.; wood sorrel, shamrock

Osmundia regalis L.; royal fern, Osmundine fern

Osmundine fern; *Osmundia regalis*

pansy; see heartsease, mountain pansy

pea, see vetch

pear tree; *Pyrus*. Species unknown; however, there are four possibilities:
 Pyrus cordate Desv., Plymouth pear; *P. salicifolia* DC., willow-leaved
 pear; *P. pyraster* Burgsd., wild pear; *P. communis* L., cultivated pear

pennyroyal; *Mentha pulegium*

peppermint; *Mentha × piperita*

periwinkle; *Vinca*

pilewort; *Ranunculus ficaria*

Pinguicula lusitanica L. or *P. vulgaris* L.; butterwort (Wordsworth notes
 that this is an "insectivorous plant, has a flower reminiscent of
 Columbines, violet (*P. v*[*ulgaris*]) or pink to pale lilac (*P.
 l*[*usitanica*].).")

Polystichum munitum (Kaulfuss) C. Presl.; sword fern

Portugal laurel; *Prunus lusitanica*

primroses, see auricula primrose, birdseye primrose, English primrose

Primula auricula L.; auricula primrose

Primula farinosa L.; birdseye primrose

Primula vulgaris Hudson; English primrose

Prunus laurocerasus L.; English laurel

Prunus lusitanica L.; Portugal laurel

Prunus padus L.; bird cherry, heckberry

Quercus robur L.; English oak

Ranunculus ficaria L.; lesser celandine, pilewort

Ranunculus repens L.; buttercup. This plant may also have been meadow
 buttercup (*Ranunculus acris* L.) or bulbous buttercup (*Ranunculus
 bulbosus* L.)

Ranunculus, various species; crowfoot

Rhubarb; probably *Rheum rhaponticum, R. officinale,* or *R. palmatum*

Ribes uva-crispa L.; gooseberry

rock ranunculus; this plant may have been the hoary rockrose,
 Helianthemum canum (L.) Baumg. Localized in Cumbria

Rosa canina L.; dog rose

Rosa rugosa Thunb.; wild rose

roses, see dog rose

rowan; *Sorbus aucuparia*

Saxifraga × urbium D.A. Webb; London pride (not known naturally in
 the wild)

shamrock; *Oxalis acetosella*

Silene acaulis L.; moss campion

snowballs; *Viburnum*

snowdrops; *Galanthus nivalis*

Sorbus aucuparia L.; mountain ash, rowan

speedwell; *Veronica spicata*

spear mint; *Mentha spicata*

spiked speedwell; *Veronica spicata*

spotted orchid; *Dactylorhiza maculata*

Stellaria holostea L.; stitchwort

stitchwort; *Stellaria holostea*

strawberry; *Fragaria vesca*

strawberry flower; *Geum reptans*

sunflowers; *Helianthus* sp.

sword fern; *Polystichum munitum*

Taxus baccata L.; yew

tassel hyacinth; *Muscari comosum*

thyme, see lemon thyme, wild thyme

Thymus praecox subsp. *britannicus* (Ronnger) Holub. Geoffrey Grigson, in the *Englishman's Flora,* identifies wild thyme or mother of thyme (to give it its Cumbrian name) as *Thymus serpyllum* L., but Margery Blamey and Christopher Grey-Wilson in the *Illustrated Flora of Britain and Northern Europe* differentiate wild thyme (*Thymus praecox* subsp. *britannicus*) from Breckland thyme (*Thymus serpyllum*): "*T. serpyllum* is confined to the Breckland soils of East Anglia and Cambridgeshire," while *T. p.* subsp. *britannicus* is found throughout Britain.

Trollius europeaeus L.; lockety goldings, globeflower

Turk's cap lily; *Lilium martagon*

Verbascum thapsus L.; Aaron's rod, great mullein, mullein (Dorothy spells it mullen)

Veronica spicata L.; speedwell, spiked speedwell

vetch; *Vicia* spp.

Vicia spp.; vetch, pea

Vinca minor L.; periwinkle, lesser periwinkle

Viola lutea Hudson; mountain pansy; may also have been heartsease

Viola tricolor L.; heartsease

wild thyme; *Thymus praecox* subsp. *britannicus*

wind flower; *Anemone nemorosa*

wood sorrel; *Oxalis acetosella*

woodbine; *Lonicera periclymenum*

yellow pimpernell; *Lysmachia nemorum*

yew; *Taxus baccata*

The Winter Garden

auriculas; *Primula auricula;* auricula primrose

autumn crocus; *Colchicum autumnale*

box; *Buxus sempervirens*

Buxus sempervirens L.; box

Aster chinensis; China aster

Carpinus betulus L.; hornbeam

China asters; *Aster chinensis*

Christmas rose; *Helleborus niger*

Clematis vitalba L.; traveler's joy

Colchicum autumnale L.; autumn crocus

Corylus avellana L.; hazel

crocus, see autumn crocus, spring crocus

Crocus vernus (L.) Hill.; spring crocus

cypress (various genera)

daffodils; *Narcissus pseudonarcissus* L. and *N. poeticus* (white and aromatic)

Daphne mezereum L.; mezereon

fir, Scotch, *Pinus sylvestris*

hazel; *Corylus avellana*

Hedera helix L.; ivy

Helleborus niger L.; Christmas rose

hepatica; *Hepatica nobilis*

Hepatica nobilis Miller; hepatica

holly; *Ilex aquifolium*

honeysuckle (semi-evergreen); *Lonicera japonica*

hornbeam; *Carpinus betulus*

hyacinth; *Muscari comosum, M. botryoides,* or *M. neglectum*

ivy; *Hedera helix*

jonquils (very fragrant); *Narcissus jonquilla*

juniper; *Juniperus communis*

Juniperus communis L.; juniper

laurel; *Prunus laurocerasus* (*Laurocerasus officinalis*) English laurel

lesser periwinkle; *Vinca minor*

lily, see Madonna lily, white lily

Lonicera japonica Thunb.; (semi-evergreen) honeysuckle

Madonna lily; *Lilium candidum*

mezereon; *Daphne mezereum*

Michaelmas daisy; *Aster novi-belgii*

Muscari botryoides (L.); hyacinth; see Dove Cottage Garden, *Muscaria comosum*

periwinkle; *Vinca major*

Narcissus jonquilla L.; jonquils

Narcissus poeticus L.; daffodil (white and aromatic)

Pinus sylvestris L. (Although Withering lists only the Scotch fir, these were among those in cultivation in 1806 in England: *Abies sibirica* (Siberian fir), *Abies nordmanniana* (Caucasian fir), *Abies balsamea* (balsam fir—introduced into cultivation in 1696), and *Abies alba* (silver fir)

Scotch fir; *Pinus sylvestris*

polyanthus; *Primula × variabilis*

primroses; *Primula* various species

Primula various species; primroses

pyracanthus; *Pyracantha* various species

Rosa arvensis Hudson; field rose

Rosa rubiginosa L.; sweet briar

snowdrops; *Galanthus nivalis*

spring crocus; *Crocus vernus*

traveler's joy; *Clematis vitalba*

Ulmus glabra Hudson; wych elm

Vinca major L.; periwinkle

white lily; *Lilium candidum*

wildflowers (various)

wild roses; see field rose

woodbine; *Lonicera periclymenum*

wych elm; *Ulmus glabra*

yew; *Taxus baccata*

The Rydal Mount Garden

Besides many of the flowers and plants used in the Dove Cottage garden and in the Winter Garden, Wordsworth made use of those in this list.

Acer pseudoplatanus L.; sycamore or great maple

eucryphia; family Eucryphiaceae, order Parietales

fern-leaf beech; *Fagus sylvatica purpurea*

rhododendron, various species; *Rhododendron*

sycamore or great maple; *Acer pseudoplatanus* L.

(See Chris Wordsworth's description in Appendix C)

Appendix C

Wordsworth was conscious later in life that people would write unauthorized biographies of him. For the sake of the family's feelings, his nephew, Christopher Wordsworth, Jr., published an official biography, *Memorials of William Wordsworth*, in 1851. He describes the garden as if a person were standing in the graveled area near the front door:

Looking to the right, in the garden, is a beautiful glade, overhung with rhododendrons in most luxurious leaf and bloom. Near them is a tall ash-tree in which a thrush has sung for many years. Not far from it is a laburnum, in which the osier cage of doves was hung. Below, to the

west, is the regular garden, not parted off from the rest, but blended with it by parterres of flowers and shrubs.

[Moving around the corner of the house to the right], we pass under the shade of a fine sycamore, and ascend to the westward by 14 steps of stones, about nine feet long, in the interstices of which grow the yellow flowering poppy and wild geranium [or Poor Robin] a favourite with the poet, as his verses show.

The steps above-mentioned lead to an upward sloping terrace, about 250 feet long. On the right side it is shaded by laburnums, Portugal laurel, mountain ash, and fine walnut trees, and cherries; on the left it is flanked by a low stone wall, coped with rude slates, and covered with lichens, mosses, and wildflowers. The fern waves on the walls, and at its base grows the wild strawberry and foxglove. Beneath this wall, and parallel to it, on the left, is a level Terrace, constructed by the Poet for the sake of a friend [Isabella Fenwick]. This terrace was a favourite resort of the Poet, being more easy for pacing to and fro, when old age began to make him feel the activity of the other terrace to be toilsome. Both these terraces command beautiful views of the vale of the Rothay. . . .

The ascending terrace leads to an arbour lined with fir-cones, from which, passing onward, on opening the latched door, we have a view of the lower end of Rydal Lake, and of the long, wooded, and rocky hill of Loughrigg beyond and above it. Close to this arbour-door is a beautiful sycamore, and five fine Scotch firs in the foreground, and a deep bay of wood, to the left and front, of oak, ash, holly, hazel, fir, and birch. The terrace-path here winds gently off to the right, and becomes what was called by the Poet and his household the "Far Terrace on the mountain's side."

The "Far Terrace," after winding along in a serpentine line for about 150 feet, ends at a little gate, beyond which is a beautiful well of clear water, called "the Nab Well," which was to the Poet of Rydal—a professed water-drinker—what the Bandusian fount was to the Sabine bard:

Thou hast cheered a simple board
With beverage pure as ever fixed the choice
Of hermit dubious where to scoop his cell,
Which Persian kings might envy.

Returning to the arbour, we descend, by a narrow flight of stone steps, to the kitchen garden, and, passing through it to the southward, we open a gate, and enter a field, sloping down to the valley, and called for its owner's name, "Dora's Field."

Near the same gate, we see a pollard oak, on the top of whose trunk may yet be discerned some leaves of the primrose which sheltered the wren's nest. . . .

On the left of this gate we see another oak, and beneath it a pool, to which the gold and silver fish, once swimming in a vase in the library of the house, were transported for the enjoyment of greater freedom.

Passing the pool, and then turning to the right, we come to some stone steps leading down the slope; and to the right, engraven on the rock, is the following inscription, allusive to the character of the descent:

Wouldst thou be gathered to Christ's chosen flock,
Shun the broad way too easily explored,
And let thy path be hewn out of the Rock,
The living Rock of God's eternal Word.

Appendix D
RHODODENDRONS INTRODUCED
INTO BRITISH CULTIVATION

This appendix lists twenty-nine species of rhododendrons introduced into cultivation in Britain before 1850. The main sources for this information are Davidian and Hillier (see bibliography).

Rhododendron Species	Date of Introduction
anthopogon	1820
arborescens	1818
arboreum	1810
barbatum	1829
calendulaceum	1806
campanulatum	1825
camtschaticum	1801
canadense*	1799–1801
catawbiense*	1808–1809
caucasicum	1803
chrysanthum	1796
ciliatum	1850
cinnabarinum	1849
cinnamoneanum	1822
dauricum	1780
ferrugineum	1752
hirsutum	1656
lapponicum	1825
lateum	1790
lepidotum	1829
maximum*	1734–1736
molle	1823
nudiflorum	1734
obtusum	1803
ovatum	1844
(periclymenoides)	1734
ponticum	1763
setosum	1825
viscosum*	1734

*From Eastern North America

Notes

Introduction: Prelude to Wordsworth

1. *The Guardian,* September 29, 1713, No. 173, 428. (1804 ed.)

2. "Moral Essay IV, the Epistle to Lord Burlington, Of the Use of Riches," in *Alexander Pope: Selected Poetry and Prose,* ed. William Wimsatt, 1951.

3. Kimerly Rorschach, *The Early Georgian Landscape Garden,* 1983, 11.

4. Walpole, Horace. "On Modern Gardening," originally published in 1785. Quotations are from the *Works of Horatio Walpole, Earl of Orford in Five Volumes,* Vol. 2, 1798.

5. Shenstone, William. "Unconnected Thoughts on Gardening," in *The Works, in Verse and Prose, of William Shenstone, Esq., in Three Volumes, with Decorations,* 5th ed., Vol. 2, ed. R. Dodsley, 1777.

6. "Letter LVI to Mr. Jago, July 1749," *Works,* Vol. 3, 159.

7. *Oxford English Dictionary,* 2nd ed., s. v. "nature."

8. Letter written July 10, 1824, *Memorials of Coleorton,* ed. William Knight, 1887, 217.

9. "Essay on the Picturesque," *Sir Uvedale Price on the Picturesque, with an Essay on the Origin of Taste, and much Original Matter,* ed. Sir Thomas Dick Lauder, Bart., 1842.

Chapter 1: The Ode and the Dung

1. The great Ode echoes with phrases reminiscent of the book of Isaiah, for example:
35: 1–2—"The wilderness and the solitary place shall be glad for them; and the desert shall rejoice, and blossom as the rose. It shall blossom abundantly, and rejoice even with joy and singing";
44:23—"Sing, O ye heavens; for the Lord hath done it: shout, ye lower parts of the earth: break forth into singing, ye mountains, O forest and every tree therein . . .";
49:13—"Sing, O heavens; and be joyful O earth; and break forth into singing, O mountains:";
55:12—" . . . the mountains and the hills shall break forth before you into singing, and all the trees of the field shall clap their hands."

2. From the Cornell edition of *The Fourteen Book Prelude,* edited by W. J. B. Owen, 1985.

Chapter 2: The Love of Flowers: Dove Cottage

1. From Vol. One of the Yale edition of *The Poems,* edited by John O. Hayden, 1977.

2. Wordsworth did publish her poems eventually.

3. In horticulture, the term *exotic* refers to any plant that does not originate in the area where the garden is grown, whereas *native* refers to plants indigenous to the area. In the United States, the definition of *native plant* differs according to the horticulturist's point of view. For one, a native plant may be defined as one that did not come with immigrants or was not imported from another country. For another, it might be a plant that did not originate more than fifty miles away. A third might consider an exotic to be a plant that does not naturally occur in a particular microclimate. For the purposes of this book, an *exotic* is a plant that was not imported into Britain. All rhododendrons, for example, are exotics in Britain, although they do very well there.

4. By the time he was living at Rydal Mount, Wordsworth had noticed the depredations made by collectors on the populations of native plants. Not only did he stop collecting himself, he warned others to leave plants in their places. Collecting wild orchids is now banned in Britain.

5. Finally published in 1904 in the single-volume *Poetical Works,* edited by Tom Hutchinson.

6. George Kirkby has been ably succeeded by his assistant, Ann Lambert.

7. Wordsworth wrote the "Farewell" to the garden as he and Dorothy were to leave Dove Cottage on their way to France to meet Annette Vallon, the mother of his illegitimate daughter. Wordsworth intended to marry Mary Hutchinson, and he felt he had to inform Annette in person.

Chapter 3: The Garden as Poem: The Winter Garden at Coleorton

1. Owen, Felicity, and David Brown, *Collector of Genius: A Life of Sir George Beaumont,* 1988.

2. From the Cornell edition of the *Shorter Poems, 1807–1820,* edited by Carl M. Ketcham, 1989.

Chapter 4: Rock of Ages: The Garden at Rydal Mount

1. At the foot of the steep hill below Rydal Mount lies the village of Rydal, with the Rydal Lodge Hotel. Now it is a bed and breakfast, but from the sixteenth century onward it was a coaching inn. As William's fame grew and the Wordsworths' circle of friends, acquaintances, and admirers increased, many of them stayed here while visiting the poet. When one friend proposed a visit, Wordsworth replied that the house would be full, but with enough notice, he could "bespeak a bed at the bottom of the hill." William Wilberforce, the great anti-slavery activist, stayed there together with his numerous family.

2. Taking a young girl in as a servant was not, in that time, necessarily an act of exploitation. Although taking in an untrained girl was cheap help to the Wordsworths, it relieved the Greene family of feeding, clothing, and housing a growing child, and it trained her in some of the skills a woman in her situation would need, both to earn a living, and to take good care of her own family. In addition, the Wordsworths ensured that their young charges could read, write, and do arithmetic. The whole family remembered all too well what Dorothy had suffered from her own dependent situation as she grew up.

3. Wordsworth found it extremely difficult to write to Lord Lonsdale, because his father had been chief steward to the current incumbent's father. When the elder Wordsworth died, the previous Lord Lonsdale owed him 5,000 pounds, a great fortune in the days when a family could be independent on 100 pounds a year. Wordsworth had to overcome his intense dislike of the aristocracy—and particularly of the Lonsdales—in order to write to him. Eventually, the current Lord Lonsdale repaid the loan his father had reneged on.

4. The job as stamp distributor was no sinecure; it required meticulous accounting subject to annual independent audits, travel to distant places to deliver stamps, and an assistant to supervise, and other duties—all of which he felt bound to do to the best of his considerable ability.

5. In her sketchy journal of the years at Rydal Mount prior to her mind failing, Dorothy records their attentiveness to her, how they would take her round the gardens in the little cart, or how William would carry her out to see the new terrace, or visit her in her room at the top of the house.

6. At Coleorton he had written (at Sir George's request and with great difficulty) two short poems to be inscribed on stone monuments. One of them, an elegy on the memory of Sir Joshua Reynolds, became the subject of a painting by John Constable, entitled "Cenotaph to the Memory of Sir Joshua Reynolds erected . . . by the late Sir George Beaumont, Bart" (1836). Both of these monuments were still in existence when we visited the Winter Garden.

7. Beginning in 1829, Dorothy's health declined steadily, until in 1833 she experienced a terrible pain in her bowels and swelling in her legs. She was in bed for weeks and became dependent on opium and brandy. By 1835, she was not only an invalid, but afflicted with what modern medicine has diagnosed as senile dementia similar to Alzheimer's disease. The family cared for her at home until her death in 1855, five years after her brother's. (Her Rydal Mount journal has never been published, but the trustees of the Wordsworth Trust at Dove Cottage kindly allowed me to read it.)

8. Dora's Field is a piece of steeply sloping wooded ground adjacent to Rydal Mount, which he had bought in 1825, when the family thought they might have to move from Rydal Mount because the landlady, Lady Fleming, wanted the house for her aunt. Having bought the field, he proceeded to have plans drawn up for a very grand house indeed, and Lady Fleming became so alarmed at having such a splendid house so close to her own Fleming Hall that she withdrew her request for them to leave.

9. Dorothy did not begin her Rydal Mount journal until December 1, 1824. Throughout, it is sketchy and contains gaps from a week to six months between entries. She wrote it more as notes to remind herself of what she had seen and experienced, rather than to inspire her brother's poetic vi-

sion. The last entry is November 4, 1835, after a six-month gap during which the illness that caused her descent into madness nearly killed her.

10. In the autumn of 1829, Dorothy wrote to her friend Catherine Clarkson that James, whom she was watching out the window, had become a good gardener. He had not known much about gardening when he arrived, so the family had taught him, and it pleased Dorothy to see "how dearly he loved his flower borders and plants."

11. The "Western Terrace" that Dorothy sometimes refers to in her letters and journal is the Farther Terrace.

12. The highest peak in the British Isles is Ben Nevis in Scotland.

13. The term "pollard" refers not to the type of oak or any other tree, but to a style of pruning in which the small branches of a tree are cut off, leaving only nubs of the main branches in winter.

Selected Bibliography
AND FURTHER READING

Horticulture

Blamey, Marjorie, and Christopher Grey-Wilson. *The Illustrated Flora of Britain and Northern Europe.* London, Sydney, Auckland, Toronto: Hodder and Stoughton, Ltd., 1989.

Davidian, H. H. *Rhododendron Species,* Vol. 1, "Lepidotes." Portland, Oregon: Timber Press, 1982.

Davidian, H. H. *Rhododendron Species,* Vol. 2, "Elepidotes," Part 1: Arboreum-Laceteum. Portland, Oregon: Timber Press, 1989.

Davidian, H. H. *Rhododendron Species,* Vol. 3, "Elepidotes," Part 2: Neriiflorum-Thomsonii. Portland, Oregon: Timber Press, 1992.

Davidian, H. H. *Rhododendron Species,* Vol. 4, "Azaleas." Portland, Oregon: Timber Press, 1995.

Grigson, Geoffrey. *The Englishman's Flora*. London: Dent, 1955. Facsimile edition, 1987.

Hays, Samuel. *A Practical Treatise on Planting and the Management of Woods and Coppices*, 1794.

Hillier Nursery. *Hillier Manual of Trees & Shrubs*, 6th ed. Newton Abbot: David & Charles, 1991.

Lawson, Peter & Sons. *List of Seeds, Plants, etc., etc.* Edinburgh, 1851.

Phillips, Roger, assisted by Sheila Grant. *Grasses, Ferns, Mosses and Lichens of Great Britain and Ireland*. London: Pan Books, 1980.

Royal Horticultural Society. *The Rhododendron Handbook. Rhododendron Species in Cultivation*. Edinburgh: Royal Horticultural Society, 1980.

Williamson, Donald W. "Wordsworth's Five Scotch Pines," private letter to Carol Buchanan, dated June 6, 1994. Williamson is the former owner of T & W Christie, Ltd.

Withering, William. *An Arrangement of British Plants According to the Latest Improvements of the Linnaean System*. Birmingham: n.p., 1796.

The Wordsworths

Letters

The Letters of William and Dorothy Wordsworth, the Early Years, ed. Ernest de Selincourt, 2nd ed., Vol. 1, 1797–1805, revised by Chester L. Shaver, 1937.

The Letters of William and Dorothy Wordsworth, the Middle Years, Vol. 2, 1806–1811, ed. Ernest de Selincourt. Oxford: Oxford University Press, 1937.

The Letters of William and Dorothy Wordsworth, the Later Years, Vol. 3–6, ed. Alan G. Hill. Oxford: Oxford University Press, 1988.

Journals

Ketcham, Carl H. "Dorothy Wordsworth's Journals, 1824–1835," *The Wordsworth Circle,* Vol. 9, no. 1, Winter (1978), 3–16.

Wordsworth, Dorothy. *The Grasmere Journals,* ed. Pamela Woof. Oxford: Clarendon Press; New York: Oxford University Press, 1991.

———. *Journals,* ed. Mary Moorman, London, New York: Oxford University Press, 1971.

———. *Rydal Mount Journals, 1824–1829, 1830–1835.* Manuscript copy in the Library of the Wordsworth Trust, Dove Cottage, Grasmere, Cumbria, England. (The author is grateful to the Wordsworth Library for allowing her access to these manuscript journals and for permission to quote from them.)

Poems by William Wordsworth

Wordsworth, William.. *Early Poems and Fragments, 1785–1797,* eds. Carol Landon and Jared Curtis. Ithaca and London: Cornell University Press, 1998.

———. *The Fourteen Book Prelude.* ed. by W. J. B. Owen. Ithaca and London: Cornell University Press, 1985.

———. "Home at Grasmere," part 1 book 1 of "The Recluse." Beth Darlington, ed. Ithaca: Cornell University Press, 1977.

———. *Last Poems, 1821–1850,* ed. Jared Curtis with Apryl Lea Denny-Ferris and Jillian Heydt-Stevenson. Ithaca and London: Cornell University Press, 1999.

———. *Lyrical Ballads, and Other Poems, 1797–1800,* eds. James Butler and Karen Green. Ithaca and London: Cornell University Press, 1993.

———. *The Poems,* ed. John O. Hayden. Vol. 1, New Haven and London: Yale University Press, 1977.

———. *Poems, in Two Volumes, and Other Poems, 1800–1807,* ed. Jared Curtis. Ithaca: Cornell University Press, 1983.

———. *The Poetical Works of William Wordsworth,* ed. Tom Hutchinson. 1 vol. London and Oxford: Oxford University Press, 1904.

———. *The Poetical Works of William Wordsworth,* ed. Ernest de Selincourt. 5 vols. Oxford: Oxford University Press, 1952.

———. *Shorter Poems, 1807–1820,* ed. Carl H. Ketcham. Ithaca: Cornell University Press, 1989.

———. *The Tuft of Primroses with Other Late Poems for* The Recluse, ed. Joseph F. Kishel. Ithaca and London: Cornell University Press, 1986.

Biographies of William and Dorothy Wordsworth

Gill, Stephen. *William Wordsworth, A Life*. New York: Oxford University Press, 1989.

Moorman, Mary. *William Wordsworth: A Biography; The Early Years: 1770–1803*. Oxford: Clarendon Press, 1957.

———. *William Wordsworth: A Biography; The Later Years: 1803–1850*. Oxford: Clarendon Press, 1965.

Wordsworth, Christopher. *Memoirs of William Wordsworth*, ed. H. Reed. London: Boston, Ticknor, Reed, and Fields, 1851. (Author's collection).

Studies of William Wordsworth

Hudson, William Henry. *Wordsworth and His Poetry*. 1914. Reprint, New York: AMS Press, 1972.

Martin, A. D. *The Religion of Wordsworth*. London: G. Allen & Unwin, Ltd., 1973.

McCracken, David. *Wordsworth and the Lake District: A Guide to the Poems and Their Places*. Oxford: Oxford University Press, 1984.

Owen, W. J. B., "The Most Despotic of Our Senses," *The Wordsworth Circle* 19, no. 3 (Summer 1988): 136–144.

Owen, W. J. B., "The Sublime and the Beautiful in The Prelude," *The Wordsworth Circle* 4, no. 2 (Spring 1973): 67–86.

The Lake District

Rawnsley, H. D. *Lake Country Sketches*. Glasgow and London: James McLehose and Sons, 1903.

Robertson, Eric, M. A. *Wordsworth and the English Lake Country: An Introduction to a Poet's Country*. New York: D. Appleton & Co., 1911.

Wilkinson, (the Rev.) Joseph. *Select Views in Cumberland, Westmoreland, and Lancashire, with appropriate letter-press descriptions*. Self-published, 1810.

Wordsworth, William, *A Guide through the District of the Lakes. The Prose Works of William Wordsworth*, Vol. 2, eds. W. J. B. Owen and Jane Worthington Smyser. Oxford: Oxford University Press, 1974.

Racedown Lodge

Evans, Bergen, and Hester Pinney. "Racedown and the Wordsworths," *Review of English Studies* 8, no. 29 (January 1932): 1–18. (The author is grateful to the present owners of Racedown Lodge, Russell and Cynthia Gore-Andrews, for sending her a photocopy of this article and for sharing their information about the house and the Wordsworths' time there.)

Dove Cottage

Kirkby, George. "Restoring the Dove Cottage Garden," 1993. Interview on tape in the author's collection. (Kirkby was chief guide at Dove Cottage and restorer of the garden to its Wordsworthian state.)

Rydal Mount

Armitt, M. L. *Miss Armitt's Rydal*, ed. Willingham F. Rawnsley, 1916. (Author's collection. The author is grateful to Steven and Margaret Owen, of Rydal Lodge Hotel, for directing her to this informal but highly informative history of the village of Rydal.)

Coleorton

Price, Sir Uvedale. Manuscript letter to Lady Beaumont, June 26, 1804. (Courtesy of the Pierpont Morgan Library.)

"Cole Orton Hall, No. 1," *Journal of Horticulture and Cottage Gardener,* November 18, 1875, 446–447.

"Cole Orton Hall, No. 2," *Journal of Horticulture and Cottage Gardener,* December 23, 1875, 558–560.

Knight, William. *Memorials of Coleorton*. Vol. 1:104–118. Edinburgh 1887. (Author's collection.)

Garden History

Addison, Joseph. Essay on winter gardens, *The Spectator* (1712, Vol. 7, no. 477), pp. 21–25.

Coats, Alice M. *The Plant Hunters; Being a History of the Horticultural Pioneers, Their Quests and Their Discoveries.* New York: McGraw-Hill, 1969.

Elliott, Brent. *Victorian Gardens.* London: Batsford, 1986.

Fleming, Laurence, and Alan Gore. *The English Garden.* London: Joseph, 1979.

Harvey, John. *Early Gardening Catalogues.* London: Phillimore, 1972.

———. *Early Nurserymen: With Reprints of Documents and Lists.* London: Phillimore, 1974.

Hazlitt, W. Carew. *Gleanings in Old Garden Literature.* London: E. Stock, 1887.

Jacques, David. *Georgian Gardens: The Reign of Nature.* London: B. T. Batsford, 1983.

Rorschach, Kimerly. *The Early Georgian Landscape Garden.* New Haven: Yale Center for British Art, 1983.

Thacker, Christopher. *The History of Gardens.* Berkeley: University of California Press, 1979.

Turner, Tom. *English Garden Design: History and Styles since 1650.* Woodbridge, Suffolk: Antique Collectors Club, 1986.

Walpole, Horace. "On Modern Gardening," *The Works of Horatio Walpole, Earl of Orford, in five volumes,* Vol. 2, 517–547. London: G. G. and J. Robinson and J. Edwards, 1798. (Originally published in 1785.)

Wright, Richardson. *The Story of Gardening, from the Hanging Gardens of Babylon to the Hanging Gardens of New York.* New York: Dodd, Mead & Co., 1934.

The Picturesque

Farington, Joseph, R. A. *The Farington Diary.* Vol. 3, September 14, 1804–September 19, 1806. Kenneth Garlick and Angus Macintyre, eds. New Haven: Yale University Press for the Paul Mellon Centre for Studies in British Art, 1978.

Gilpin, William. *Three Essays: On Picturesque Beauty; On Picturesque Travel; and on Sketching Landscape: To Which is Added a Poem on Landscape Painting.* 2nd ed. London: R. Blamire, 1794.

Hussey, Christopher. *The Picturesque: Studies in a Point of View.* London: Cass, 1967.

Pevsner, Nikolaus, ed. *The Picturesque Garden and Its Influence Outside the British Isles.* Washington, D.C.: Dumbarton Oaks, Trustees for Harvard University, 1974.

Price, Sir Uvedale. "Essay on the Picturesque," in *Sir Uvedale Price on the Picturesque, with an Essay on the Origin of Taste, and much Original Matter.* Edinburgh: Caldwell, Lloyd, and Co., 1842.

Humphry Repton

Carter, George, Patrick Goode, and Kedrun Laurie. *Humphry Repton, Landscape Gardener, 1752–1818.* Norwich: V&A/Sainsbury Centre for Visual Arts, 1982.

The Red Books of Humphry Repton (1752–1818), ed. Edward G. Malins. London: Basilisk Press, 1976.

Alexander Pope

Charlesworth, Michael. "Alexander Pope's Garden at Twickenham: An Architectural Design Proposed," *Journal of English Garden History* 7, no. 1: 58–52.

Pope, Alexander. "A Discourse on Pastoral Poetry," in *Alexander Pope: Selected Poetry and Prose,* ed. William Wimsatt. New York: Holt, Rinehart and Winston, 1972.

———. "Moral Essays, Epistle IV: To Richard Boyle, Earl of Burlington," in *Alexander Pope: Selected Poetry and Prose,* ed. William Wimsatt. New York: Holt, Rinehart and Winston, 1972.

———. Anonymous Essay on Gardening in *The Guardian* Vol. 2, no. 173, (Tuesday, September 29, 1713): 424–428. Reprint, John Sharpe, 1804.

Sambrook, A. J. "The Shape and Size of Pope's Garden," *Eighteenth-Century Studies* 5 (1972): 450–455.

Spence, Joseph. *Anecdotes, Observations and Characters of Books and Men from the conversation of Mr Pope and other eminent persons of his time.* London: W. H. Carpenter, 1820. Reprint, London: Centaur Press, 1964.

Wimsatt, William. "Introduction," in *Alexander Pope: Selected Poetry and Prose.* New York: Holt, Rinehart and Winston, 1972.

Aesthetics

Brennan, Matthew C. *Wordsworth, Turner, & Romantic Landscape: A Study of the Traditions of the Picturesque & the Sublime.* Columbia, SC: Camden House, 1987.

Burke, Edmund. *Inquiry into the Origin of our Ideas on the Sublime and the Beautiful.* 1757. Cambridge: Harvard Classics Edition, ed. Charles Eliot. 1988.

Dodsley, R. "A Description of the Leasowes," in *The Works, in Verse and Prose, of William Shenstone, Esq., in Three Volumes, with Decorations,* 5th ed., Vol. 2. ed. R. Dodsley, 1777.

Hipple, Walter John, Jr. *The Beautiful, the Sublime, and the Picturesque in Eighteenth-Century British Aesthetic Theory.* Carbondale: Southern Illinois University Press, 1957.

Hogarth, William. *An Analysis of Beauty.* London: J. Reeves, 1753.

Knight, Richard Payne. *An Analytical Inquiry into the Principles of Taste.* London: T. Payne, 1805.

Noyes, Russell. *Wordsworth and the Art of Landscape.* New York: Haskell House Pub., 1973.

Shenstone, William. "Letter XXXIV: To Mr. Graves, Written in Hay-Harvest, July 3, 1745," in *The Works, in Verse and Prose, of William Shenstone, Esq., in Three Volumes, with Decorations,* 5th ed., Vol. 3, ed. R. Dodsley. London: J. Dodsley, 1777.

————. "Letter LVI: To Mr. Jago, July 1749," in *Works,* Vol. 3.

————. "Letter LXXX: To Mr. Jago, July 1749," in *Works,* Vol. 3.

————. "Unconnected Thoughts on Gardening," in *Works,* Vol. 2, 124 ff.

Romanticism

Abrams, Meyer H. *The Mirror and the Lamp: Romantic Theory and the Critical Tradition.* New York: Oxford University Press, 1953.

————. *English Romantic Poets.* Modern Essays in Criticism. New York: Oxford University Press, 1960.

Bradley, A. C. *Oxford Lectures on Poetry.* London: Macmillan, 1909. Reprint New York: St. Martins Press, 1963.

Clark, Kenneth. *The Romantic Rebellion: Romantic Versus Classic Art.* London: Sotheby Park Bernet Publications Ltd., 1973.

Heffernan, James A. W. *The Re-Creation of Landscape: A Study of Wordsworth, Coleridge, Constable, and Turner.* Hanover: University Press of New England for Dartmouth College, 1984.

Twitchell, James B. *Romantic Horizons: Aspects of the Sublime in English Poetry and Painting, 1770–1850.* Columbia: University of Missouri Press, 1983.

Wilton, Andrew. *J. M. W. Turner: His Art and Life.* New York: Rizzoli Press, 1979.

The Concept of Nature in the Eighteenth Century

Bate, Walter Jackson. *From Classic to Romantic.* New York: Harper and Row, 1961.

Lovejoy, Arthur O. *The Great Chain of Being: A Study of the History of an Idea.* Cambridge: Harvard University Press, 1961.

Owen, Felicity, and David Brown. *Collector of Genius: A Life of Sir George Beaumont.* New Haven, London: Yale University Press, 1988.

Simpson, J. A., and E. S. C. Weiner. *The Oxford English Dictionary,* 2nd ed. Vol. 10. 1989.

Willey, Basil. *The Eighteenth Century Background: Studies on the Idea of Nature in the Thought of the Period.* New York: Columbia University Press, 1969.

Index

Pyne, J. B., **16**, **119**, **123**
pyracantha, 99

R

Racedown Lodge, xvii, 35–36,
 52–54, 73, 101, 102, 107,
 108, 120
radishes, 72
Recluse, 36, 83
Reed, Mark L., xviii
Repton, Humphry, 19–21
Reynolds, Sir Joshua, 111
rhododendrons, 159, 170–173
River Duddon, 123
River Rothay, 118
Robin and the Butterfly, 82
rock, 27, 62, 64, 67, 69, 73, 77,
 79, 95, 105, 111–112,
 129–130, 153, 154, 157, 160,
 162, **179**, 180; rock garden,
 151; rock outcropping, 34,
 69, 71, 79, 139, **158**; rock
 pool, 38, 131, 138, 154, **155**,
 157, 173, 180; rock seat, 64,
 68, 82; rock steps, 109; rock
 wall, 118, **140**, **151**, 173
Rock of Names, 79, 129
rockwork, 138, 139, **152**, 157
Rome, 4
Rosa rugosa, **71**, 76, **178**
Rosa, Salvator, 4, 16
rosemary, 76

roses, 57, 62, 81, 159, 171, 172
Rothay (spelled Rotha in Words-
 worth's time), **136**
rowan, or mountain ash, 77
Royal Horticultural Society, 182
Rydal village, 115, **193**
Rydal church, 128, 129
Rydal Fell, 118
Rydal Mount, xvi, xvii, xviii, 28,
 32, 34, **38**, 41–44, 47, **51**,
 83, 115, 116–117, 117–118,
 120–121, 124, 129–130,
 134–135, 137, 139, 142–143,
 154, 156, **156**, 159, 174, 177,
 178, **179**
Rydal Water, **32**, 118, **119**, 139,
 142–143, 146–147, 153, **169**,
 187, **190**

S

scarlet runner beans, 72, 76
Scotch fir, 170
Scotch pine, 99, 109, 171
Scott, Sir Walter, 111, **112**, 120
Scott's seat, **112**
"Seaport with the Embarkation of
 Saint Ursula," 4
second cottage, 97, **98**, 99
Serpentine, 9
Shenstone, William, 14–16
Silver How, **61–62**, 67, 70, **186**

Simpsons, Wordsworths's neigh-
 bors, 76
Sloping Terrace, 138, 139, **141**,
 143, **148–150**, 152, 160, **161**
snowdrop, 72, 102
Southey, Robert, 18
spearmint, 76
Spectator, 94, 95
Sphagnum auricularum var.
 auriculatum, 80
sphagnum moss, 80
spotted orchid, 74
stepping stones, 69, 71
steps, 44–45, 60, **65**, 110, 113,
 133, 139, 140, 141, 142, 145,
 163
stitchwort, *Stellaria holostea* L., 72,
 74
stone, 34, **41–44**, 64, 69, 72, 79,
 90, 102, 104, 109, 113, 129,
 130, 138, 143, **144**, 154, 158;
 stone bench, 108; stone en-
 trance, 47, **111**; stone hut,
 138; stone steps, **31**, **43**, **44**,
 68, 109, 133, 138, 139, **150**,
 160, 172; stone table, 108;
 stone terraces, 34; stone wall,
 40, **48**, **51**, **54**, 60, **67**, **69**, 79,
 83, 89, 95, 143, 160
stonescaping, 143
stonework, 34, 44, 64, 130, 143
Stowe, 7, 9
strawberries, wild, 76

Summer House, **58**
sweet peas, **57**
sycamore, 160, **164–165**, 170, 171

T

T & W Christie, Ltd., 170
The Graham Children, 11
The Rake's Progress, 11
"The Seven Sisters," 80
"Thorn, The," 77
thyme, 76–77
"Tintern Abbey," 30
"To a Butterfly," 60, 81
"To Joanna," 26
"To the Same Flower," 76
"To the Small Celandine," 76
"To the Spade of a Friend," 72
Town End, Grasmere, 37, 55
Traveler's joy (*Clematis vitalba*),
 102
Turk's cap lily (*Lilium martagon*
 L.), **75**, 76
Turner, Joseph Mallord William,
 12, 18
turnips, 36, 72
Twickenham, 7

U

Ullswater, 62, **192**
*Unconnected Thoughts on Gar-
 dening*, 14, 15